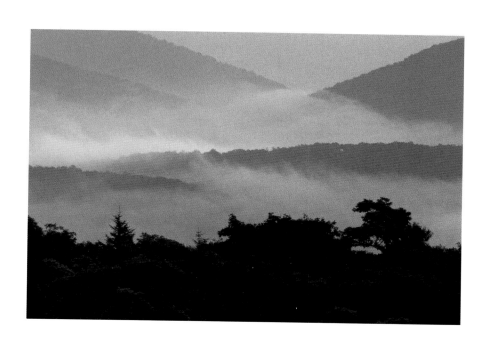

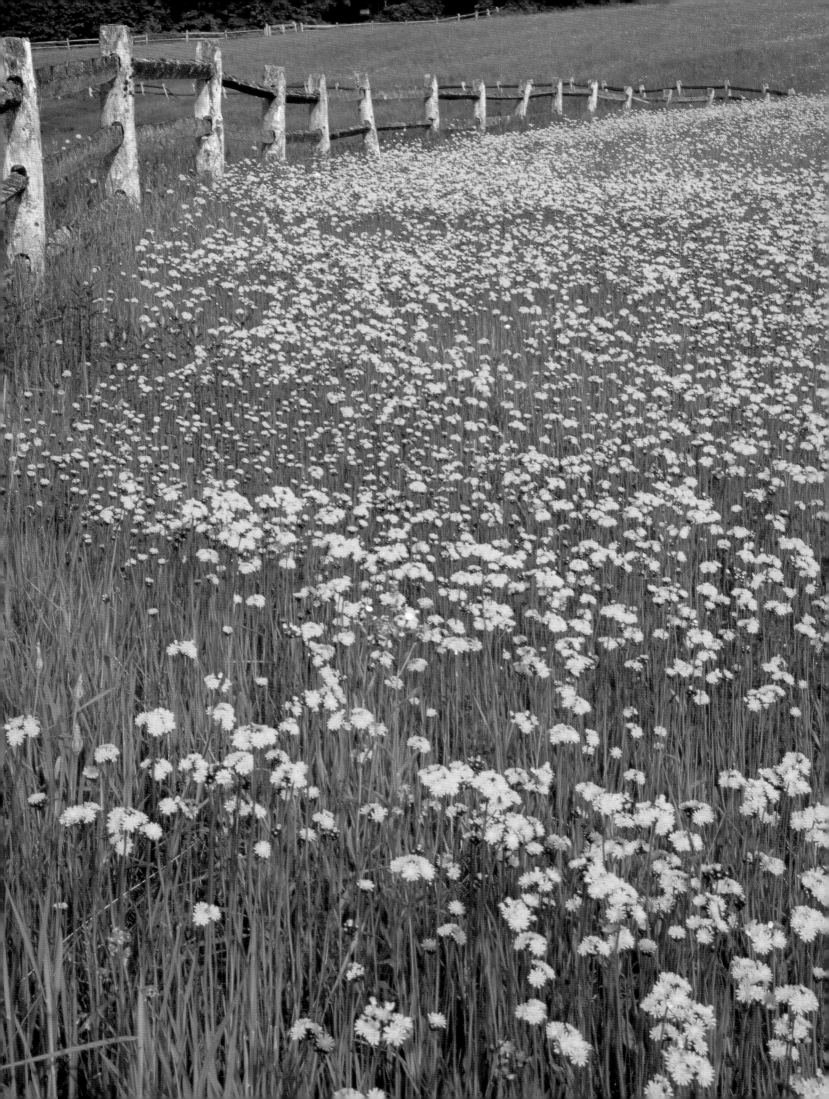

MOUNTAIN MEMORIES

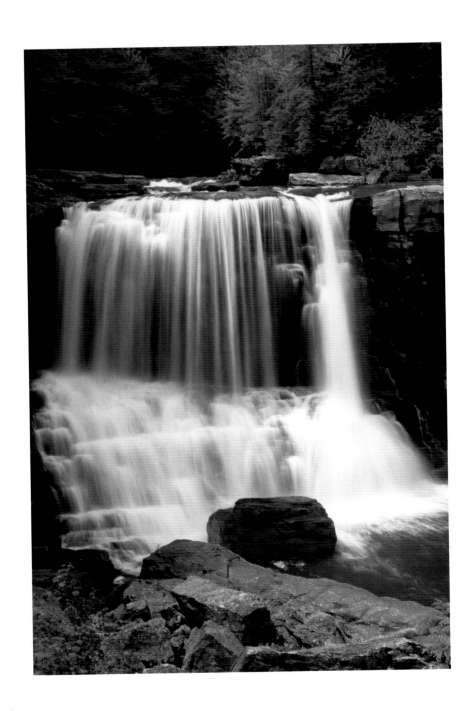

MOUNTAIN MEMORIES

An Appalachian Sense of Place

Text and photography by Jim Clark

With a Foreword by Kathy Mattea

Vandalia Press

Morgantown, 2003

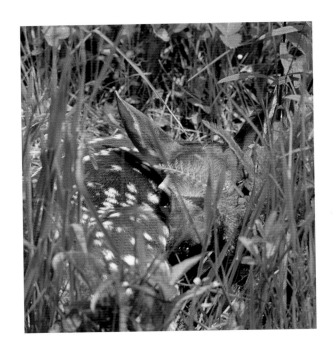

"Everything that is new or uncommon raises a pleasure in the imagination, because it fills the soul with an agreeable surprise, gratifies its curiosity, and gives it an idea of which it was not before possessed."

— Joseph Addison

To the apple of my eye and the diamond in my heart:

my son Carson, and his beautiful mother and my wonderful wife, Jamie.

Vandalia Press, Morgantown 26506
© 2003 by West Virginia University Press

Text and Photographs © Jim Clark

10 09 08 07 06 05 04 03 8 7 6 5 4 3 2 1

ISBN (cloth) 0-937058-77-7 (alk. paper)

Library of Congress Cataloguing-in-Publication Data

Clark, Jim 1953–.
 Mountain Memories: An Appalachian Sense of Place
 p. cm. —
1. Natural History – Appalachian Mountains. 2. Natural History – Appalachian Mountains – Pictorial works. 3. Natural History – Appalachian Region. 4. Photography – Appalachian Mountains. I. Title. II. Clark, Jim. III Mattea, Kathy.
IN PROCESS

Library of Congress Control Number: 2003104077

Design by David Alcorn, Alcorn Publication Design
Printed by C & C Offset Printing Co.
Printed in China

Vandalia Press publishes fiction and non-fiction of interest to the general reader concerning Appalachia and, more specifically, West Virginia.
See our website at www.vandaliapress.com to learn of forthcoming titles.

Page 1: Sunrise – Dolly Sods; page 2: Field of Hawkweed along fence line on the Highland Scenic Highway, Pocahontas County; page 4: Blackwater Falls – Blackwater Falls State Park – Summer Scene; page 6: White-tailed Deer Fawn, Webster County

Contents

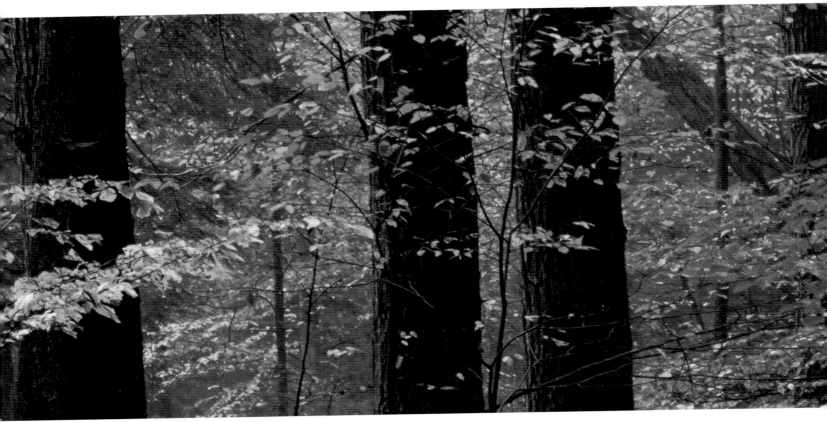

Early Autumn – Cathedral State Park

Foreword

In my travels around the country and the world, I run into countless people who call themselves West Virginians. My first question to them is usually something like "How long have you all been gone?" The replies vary, but I remember one couple's answer: twenty-five years. And yet they still think of themselves as West Virginians.

It's a curious thing, this identity as a Mountaineer. I left the state at nineteen, and still feel like a West Virginian at heart. I guess it's in the blood, in our psyche, in our approach to the world.

The rugged beauty, the isolation, the visual poetry of West Virginia is something we carry with us throughout our lives. As a kid, I spent time all over the state. I've ridden Cass Scenic Railroad, picked huckleberries on Bald Knob, and ridden horses to the top of Seneca Rocks. I've whitewatered down the New River, hiked to the Virgin Hemlocks in Monongahela National Forest and learned to ski at Snowshoe. I've camped at Pennsboro, taken music ministry to the coalfields of Logan County, gone for a run along the banks of the Ohio in Wheeling, spelunked in the caves of Greenbrier County, and sung the National Anthem at Mountaineer Field. I've put a penny on the railroad tracks in Putnam County, watched the fireworks in Charleston from the deck of the P.A. Denny, and helped run a trotline across Elk River. I am a West Virginian at heart, and always will be.

How do we take this innate sense of what is West Virginia, and impart it to someone who may never have visited the state? How do we articulate what makes us love it so? Jim Clark has done this for all of us.

This book is historical and educational, but more than that, it is inspiring. Jim's photographs range from a majestic vista to a minuscule, stolen moment of intimacy with a creature we seldom see. It's as if he has a special window, a gift for snapping the shutter at just the right moment.

There's magic on these pages. And wonder. Jim's is a world with no cell phones, no pagers, no Internet—a world where there is no need for television. He sees through God's eyes. His vision enhances our own, and we are richer for his love of our beautiful state.

I will always have an Appalachian sense of place, I suppose. Jim's mountain memories echo my own, and those of so many others who hold this special corner of the world in their heart. If you have never before seen these hills, perhaps this book will inspire you to make a few memories of your own. As for me, I turn the pages of this book and feel lucky to have so much of this beautiful, mysterious place in me.

Kathy Mattea
West Virginian
Two Time Grammy Award Winner
Two Time Country Music Association Artist of the Year

Acknowledgements

The truest joy I have is sharing my passion and love of nature with my family and friends. I would like to thank them, but I will undoubtedly forget someone. To those, I want to express my appreciation and gratitude for their role in the creation of this book.

In memory of a wonderful woman, mother, and wife, who left us way too early: Fran Rappaport. We miss you, but your love for life and family has been forever etched in our hearts. Our son Carson will know about how wonderful his grandmother was to everyone.

Thanks to my neighbors Jenny, Jerry, Jacob, and Charlotte Buracker, for dog sitting, delicious meals, and your friendship. The neighbors on the other side, Jack and Eileen Gudat, were equally supportive and my thanks go to you two, as well. A few doors down the street, Marge Ahalt, a woman whose passion for West Virginia nearly equals mine, offered up countless meals, memories, and hugs.

My deepest appreciation goes to the fine folks at The Mountain Institute, especially Marcie and Ryan Demmy Bidwell and more recently, Matt Tate and Doug Wandersee. Thanks for your support and for what you do as an organization to protect and promote mountain cultures and environments around the world. Thanks to Olive and Charlotte at the Cranberry Mountain Visitor Center for hugs and down home conversation. Appreciation goes to the Canaan Valley mama Marilyn Aikman for your advice, our lunches together, and the time we spent talking about photography, nature, and "Almost Heaven."

To the Conservation Fund, the Canaan Valley Institute, and The Nature Conservancy, deepest thanks for your efforts to protect these special places.

For guiding this book from my imagination to this printed page, thanks to editor Danny Williams of West Virginia University Press and designer David Alcorn of Alcorn Publication Design.

In memory of my mentor and best friend in life, John Netherton: You will be truly missed. I will continue to carry on your passion for life. Thanks, Johnny Boy. To my new-found photography partner and friend, Bill Campbell – thanks for sharing these mountains with me and sharing with others our passion for photography and nature. To my "photo-dawg" Bailey, you were a great partner during the years we traveled through West Virginia. I miss you Bailey Bones.

Thanks to Ray and Judy Schmitt for their hospitality, encouragement, and inspiration. To my frequent photography partners, Greg Knadle and Randy Rutan, thanks for your company. To my dear friend, Pat Price: What a pleasure it was to take you through the mountains of my heart and share with you that special Greenbrier morning. Thanks for your friendship and encouragement. To all teachers who were worth something, from elementary school

through college: Thanks for making my life more interesting, challenging, and memorable, and for preparing me for my wonderful journey through life. In particular, thanks to Mrs. Freeman, Mr. Simpson, Mr. Justice, Dr. Michael, and Dr. Martin. To my colleagues of the U.S. Fish and Wildlife Service and especially at the National Conservation Training Center: Thanks for celebrating with me nature's glorious seasons and for sharing with me your own Mason jar memories. Thanks to composers Jon Archer, Michael Gettel, and Mark Isham. Your music lifts my heart and ignites my love for life. A special thanks to a true mountain lady, singer/songwriter Kathy Mattea – you make us West Virginians proud.

Thanks goes to my sisters, Helen and Joyce, and my brothers, Charles and Norman. You were always there to help me see my dreams come true. I love you all. Helen, you are still the best twin sister in the world.

This project was made more interesting, fun, and memorable with the birth of our son, Carson, in 1999. Thanks, Carson, for entering my life and becoming the best good luck charm any father could have. My love and admiration goes to my beautiful wife, Jamie – thanks for understanding my passion for photography. And thanks for doing more than I or anyone else could ever do to protect these wild places for Carson and his generation.

Finally, a special hug and thanks to a real woman of the mountains – a true Mountain Mama – my mother, Pauline Clark. Thanks, Mom, for showing me how to celebrate life, to be nice to others, and to keep compassion in my heart. You'll never know how much I love you. And Mom, snakes and snow aren't that bad.

Jim Clark

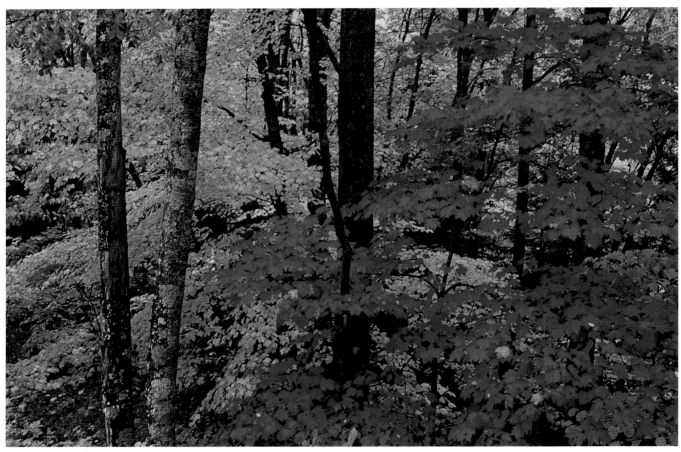

Red Maple on the road to Spruce Knob

"Hold out your hands to feel the luxury of the sunbeams."

—Helen Keller

Introduction

I n the Appalachians, there are two absolutes: mountains and trees. Although not unique to the Appalachians, they do define the fundamental nature of this ancient landscape.

Visitors will always include the words "mountains" and "trees" when describing the Appalachians. No matter where you are in the Appalachians, the mountain in front of you or around the next turn in the road will influence your next opportunity. To go from point A to point B, a mountain factors into the equation. The solution is to go around, over, or under it. And whatever vista is before you, a forest or at least a grove of trees will be included in the view. To live in the Appalachians, one must love or tolerate mountains. Having a fondness for trees doesn't hurt either.

As a youngster living in the mountains of southwestern West Virginia, I was never fond of the options for dealing with mountains. My preference was to stay put in the small mountain valley I called home. My innate lack of balance combined with the narrow roads snaking along our mountains never agreed with each other. Motion sickness was then, and remains today, a curse.

My parents dreaded when I would travel with them. Trips became major events; even short trips to the next town, just thirteen miles away, became ordeals. These excursions were an excruciating experience not only for me, but for my siblings as well. They were not too excited about sitting next to me during these drives. But despite it all, we always found a way to beat the odds and I somehow managed to survive each and every outing.

Lack of intestinal fortitude for travel aside, I never lost my love for the mountains. As many times as we left home each summer for the beaches of North Carolina, I was always happy to return. My sense of balance may have been lacking, but I never lost my sense of place for the forests and mountains of West Virginia. I never got enough of what the mountains and forests offered. I still can't.

Like a favorite hand-stitched quilt, these mountains remain a great comfort to me. There is always a sense of relaxation that falls over me as soon as I get a glimpse of their blue-ridged summits. Once in the heart of the Appalachians, my pulse rate slows down a bit and all is right with the world. And like that old quilt, how grand it is to be snuggled inside these mountains.

The mountains surrounding my home became my close friends. At an early age, I focused my attention and interest on the nature of these mountains. An infatuation with birds became the initial catalyst, and after becoming an expert about the local bird life, I turned my attention to the other critters and plants. I exploited my youthful exuberance to learn as much as I could. Before long, I started to understand the connection of all living things to each other. The fundamentals of ecology were something I could comprehend. I understood what John Muir meant when he wrote that when pulling at a single strand of nature, one would find it attached to the rest of the world. The mountains showed me that connection, not only to the life surrounding my home, but also to other places in the world.

These mountains – my mountains – became the best mentors a young naturalist could ever have. They challenged me. They protected me by keeping me out of trouble as a teenager. They continued to offer up something new every time I hiked their ridgelines. They offered just enough to make me want to learn more. They kept me hungry.

As I got older, I discovered that the mountains had a voice, a voice of wisdom and reason. The mountains spoke to me in subtle and discreet ways through their forests, creatures, and seasons. Warm spring nights summoned me outside, tempting me to search for chorus frogs calling along the shallows of a local lake. Summer breezes drifting down the valleys whispered a challenge for me to uncover all the mysteries hidden in the lush forests. The blue autumn skies invited me to explore another ridge or remote valley, and winter's fragile landscape beckoned me to strike out into the morning cold and wander its snowy wonderland.

The mountains hid stories on every ridge top and along every slope. The seasons, each a reason for celebration, yielded clues to treasures that required me to look a little deeper to uncover. As an adult with a child-like curiosity, I continue to find much to celebrate and discover while exploring these mountains.

The more I learned about the mountains, the more I learned about myself. The mountains challenged me to look beyond their forests and rivers to discover my own strengths and weaknesses. I became confident in my abilities to accept challenges and to take risks. My solitary treks along the summits and ridges gave me time to think and reflect, and while I may have been alone, I was never lonely.

This ancient landscape holds a personal magic for me, and with this book I want to share with you some of my favorite places of the heart, to reveal some of their secrets and wonders. From the fascinating birds nesting and migrating along the highland reaches, to the wonderful variety of trees covering the landscape, to the enchantment of autumn and the mysteries of a summer's night, I hope these essays and images will help you see and feel the magic of this special landscape. I hope a spark is ignited in your heart.

Although most of the experiences I'll be sharing with you come from my time living, photographing, and working in West Virginia, the entire Appalachian mountain chain—from Maine to Alabama—is worth exploring. I hope this book creates a thirst, an insatiable hunger for you to explore the Appalachians.

If you are willing to listen, the Appalachians will help you hear the hoot of the barred owl or the soft rustle of leaves during a summer afternoon. If you are willing to watch, these mountains will show you ruffed grouse strutting along an old dirt road or a flock of turkeys gleaning insects from a summer meadow. If you are willing to use your sense of smell, these mountains will refresh you with the sweet fragrance of a spring rain or the invigorating aroma of autumn leaves. If you are willing to touch, these mountains will help you feel the sensation of a cool mountain stream or the warmth of a summer afternoon. If you are patient, these mountains will help you experience the best of what this landscape can offer. If you want to feed your soul with nature's best, you've come to the right place. Welcome to my mountains of the heart.

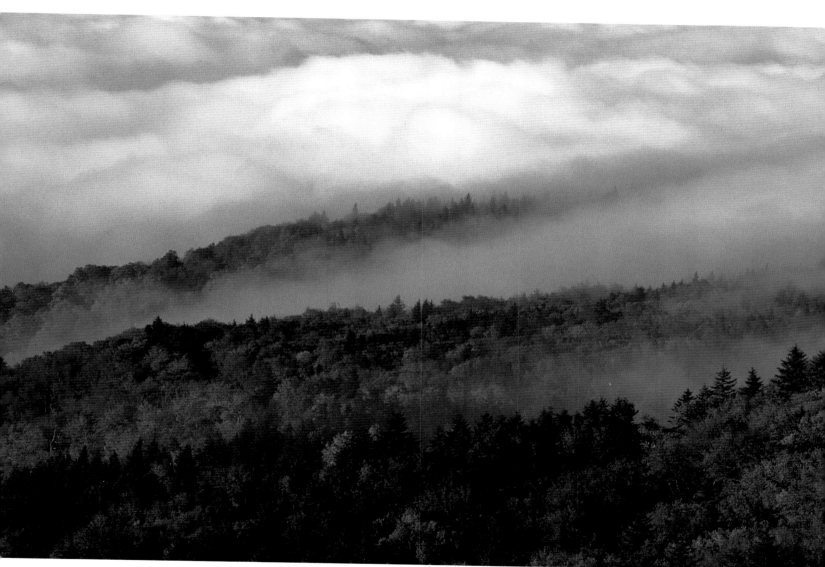

Autumn Morning Fog – Summit of Spruce Knob

Following page: Sunrise – Dolly Sods

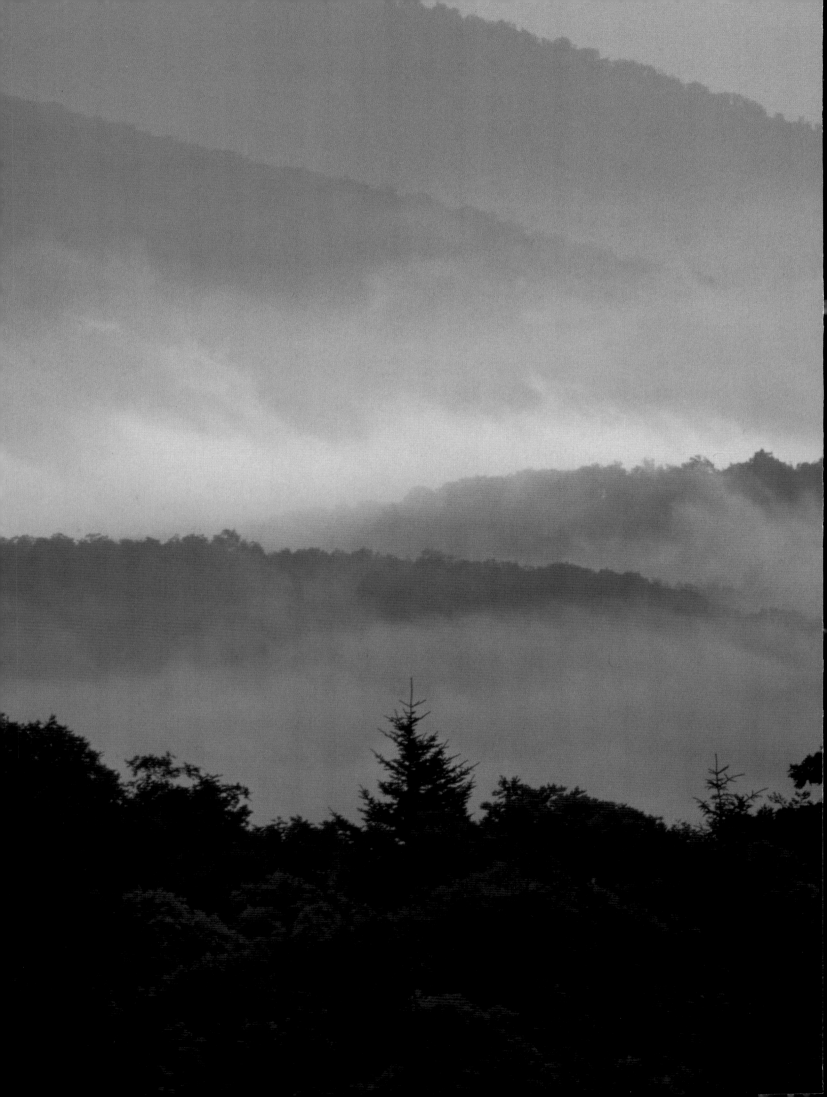

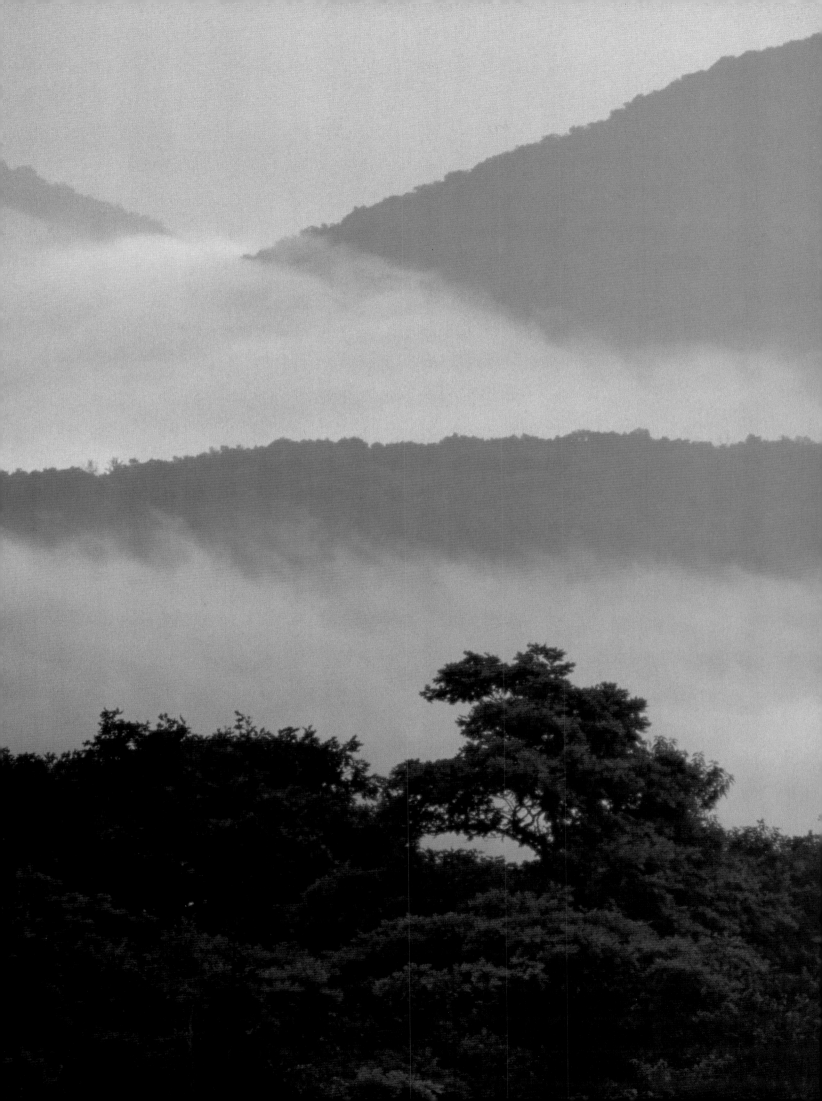

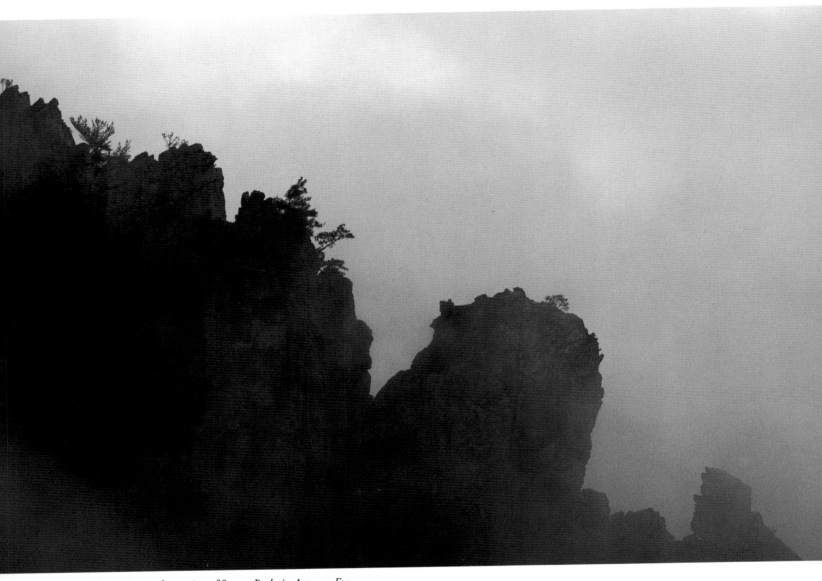

Isolated Scenic of a portion of Seneca Rocks in Autumn Fog

"Yet it is a singular contradiction that in their outlines old mountains look young, and young mountains look old...All the gauntness, leanness, angularity, and crumbling decrepitude are with the young mountains; all the smoothness, graceful, flowing lines of youth are with the old mountains."

—John Burroughs

Ancient, But Wise Beyond Their Years

ool temperatures on this late spring morning greet me while driving along the Highland Scenic Highway in the Monongahela National Forest in Pocahontas County, West Virginia. Early morning light filters through the hardwood and spruce forest lining the road, painting the trees with shafts of gold. Where the forest canopy opens up, single beams of brilliant luminescence stream through, enhancing the spiritual ambience of this natural cathedral. At the turnoffs, I am treated to a visual feast of misty-blue ridges stretching to the horizon. A great day is at hand.

Below the highway, banks of thick fog shroud the Williams River Valley. As the sun rises above the summits, the fog dissipates. The clouds move on. Blue skies appear. A light breeze stirs the meadow grasses, creating a waving sea of green. The rising temperatures warm up dew-covered butterflies – fritillaries, yellow sulphurs, and orange-spotted blues – each of whom spreads its wings and begins exploring the flowers blanketing the meadows. Blue-eyed grass and golden yellow hawkweed provide more color to the meadow. Bluebirds dart back and forth from fence post to cavity tree, gathering insects to feed their hungry nestlings. A rose-breasted grosbeak sings from its perch along the meadow's edge. Appalachian spring, pure and simple.

Exploring the Highland Scenic Highway is one of my favorite pastimes with or without a camera, and it never fails to provide a surprise or two or three or four. This summer morning is no exception. Even before sunrise, just below the highway on the Williams River Road, I spy a female common merganser snoozing on a massive boulder in the middle of the river. As her eyes open, she doesn't appear to be too concerned by my voyeurism, even granting me a few minutes to take images of her.

Backlit view of field of Hawkweed in meadow along the Highland Scenic Highway – Pocahontas County

I continue my journey up to the Highland Scenic Highway. On the last stretch of the Williams River Road, I watch the sunlight peek over the trees and reflect on the water. Abstract patterns are formed by the interplay of light, color, and water – impressionistic paintings that no human could ever equal. I have to remind myself to keep my eyes on the road.

Back on the Highland Scenic, I spot two hen turkeys with their poults feeding along the edge of the highway. Wary as these birds are, even when I stop my truck, they remain reluctant to leave. But move on they do, and before long, the hens have their young ones safely up a steep embankment and into the forest. Although the adults are ahead of the poults, their soft clucking serves notice as to where the young ones should go. Attentive mothers, hen turkeys are.

The wonderment of the day doesn't end here. While photographing hawkweed flowers and grasshoppers in a meadow along the road, I am serenaded by indigo buntings and eastern towhees, their songs creating a delightful mood to the already glorious morning. Count this day as another wonderful Appalachian memory.

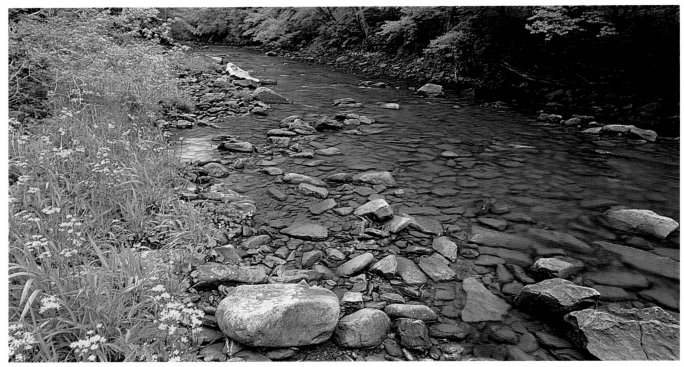

Elk River in Spring

As always when I visit this unique region of the Appalachians, I fail to reach the destination I had planned ahead of time. Something always tempts me to stay just a bit longer, and today is no different. Just before I exit the highway, a hen ruffed grouse and her chicks provide another reason to delay my trip to photograph at the Cranberry Glades Botanical Area. I'm not successful in getting photographs of the family, but like the turkeys just down the road, they give me yet another mountain memory. As Aristotle wrote, "In all things of nature, there is always something of the marvelous."

East of the Mississippi, no more impressive landscape exists than the Appalachian Mountains. Paralleling the Atlantic coast from Quebec to northern Alabama, the Appalachians are the world's second-longest chain of mountains, extending north to south for more than 2,100 miles. Ranging from 100 to 300 miles in width, the Appalachians boast summits reaching more than 6,600 feet. Crustal plate collisions during the Ordovician period created these mountains, making them the senior member of the world's ranges.

The Appalachians might be ancient, but they are wise beyond their years. Their current elevations are minuscule compared to the "fourteen thousand footers" in the Rockies; however, they have been around a much longer time, making the Rockies mere teenagers in the geological scheme of things. Before the Rockies started forming, the Appalachians had elevations reaching beyond 14,000 feet; some geologists estimate elevations exceeded 30,000 feet, higher than present day Everest. But time – especially hundreds of millions of years of time – wears everything down. The Appalachians were no exception. These mountains were shaped by an unrelenting geologic assault from wind, rain, and lift. But this rumpled quilt of old mountains has an illustrious history, and the richness of life found within its coves, slopes, and summits remains second only to the barrier reefs. The gentle hills evince an impression of beautiful simplicity, but within their forests and valleys and along their rivers lie an amazing landscape of life. Ancient, diverse, and full of life – that's the Appalachians.

The Appalachians harbor an extraordinary diversity of plants and animals. In the southern Appalachians alone are more than 2,500 species of flowering plants and 400 species of mosses. A look at the Great Smoky Mountains straddling the borders of Tennessee and North Carolina offers an example of the amazing biological diversity found here.

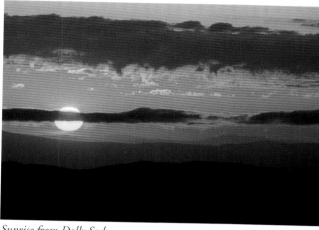

Sunrise from Dolly Sods

The Great Smoky Mountains are renowned for the abundance and composition of their plants and wildlife, and the depth and integrity of the wilderness sanctuary within their boundaries. Covering 800 square miles, the Great Smokies harbor more than 2,000 fungus species, 1,500 plants, 130 trees, 27 salamanders, 200 bird species, and 70 mammal species. The park also protects nearly 130,000 acres of old growth forest, one of the largest remaining tracts of ancient forests along the eastern seaboard. Imagine for a second, what this region must have look liked before the arrival of the ax, plow, and Shay steam engine. And the Smokies are only one sub-region of this amazing mountain chain.

Other regions of the Appalachians host their own diversity of plants, animals, and landscapes. In northern New Hampshire and southwestern Maine lie the rugged **White Mountains,** with elevations reaching nearly 6,300 feet. Here spectacular gorges, plunging waterfalls, and luxuriant forests of beech and maple dominate the landscape. The **Green Mountain** range of central Vermont, Massachusetts, and Canada's Quebec Province have forests of evergreen, birch, and sugar maple. Major portions of both the White and Green mountain ranges are included in the National Forest System.

Along the border of New York and Massachusetts and extending into the southwestern corner of Vermont are the **Taconic Mountains.** In southeastern New York, near the Hudson River, lie the fabled **Catskill Mountains,** a low range made famous by the writings of Washington Irving. Here, nature and literature met to create romantic stories of the Appalachians.

In the Mid-Atlantic region are the **Allegheny Mountains** or as locals call them, the Alleghenies. The Alleghenies include ranges west of the Blue Ridge in Pennsylvania, Maryland, Virginia, and West Virginia. These mountains form a divide between rivers draining into the Gulf of Mexico and those flowing into the Atlantic Ocean. Composed of stratified rocks of the Silurian, Devonian, and Carboniferous ages, the Alleghenies are rich in minerals, especially coal, still an important and controversial element of the regional economy.

The easternmost range of the Appalachians, the **Blue Ridge Mountains,** extends from northern Georgia northeastward across western North Carolina into western Virginia and eastern West Virginia. The northern terminus occurs near Harpers Ferry, West Virginia, at the confluence of the Potomac and Shenandoah Rivers. Most summits in the Blue Ridge vary between 2,000 and 4,000 feet, but a subsidiary range, the **Black Mountains,** forms the highest summits in the Appalachians. Situated in western North Carolina, the Black Mountains are so labeled because of the evergreen forests covering their summits. Within this range is Mount Mitchell, at 6,684 feet the highest point east of the Mississippi River.

In the southeastern reaches of the Appalachians are the **Cumberland Plateau** and **Cumberland Mountains**, which reach along the southwestern border of Virginia and southeastern Kentucky, across eastern Tennessee, northern Georgia, and northeastern Alabama. The Cumberland Mountains are renowned for their underground streams and caverns and steep, narrow gorges. In western North Carolina and eastern Tennessee rise the **Great Smoky Mountains**, one of the oldest upland regions in the world, internationally recognized for its diversity of life.

With such a spectrum of forests and landscapes, the Appalachians remain as one of the world's unique ecosystems, and this uniqueness did not escape the early explorers and naturalists. The Appalachians provided just the right enticement to keep naturalists busy, happy, and content.

The rich biological diversity of the Appalachians has fascinated nature enthusiasts, both professional and amateur, ever since the first European settlers reached the region. However, the first true naturalists, the Native Americans, were already experts on the region's many species of plants and animals. The discoveries made by those who arrived later were actually re-discoveries of what was already known.

In exploring the North American continent, European naturalists were resolute in cataloguing every plant and animal they encountered. Early naturalists included individuals such as John Banister (1650-1692), who traveled the southeastern region of Virginia studying and collecting plants, mollusks, and insects. Mark Catesby (1679-1749)

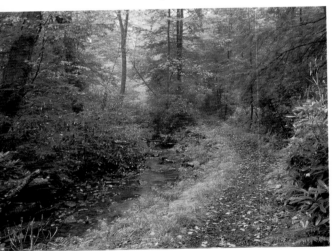

Early Autumn – Cathedral State Park

explored the mountains of Virginia, the Carolinas, and Georgia. An excellent painter, Catesby was considered the New World's authority on herpetology. John Bartram (1699-1777), a frequent guest of Benjamin Franklin, explored the Black Mountain region of North Carolina. Bartram's son, William (1739-1823), was the first "native-born" naturalists/artist, and in 1791 he authored the American classic *Travels*. William's nature writing integrated natural history with his love for nature, hence giving him the title as the first of the New World's "spiritual naturalists."

Other early naturalists included André Michaux (1740-1802) and his son, Francisco. In addition to a description of the flora of Kentucky, Francisco published in 1817 the classic *North American Sylva*, one of the earliest comprehensive works on North American trees. John Fraser (1750-1811), a Scottish draper and an avid botanist, often accompanied Michaux on his expeditions to collect and identify plants. Also assisting Michaux were naturalists Fredrick Pursh (1774-1820) and Constantine Samuel Rafinesque (1783-1840).

America's first native-born botanist, Pennsylvanian Benjamin Smith Barton (1766-1815), recruited Pursh and Thomas Nuttall (1786-1859) to collect plants for him. One of the most prominent botanists, Asa Gray (1810-1888), explored the Highland region of southwestern North Carolina. Gray's classic treatise, *Manual of Botany,* became the standard reference of the day for plants of the northeastern United States. Between 1828 and 1845, Charles Wilkins Short (1794-1863), a physician and botanist, published thirty papers about the vascular plants of Kentucky.

Although the initial focus was centered on plants, many early naturalists documented the wildlife of the Appalachians. John James Audubon (1785-1851) and Alexander Wilson (1766-1813) explored the Appalachians collecting and painting birds. Spencer Fullerton Baird (1823-1887), a dominant figure in American natural history and Assistant Secretary of the Smithsonian Institution for twenty-eight years, explored the mountains of his home state of Pennsylvania. As a young man, Baird often corresponded with Audubon and assisted Audubon in collecting mammal specimens for Audubon's treatise on quadrupeds.

Edward Drinker Cope (1840-1897) conducted expeditions through Virginia, inventorying and studying the region's terrestrial, aquatic, and geological resources. The father of the modern nature essay, John Burroughs (1837-1921), often accompanied the influential and wealthy on trips through the Appalachians. During one excursion in 1918, Burroughs traveled with Thomas Edison, Harvey Firestone, and Henry Ford to camp and fish in the backcountry of West Virginia.

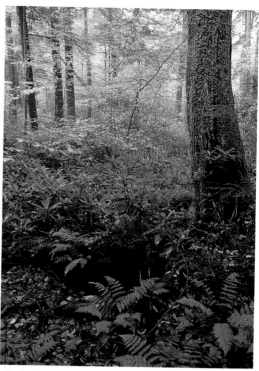

Early Autumn – Cathedral State Park

Female naturalists also played a major role in contributing to the understanding of Appalachian ecology. In 1859, Pennsylvania entomologist Margaretta Hare Morris (1797-1867) explored the Delaware Water Gap region. In 1850, Morris became one of the first two women to be admitted to the American Association for the Advancement of Science. Entomologist Annie Trumbull Slosson (1838-1926) spent several summers investigating nature in North Carolina. Naturalist and writer Emma Bell Miles (1879-1919) wrote about the nature of the Appalachian Mountains in Tennessee, while Mabel Rosalie Edge (1877-1962) led efforts to create the Hawk Mountain Sanctuary in Pennsylvania. Ecologist E. Lucy Braun (1889-1971) traveled more than 65,000 miles in twenty-five years documenting the forest ecosystems of the eastern United States. Her 1950 publication, *Deciduous Forests of Eastern United States*, remains a classic.

During the twentieth century, exploration of the Appalachians continued to ignite the curiosity of naturalists. Considered the dean of Appalachian natural history, naturalist Maurice Brooks (1900-1993) authored the classic, *The Appalachians*. Other naturalists investigating the Appalachian landscape at this time included Roger Tory Peterson (1908-1996), Eugene Odum, Graham Netting, Arthur Stupka (1906-1999), George Miksch Sutton (1898-1982), Walter Edmond Clyde Todd (1874-1969), and Edward Raney (1909-1984). Today, naturalists and writers such as Chris Bolgiano, Marcia Bonta, George Constantz, Rodney Bartgis, and Scott Weidensaul continue to bring awareness to others about the natural wonders of the Appalachians.

For those wondering if the treasures these mountains harbor have all been found, I invite you to check it out for yourself. The tapestry of life that is the Appalachians remains full of surprises, wonder, and mystery. The pot of gold has yet to be found, but the treasures you'll find along the way are worth the trip. These mountains don't demand our attention, they merely invite us. So many wonderful things are yet to be discovered here. If the vistas don't capture your heart, the lively cast of wild characters surely will.

Following page: Yellow Birch Forest along Shavers Fork

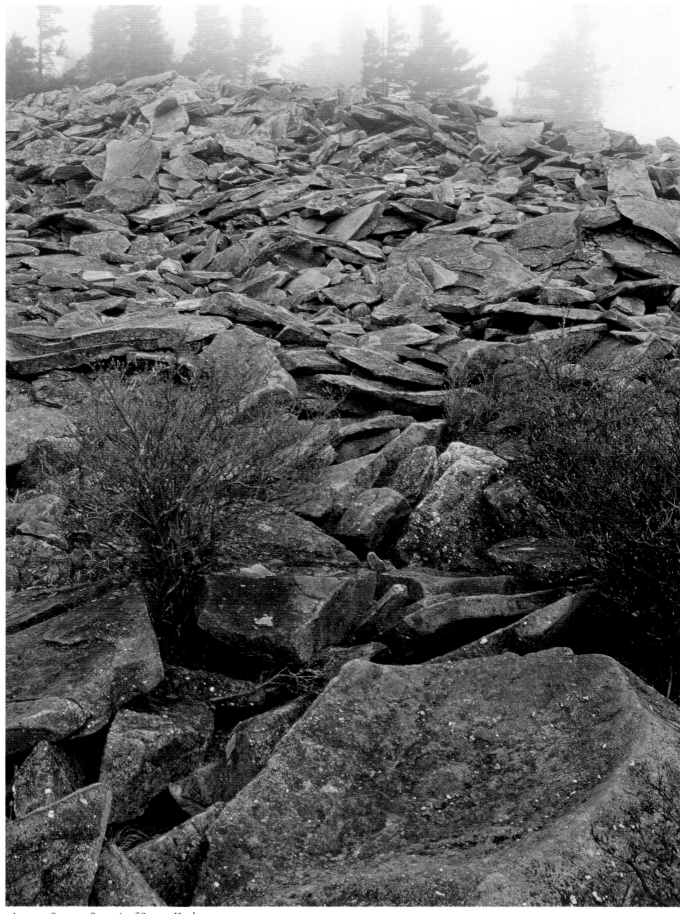

Autumn Storm – Summit of Spruce Knob

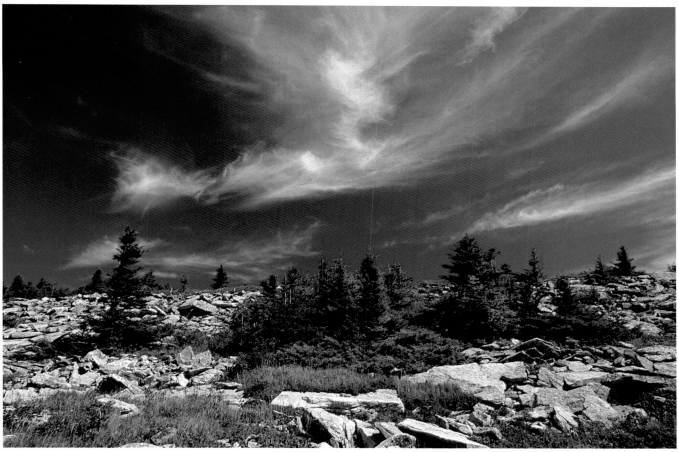

Summer – Summit of Spruce Knob

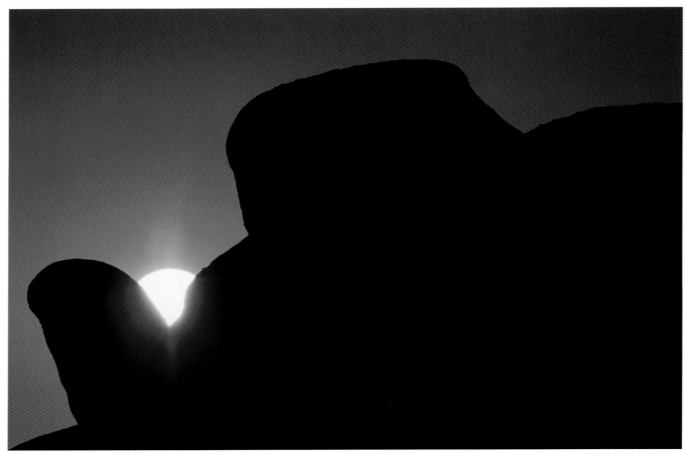

Sun rising from behind a massive boulder on Dolly Sods

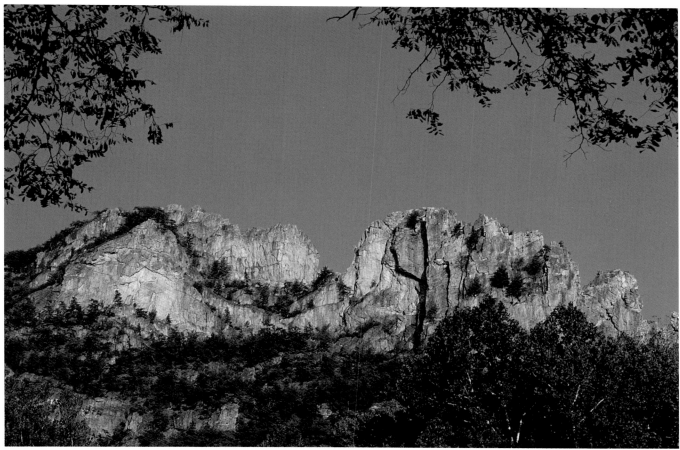

Seneca Rocks

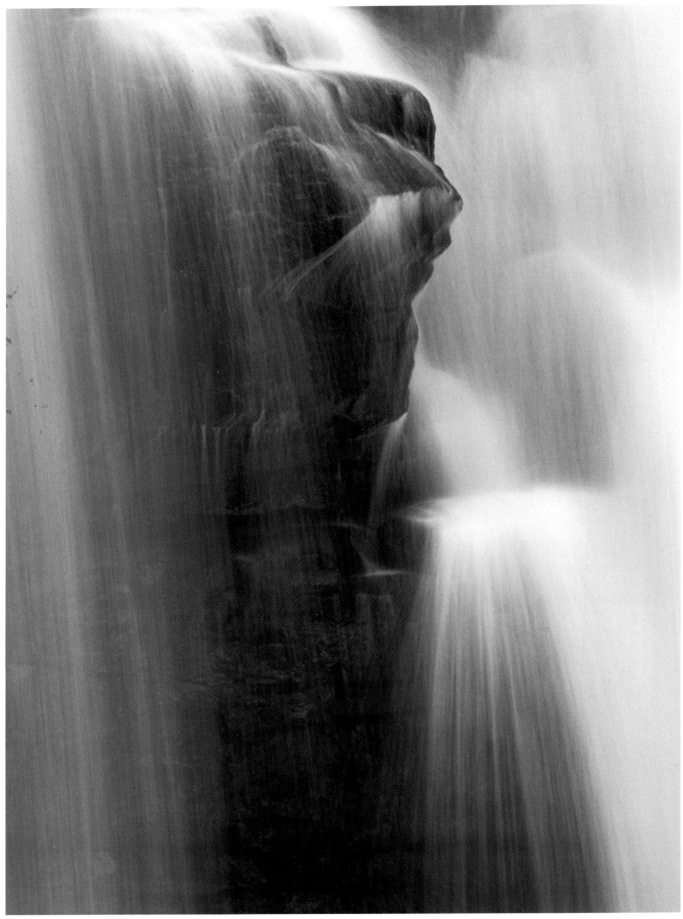

Summer Scene – Blackwater Falls State Park

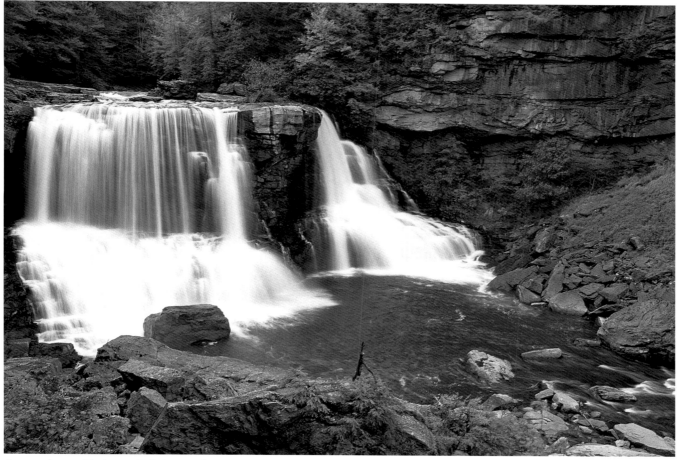

Summer Scene – Blackwater Falls State Park

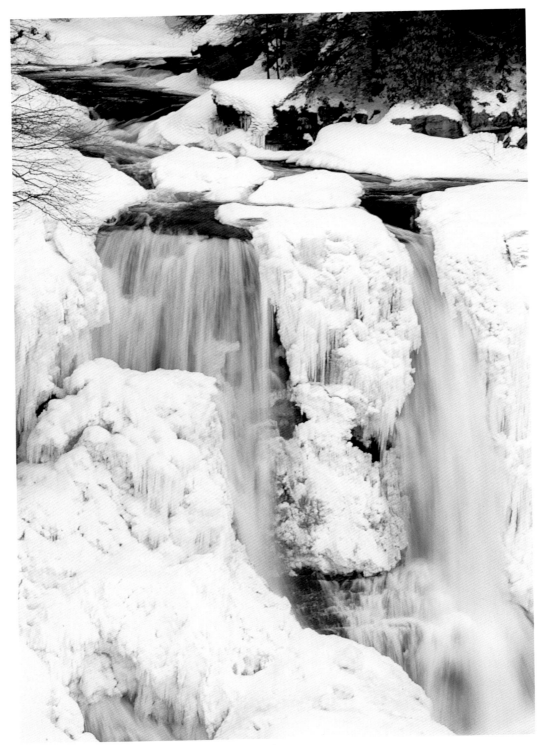

Blackwater Falls in Winter – Blackwater Falls State Park

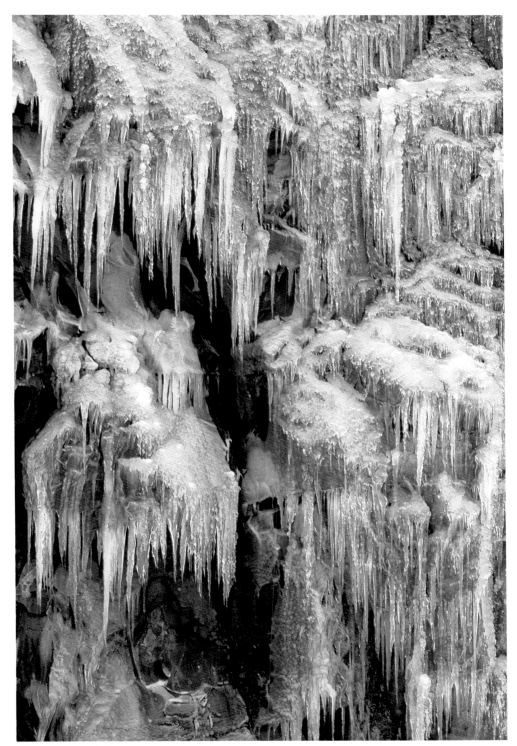

Icicles – Randolph County

Following page: Appalachian Morning Fog – Highland Scenic Highway

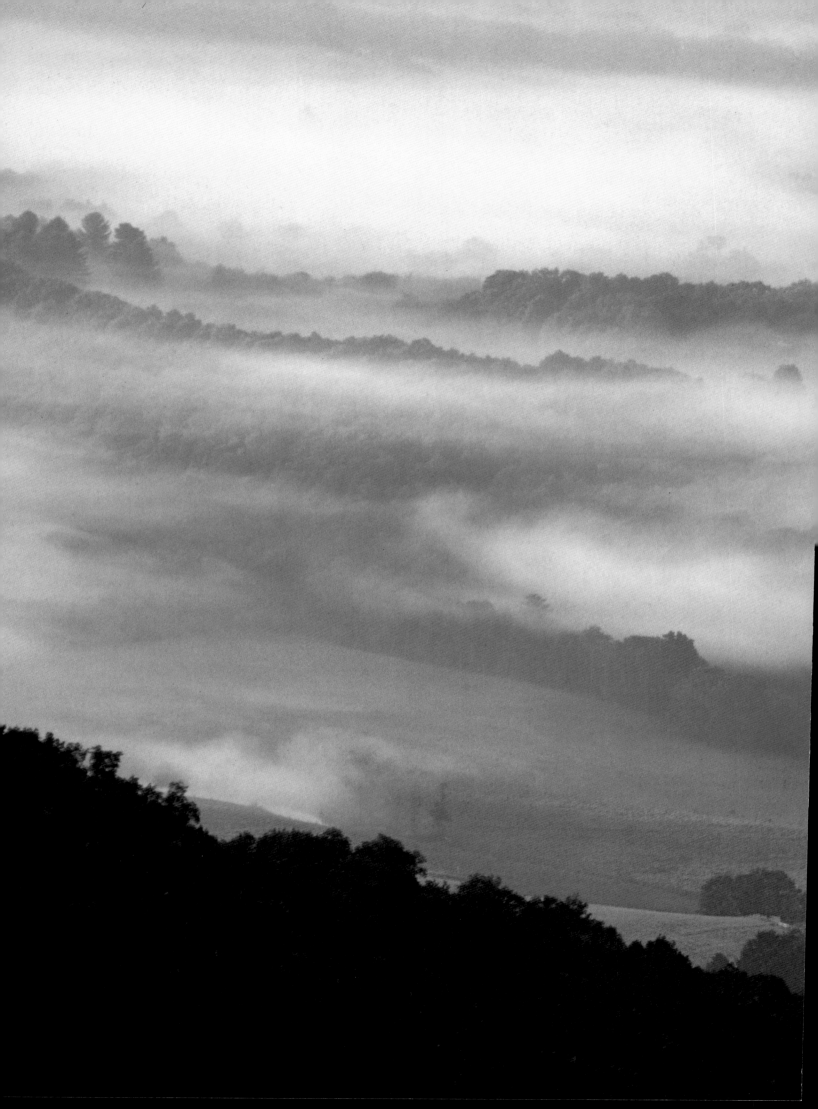

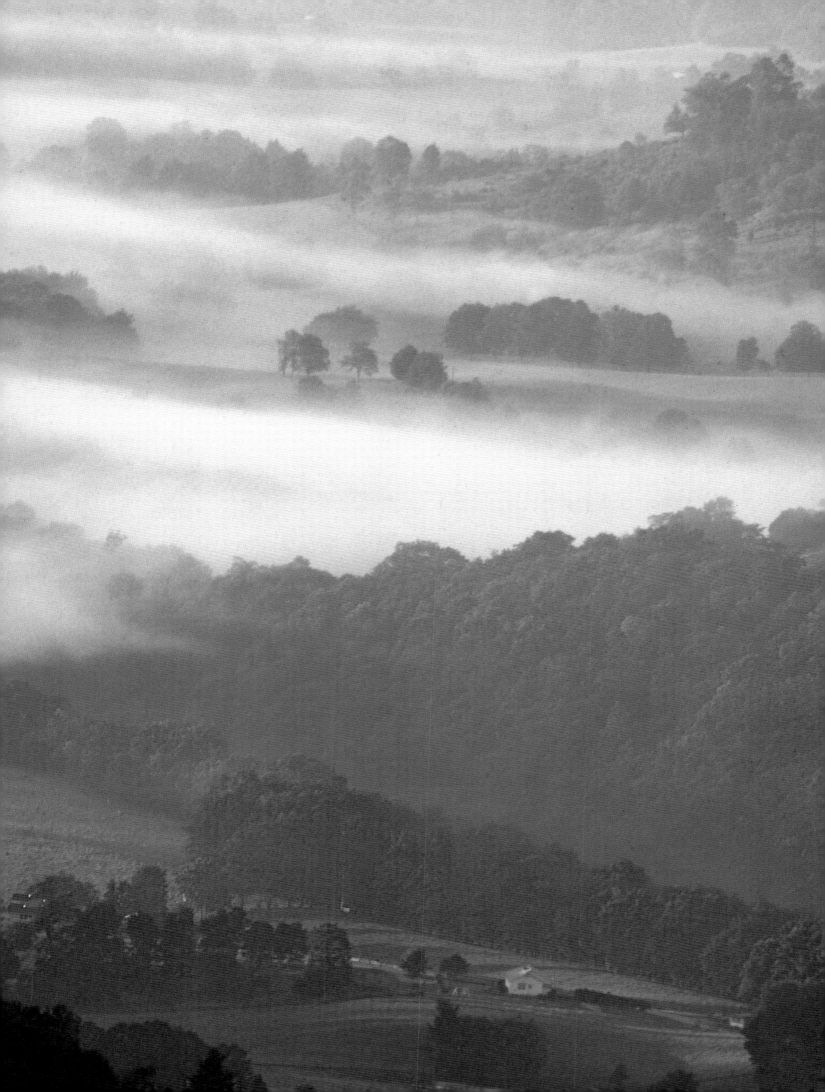

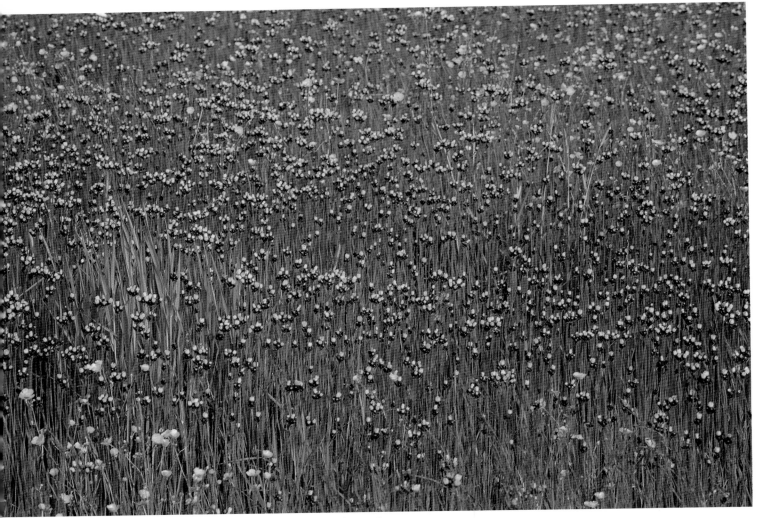

Meadow of Hawkweed – Highland Scenic Highway, Pocahontas County

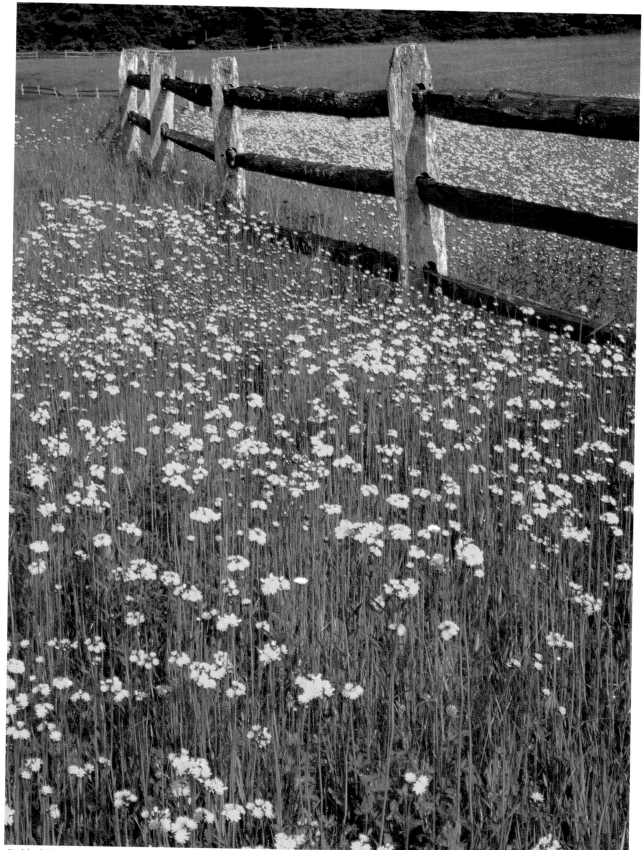

Field of Hawkweed along fence line – Highland Scenic Highway, Pocahontas County

Following page: Autumn Morning near Dolly Sods

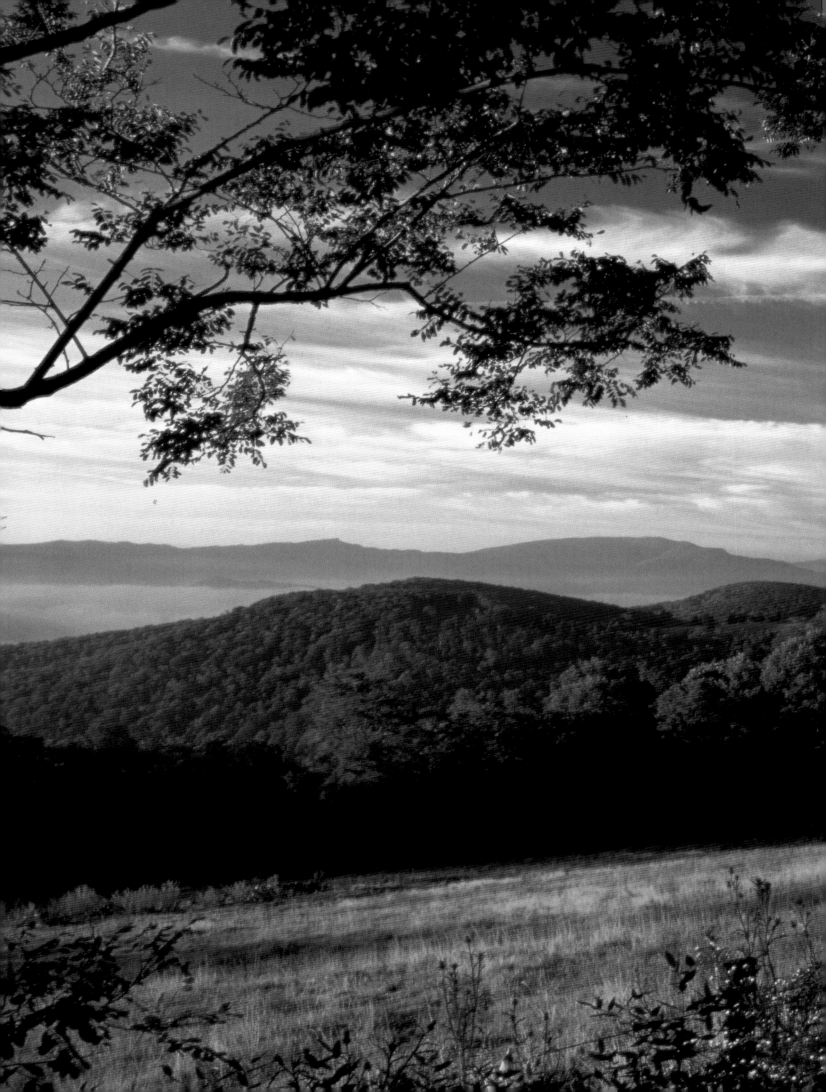

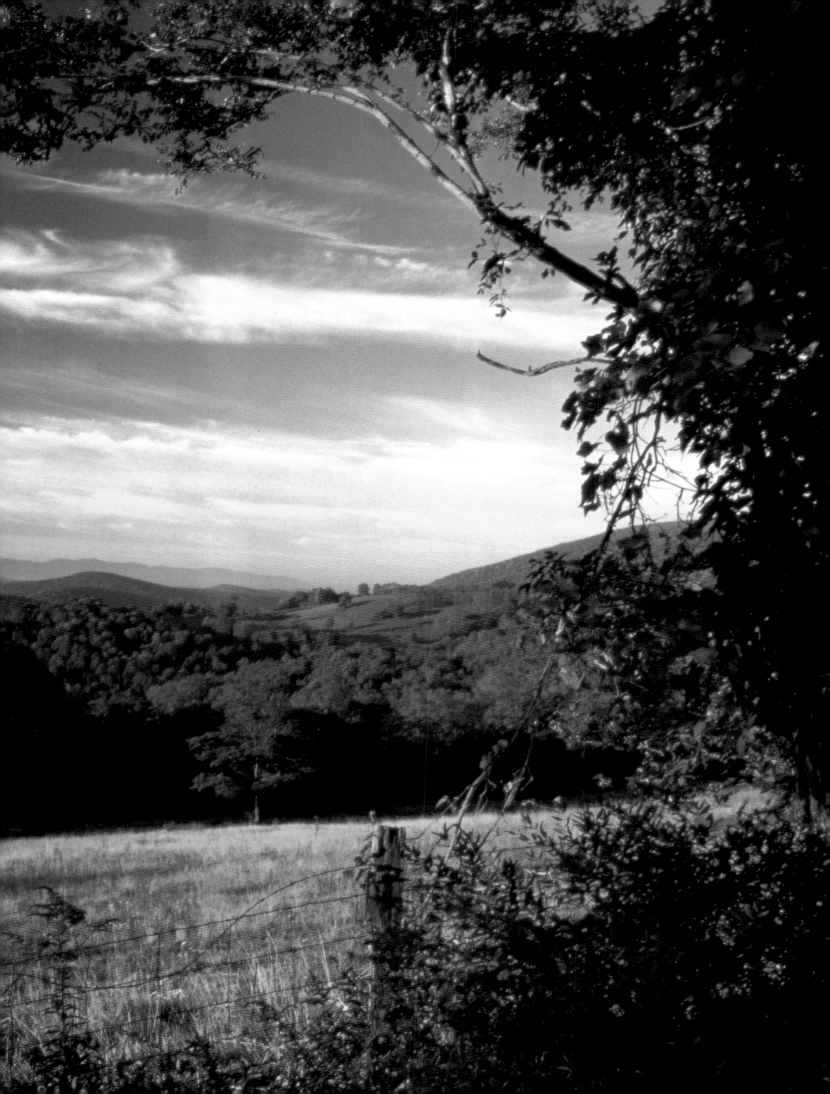

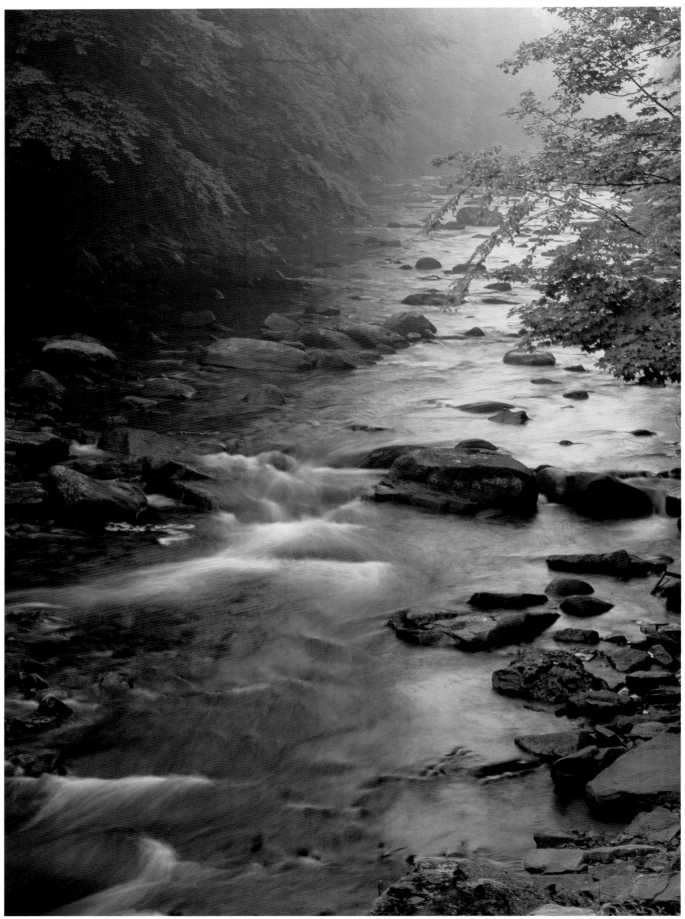

Early spring morning – Williams River, Monongahela National Forest

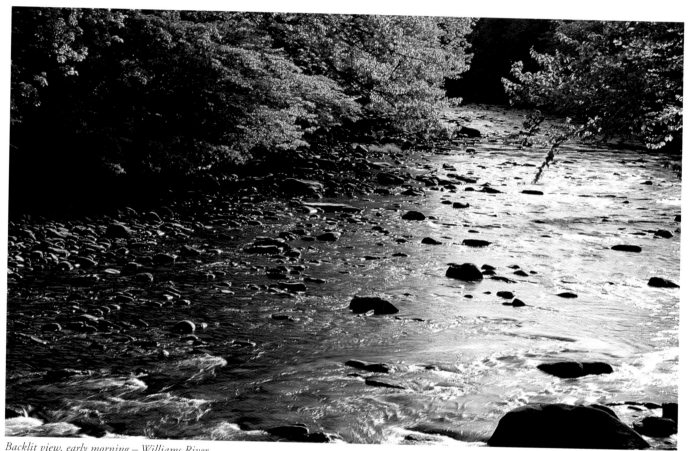

Backlit view, early morning – Williams River

Following page: Blackwater River in Autumn – Canaan Valley State Park

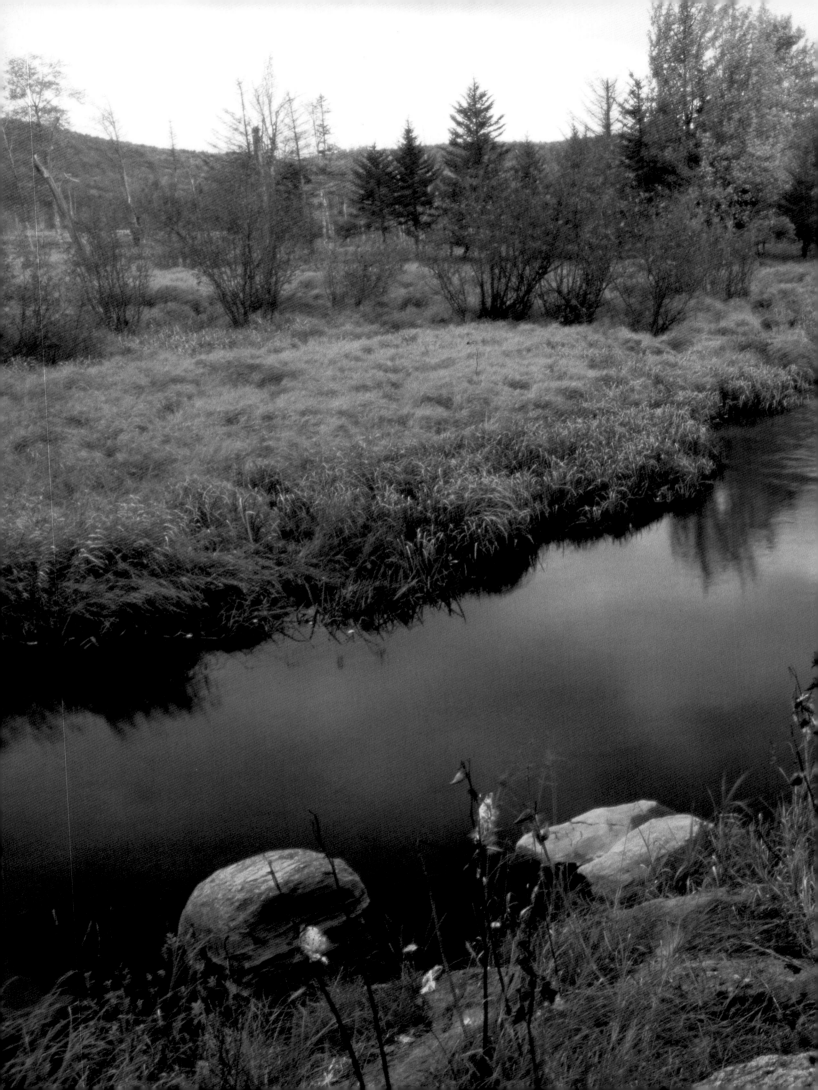

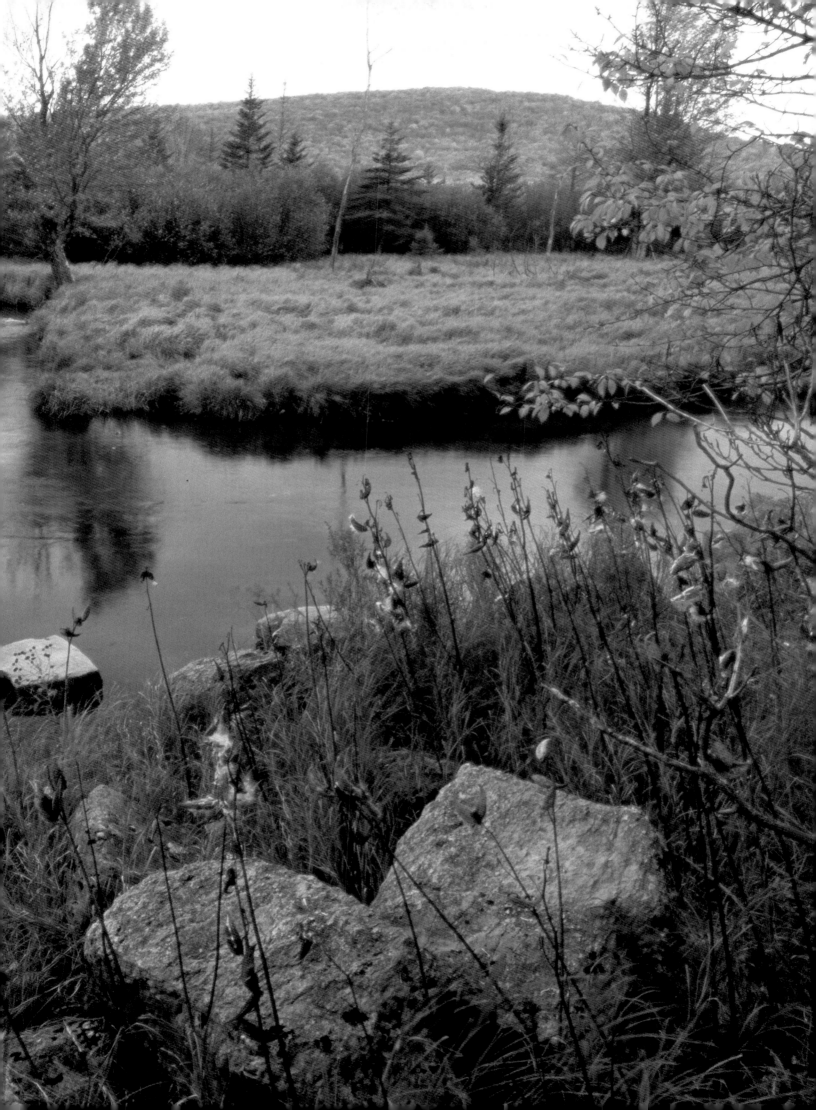

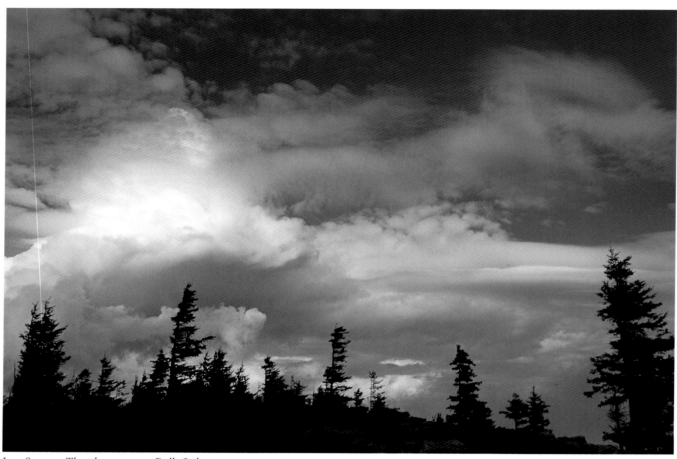

Late Summer Thunderstorm over Dolly Sods

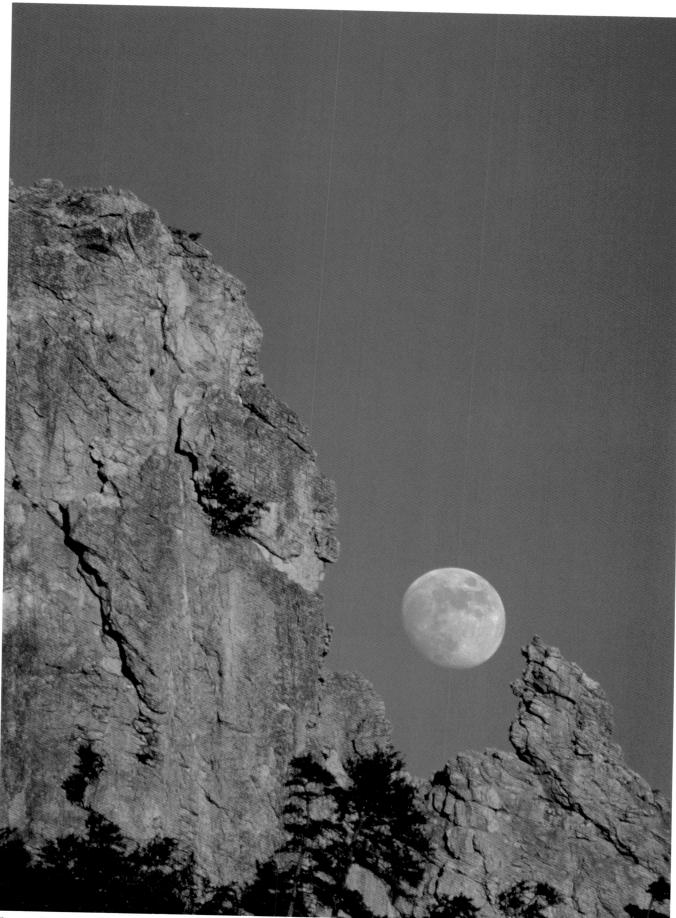

Summer Moonrise over Seneca Rocks

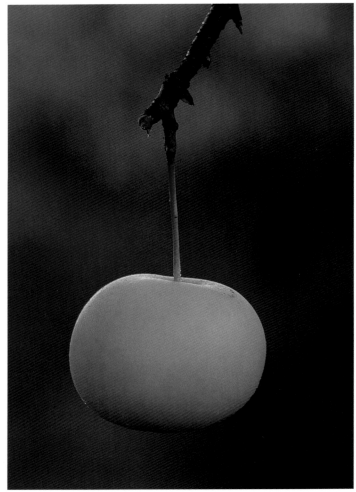

Apple on Frosty Autumn Morning – Blackwater Falls State Park

"One way to open your eyes to unnoticed beauty is to
ask yourself, What if I had never seen this before?
What if I knew I would never see it again?"

—Rachel Carson

Mason Jars and Memories

Afew years ago, I spent a week photographing the emerging spring season in the Allegheny Highlands of West Virginia, a landscape of gentle rolling mountains, emerald green forests, and surging, wild rivers. The trip became the highlight of a journey back to the Appalachian Mountains where my passion for the natural world began.

West Virginia was home for my first twenty-three years. My wildlife career would take me to assignments west of the Mississippi River, but after a fifteen-year absence from the state, I returned in 1993. Even with the lure of the western wilderness, my heartstrings kept pulling me back to the Appalachians. Although my wife Jamie and I settled just outside Washington, D.C., my career took me to the National Conservation Training Center located near Shepherdstown, West Virginia. I had returned home.

In May 1999, my friend and fellow photographer Pat Price and I roamed the narrow roads of eastern West Virginia, photographing the essence of an Appalachian spring. Watching the season's emergence added to our excitement: songbirds returning from their wintering haunts, filling the forest with song; mountain streams overflowing with winter's bounty of snowmelt, and nature's paintbrush decorating the meadows and roadsides with a cornucopia of colorful wildflowers. The sunrises and sunsets also offered inspiration, serving as catalysts to rise early and stay late.

Before sunrise on the final day of our trip, we departed our motel in Marlinton and headed toward Babcock State Park, a quaint mountain reserve nestled along the rim of the ancient New River Gorge. Our plan for the day was to arrive at Babcock before daybreak and use the morning light to photograph Glade Creek Gristmill, one of the country's most photographed historical structures. As photographers, we knew to expect the unexpected. We got exactly that.

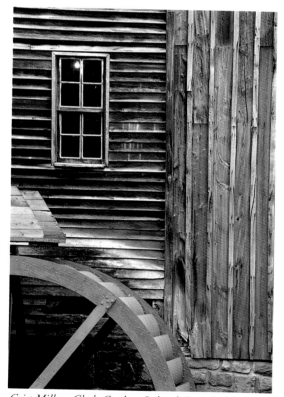

Grist Mill on Glade Creek – Babcock State Park

As darkness yielded to dawn, an incredible scene unfolded outside our windows. In the early morning light a perfect Appalachian spring morning was beginning. The gristmill, still two hours away, would have to wait. Something special was happening, something too good to pass up.

After parking the truck, we found a spot along an old fence to position our tripods. With the sun below the horizon, the sky became adorned with an assortment of red hues, accentuated by a parade of downy, white clouds. In the foreground, alternate rows of plowed and unplowed fields added to the composition, while in the distance,

a hedgerow created a leading line to an old barn. A lone rooster crowed. With the morning air fresh and vibrant with the songs of robins and song sparrows, we became immersed in photographing this enchanting scene. Even as the sun rose high above the horizon, we remained reluctant to leave.

Many special moments and places filled our hearts during our Appalachian sojourn, some familiar and many not so familiar. Each became a celebration, and photographing that spring sunrise in rural Greenbrier County would be one forever secured in our memories. For Pat, this was something new, but to me, this is what I expect of these mountains: Appalachian magic had woven its spell on yet another soul.

Spring Sunrise – Greenbrier County

The Appalachian Mountains' primeval rhythms beat with a cadence inviting all to listen. Blessed with an infinite arrangement and variety of life, the Appalachians' many faces offer a sense of place – a cathedral for the kindred spirit – no matter the season. For those living within these ancient mountains, there is a secret to storing all those memories. It requires a little magic, some imagination, and a glass container called the Mason jar.

The Mason jar is as much a symbol of the Appalachians as the dulcimer, apple butter, and a fog-draped August morning. There's nothing fancy about it, but in these mountains, the Mason jar never outlives its usefulness. I would guess every house in my hometown of War, West Virginia has a collection of Mason jars on a shelf inside a kitchen cupboard or in the cool alcove of a cinder-blocked shed. A home is not a home without the Mason jar.

Mason jars are still used for canning beans, beets, sauerkraut, and for preserving jams, jellies, and fruit. They served as drinking glasses and probably still do, and before refrigeration, Mason jars were used for storing cooked meat. They are well suited as storage containers for "white lightning" or as most folks know it, moonshine. The "shine" can't eat glass.

For a young naturalist, the Mason jar ranked beside binoculars and field guides as an essential tool for uncovering nature's mysteries. What better device to capture fireflies in the backyard during a warm June night, or collect butterflies in a meadow on a balmy summer day, or scoop a water sample from a farm pond? What better herbarium to keep salamanders and other creepy crawlies? Mason jars were part of my everyday field collecting gear.

What I would not know until much later in life, however, is that Mason jars are magical. I remember my mother saying Mason jars could capture moments and store them as memories. All one had to do was open the jar, let the moment seep inside, and seal the lid. The moment would become a memory, which could be taken out anytime.

Difficult as it was for a youngster to fully understand this magical quality, as the years went by I began to understand what she meant: to hold on to those special moments that would enrich my life. She knew that as we grow older, memories become precious and we tend to rely on them more and more.

I find myself dipping into my Mason jars quite often. When I need a break, I hold one and think back on the good times I've had. A passion for nature photography and writing would add a new dimension to my love of the outdoors later in life, but those early experiences of just exploring these mountains with a field guide and binoculars created many memories that remain with me to this day.

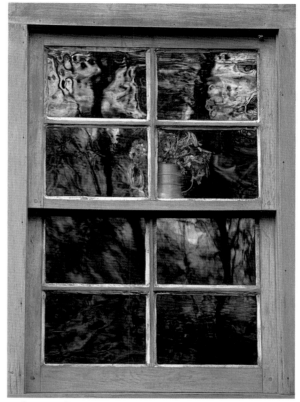

Reflections of Seneca Rocks from Homestead – Seneca Rocks Visitor Center

I keep an open Mason jar in my office to remind me to take time and reflect back on the wonderful memories I have collected over the years. My Mason jar memories come not just from exploring the West Virginia landscape, but also from wandering the mountains of Pennsylvania, Virginia, Tennessee, and North Carolina. I discovered wherever one travels in the Appalachians, there are Mason jars memories to be gathered. No matter the time of year or day, a treasured moment always seems to be around the next corner. As naturalist Edwin Way Teale wrote, "The most durable harvest of our lives, in all probability, is our harvest of memories."

❖❖❖

Each season in the Appalachians offers a fresh discovery, a new perspective. Every new sight, sound, and fragrance excites the senses and re-ignites a memory. The challenge becomes soaking in as many memories as you can, but not rushing to find all the memories at once. For me, these are only a handful of Mason jar memories that keep me smiling:

Appalachian Spring Memories: *Listening to American toads and spring peepers in the pond below my home as they fill the spring night with their energetic trills and peeps ... Admiring the tenacity of a male song sparrow singing from a box elder in my father's garden as it attempts to attract a mate amongst Dad's cucumbers, tomatoes, and squash ... Savoring the sweet, fresh fragrance of a late afternoon April rain while hiking around Berwind Lake.*

Appalachian Summer Memories: *Watching blankets of fog drift down steep mountain slopes on a warmer than usual summer morning ... Observing flocks of rough-winged swallows and chimney swifts swoop and dive above our home just before dusk ... Welcoming the mesmerizing cadence of katydids and crickets on a sultry August night ... Enjoying the late summer colors of Joe Pye weed, spotted jewelweed, and ironweed carpeting the riverbanks and abandoned meadows.*

Appalachian Autumn Memories: *Tasting the sweet October air while hiking the mountain ridges above home ... Eavesdropping on the raucous protests of blue jays as they dash across the valley on a crisp blue-skied autumn day ...*

Inspecting the last cluster of brown leaves clinging to the far reaches of a red oak tree in late November ...Feeling the dance of raindrops on my face during a late autumn drizzle.

Appalachian Winter Memories: *Celebrating no school after a major snowstorm covers the narrow, winding mountain roads ... Admiring the beauty and early morning silence of a mountain landscape sculpted with fresh fallen snow... Laughing at the antics of titmice, chickadees, and cardinals as they compete for sunflower seeds at Mom's bird feeder... Shivering from bone-chilling temperatures on a frigid winter night while searching the heavens for Orion and other winter constellations.*

Throughout my travels in the Appalachians, I have added memory after sweet memory to my Mason jar, and they are not restricted just to my beloved West Virginia:

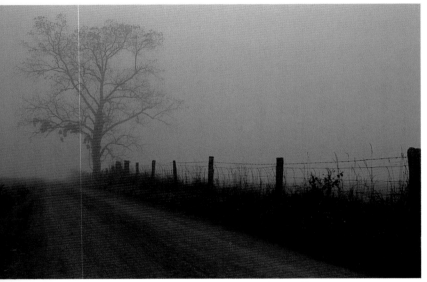

Morning fog and tree along country road – Pendleton County

Watching the eerie Brown Mountain lights and hiking the remote, rugged Linville Gorge in northwestern North Carolina ... Celebrating my high school graduation by spending a week with my brother, Charles, and his friend, Bill, backpacking along the Appalachian Trail in the Great Smoky Mountains National Park ... My niece Joni never failing to remind me of our hike into a spruce-fir forest on Grandfather's Mountain in North Carolina and how she got us "unlost" and back to the car before dark (she was about eight at the time and I was, well...never mind) ... Catching my first glimpse of a pileated woodpecker as it darted through the forest, its piercing yodel resonating through the Jefferson National Forest in southwestern Virginia ... An autumn day of "raptor-watching" on Hawk Mountain in Pennsylvania and marveling at the thousands of broad-winged hawks flying overhead ... Those dreary, rain-drenched family reunions on Mount Rogers and Whitetop Mountain in southwestern Virginia ... My first solo-backpacking trip into the Jefferson National Forest ... And a special memory – my family's summer vacation in 1966 along the Blue Ridge Parkway, Skyline Drive, and the Great Smoky Mountains National Park; the last vacation we would have with our father, who died in 1967. We sensed Dad wanted to show us what made these mountains special to him. For me, he succeeded.

Now, with our young son, Carson, we have started adding to his Mason jar by taking him on hikes in the mountains near my hometown. At ten months old, he even experienced the steep climb (albeit in the safety and comfort of a baby backpack) to Maryland Heights, which offers a striking vista of the historic community of Harpers Ferry in the eastern panhandle of West Virginia. From all indications, he had a blast, as did his parents. We look forward to many more Mason jar memories with him. I expect we will need more than one jar.

Spring Reflection at St. George's Church – Smoke Hole Canyon, Monongahela National Forest

Barn – Pocahontas County

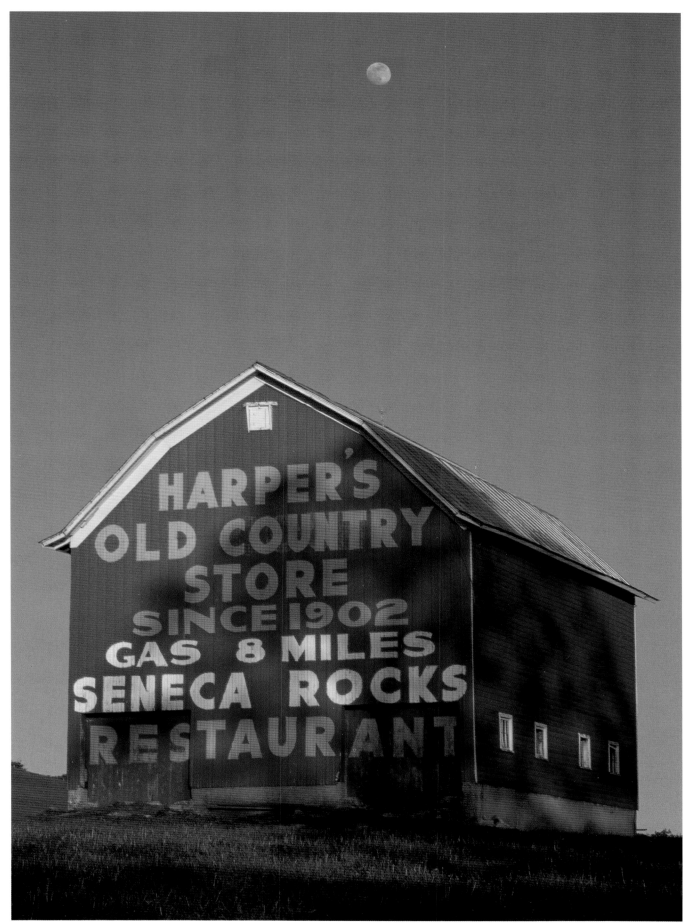

Spring Moon over Barn – Pendleton County

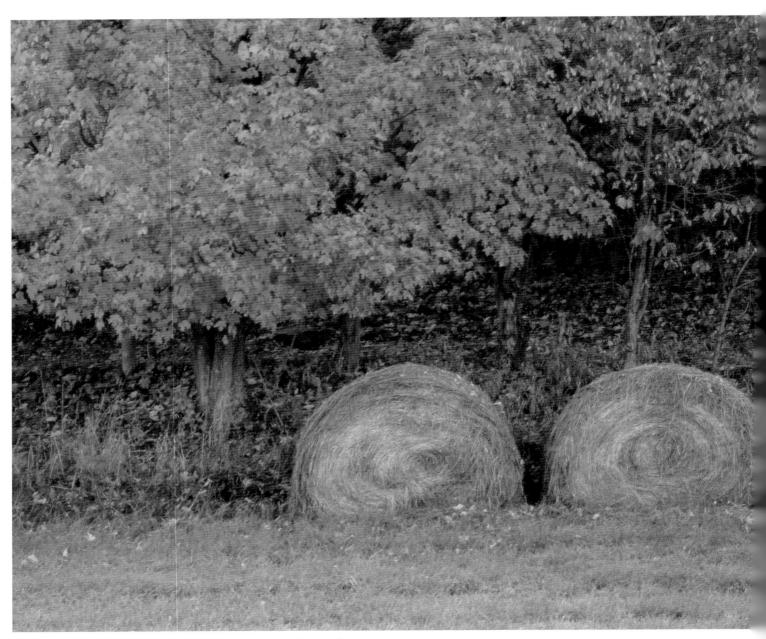

Hay bales beside sugar maple tree on early Autumn morning – Monroe County

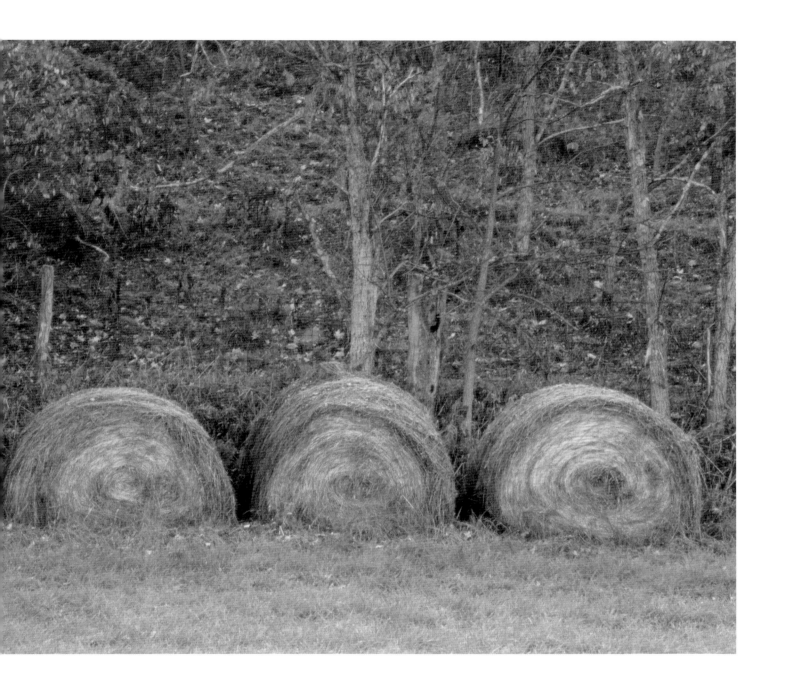

58

Spring Sunrise – Greenbrier County

Autumn Sunset near Seneca Rocks

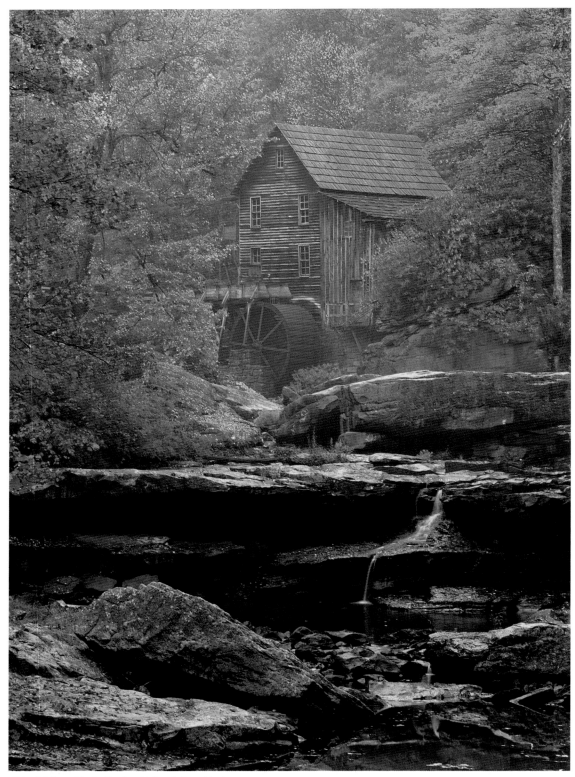

Grist Mill on Glade Creek – Babcock State Park

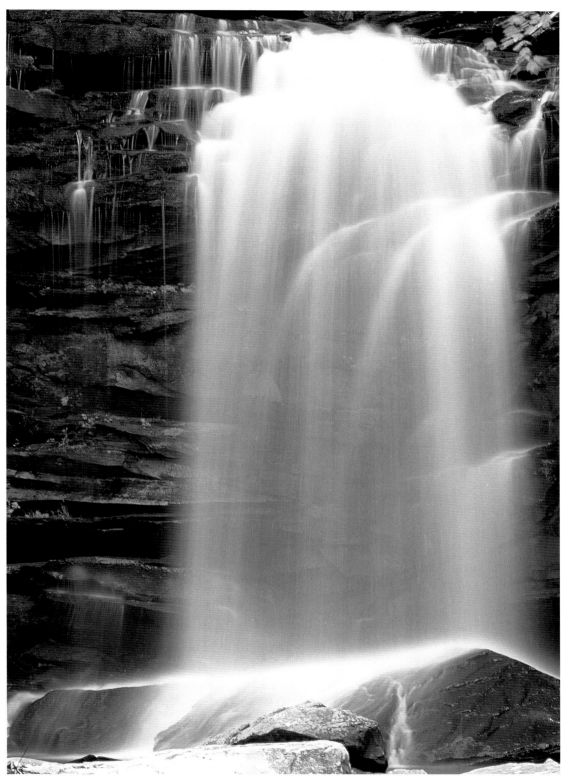

Middle Falls of the Falls of Hills Creek – Monongahela National Forest

62

Maple Seeds in Spring – Highland Scenic Highway, Pocahontas County

Maple Leaves in Spring – Highland Scenic Highway, Pocahontas County

Following page: Ground Pine and Moss in forest along road to Spruce Knob

Spring Skies – Jefferson County

"Amongst these trees night by night, through the whole land, did shew themselves an infinite swarme of fierie wormes flying in the ayre, whose bodies...make such a shew and light, as if every twigge or tree had been a burning candle."

—Sir Francis Drake 1577

Fireflies, Night Voices, and Dancing Waters

June in the Appalachians is not allowed without fireflies luminating the night, especially for those of us who are young at heart. Although Sir Francis Drake's observations occurred during his journey to Indonesia, his eloquent description of the firefly's ability to light up the sky and provide a "shew" describes the romance of fireflies everywhere. Nothing embodies the Appalachians more than the evening dance of fireflies in summer.

Every youngster in my hometown celebrated the arrival of fireflies to the early summer nights. We marveled at how these tiny creatures could light up their "butts." On warm June nights, my siblings and I, with Mason jars in hand, chased these hovering flashlights, hoping to capture enough to light up our darkened bedrooms. Of course, that never happened, but it was worth the effort. Now I watch my young son's wonderment for "lightning bugs," the very same thing that captured my imagination as a kid.

Contrary to Drake's description, fireflies are not worms or flies, but soft-bellied beetles with blinking taillights. In North America, more than 200 species roam the summer night, and within the mid-Atlantic region, more than thirty species occur. For me, however, a firefly is a firefly.

Firefly experts – entomologists – say the wondrous light source originating from the beetle's behind is due to the insect's ability to turn off and on a chemical reaction in their abdomens. They produce "cold light," which means they lose no energy. For nature lovers, it's just magic—pure mountain magic. I often wondered how such a creature could create a light source from its behind, but I did not allow scientific curiosity take the joy out of just watching them. As Thoreau wrote, "You must not know too much or be too precise or scientific about birds and trees and flowers and watercraft; a certain free-margin, and even vagueness—ignorance, credulity helps your enjoyment of these things." The same goes for lightning bugs. So, magic it will be.

Since nature lovers are inherently romantic at heart, it's comforting to know fireflies are a passionate bunch of bugs. Sadly for us and tragically for them, their sexual pursuits last for only about 10 days. Considering the firefly spends most of its existence as a glowworm beneath the surface, an energetic ending to a short life is indeed expected and, I'm sure, welcomed. Ten days can be a lifetime of bliss.

Fireflies begin life hatching from eggs during the summer and early fall. Feeding on a variety of invertebrates such as snails and earthworms, the pupae languish below the ground through winter and spring. By the following summer, they emerge as the winged adult we all enjoy watching. Then the delightful light show begins.

Each firefly species possesses its own distinguishing sequence of flashes and pauses, a coded signal from the males signaling to the females to venture out and mate. Each species also has its own flight patterns and a certain time of the evening it illuminates. They even vary in how far above ground they fly and the color of the light

emitted, some flashing yellow, others green or amber. In the pursuit of love, every advantage counts. Females also flash in response to the male's lighted signal. Once the pair meets, all flashing ceases and the lovemaking begins. Lights out please.

For fireflies, love is literally in the air. So, here's to the amorous techniques of the firefly – may their glowing butts keep lighting up the meadows, fields, and yards of the Appalachians. Of course, fireflies glowing at night are only one wonderful aspect of a summer day or night. The summer season of the Appalachians offers many more Mason jar memories.

❖❖❖

A jet-black sky adorned with a billion sparkling stars brings a special luster to this summer evening. Each star adds its own exceptional illumination to the night. In the meadow, amidst a timeless tempo of crickets and katydids, a constellation of fireflies just above ground level lights the summer night. Like the stars, these living celestial lights present their own unique glow to the summer darkness. Beyond the meadow and in the interior reaches of a woodlot, an owl calls. Its distant "who, who, cooks for you all" call divulges it as a barred owl. Along the horizon, a lone sycamore tree stands silhouetted on a hill. Twinkling stars, flickering fireflies, hooting owls, and ghostly silhouettes make this a nice evening to be in these mountains. A typical summer's evening in the highlands of West Virginia.

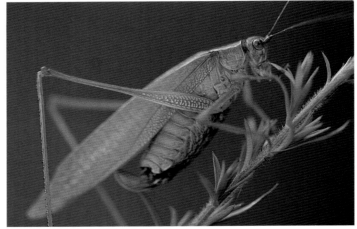

Katydid – Seneca Rocks

The mountains of home not only provide the fireflies in the summer night, but also an assortment of other nocturnal creatures, complete with their own personalities and sounds. The most obvious and recognized are the owls. While camping at Berwind Lake, we would listen to the barred owl's soft hooting from within a cove hardwood stand. Directly across the lake, the throaty hoots of a great horned owl sounded in the oak-hickory forest. Near our campsite, without warning, the quavering whistles of the screech owl would shake our nerves. At the time, we weren't aware of the small size of this scary creature. The sound it emitted kept us from even questioning its stature. For us kids, all these night sounds conjured up a million frightening thoughts in our adolescent minds. And owls were not the only critters stirring up the summer nights.

Another common night bird, the whippoorwill, with its mellow and consistent "whip-poor-will" call, could be heard throughout the night. And as I would soon discover, an occasional songbird would burst into song in the wee hours of the night. Even songbirds talk—or in this case, sing—in their sleep.

Birds were not the only voices of the night. Along the shallow portions of the lake, a variety of frogs and toads made their own night music. Among rushes and cattails, spring peepers found refuge and a nice stalk to perch on while peeping. A chorus of peepers calling during an early spring night provided a true auditory Appalachian sense of place. Warm nights with a light drizzle, what we call a "froggy night," would motivate the peepers to peep even more, almost to a frenzy pitch. Standing near a pond brimming with peeping peepers will leave your ears ringing.

The peeper's distant cousin, the mountain chorus frog, produces a call reminding me of someone raking a finger across a comb. These little frogs were more common in the water-filled ditches along the mountain roads. As the temperatures warmed, the constant trilling of American toads filled the night air. Fowler's toads and leopard frogs added their signature sounds to the evening, as well. Upon summer's arrival and the start of humid, warm nights, the jungle-bird voice of the gray tree frog, mixed with the sweet cadence of the katydid, dominated the nightly symphony. On occasion, even the diurnal cicadas added their electric buzz calls to the sultry August nights.

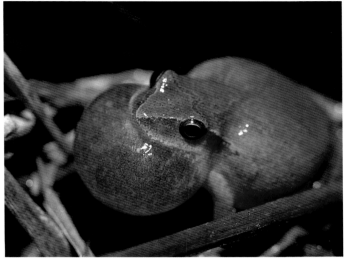

Spring Peeper

Croaks, peeps, chirps, buzzes, and whirs. Voices of the night. Voices of the mountains. This landscape never seemed to sleep during summer. For me, that was fine, and although I became fairly proficient at figuring out what critter was making a particular racket, even I, the only naturalist in town, could get stumped on occasion.

During my sophomore year in high school, I had become rather skilled at identifying every bird found in the mountains. I was passionate, or maybe downright obsessive, with birds, trees, flowers, and all things nature. Birds, however, served as the catalyst for my life-long interest in nature and my eventual career as a wildlife biologist.

By age ten, I knew all about the birds and other creatures roaming the forests of southern West Virginia. Or so I thought. I was rather confident, maybe a bit too much, in my ability to identify birds by sight and sound. I could tell just by looking at the habitat what birds to expect. My buddies didn't appear too impressed, but for me, as the only kid in the neighborhood or the county who knew such things, I was rather proud of this self-acquired skill.

My skill at identifying birdcalls resulted from using my Dad's reel-to-reel tape recorder to document birdcalls every Saturday morning in the spring and summer. For entertainment, I would constantly play these recordings and before long, I had mastered the fine art of bird song identification.

As the town's authority in all matters ornithological, I figured nothing could stump me. But one particular night in June 1967 proved otherwise. I quickly discovered that a 13-year-old ornithologist still has much to learn; make that, a lot to learn.

This particular June evening was like all the others. Nothing unusual. A cool mountain breeze filtered through my opened bedroom window. Stars glittered in the sky, while the blue light of a half-moon illuminated my darkened room. Quietness prevailed for a while.

In the midst of a teenager's much deserved and required sleep, I was suddenly awakened by an unusual cacophony of whistles, chirps, and croaks coming from an overgrown field below our house. The time must have been

around midnight and not a creature was stirring, except for the creature making all the noise in the field. Time was at hand to investigate. The town's ornithologist would uncover this mystery in no time.

I donned my jeans and a t-shirt, and left to investigate the source of this midnight madness. With flashlight and binoculars in hand, I left the house, crawled down a steep hillside, crossed two sets of railroad tracks, and trekked through a field of brambles, briars, and poison ivy to locate the culprit. No challenge was too formidable to uncover this mountain mystery.

Within an hour or so, and with patience, scratches, and diligence, I used my skill at "pishing" to lure the songster out of hiding. The mystery creature was none other than a yellow-breasted chat, singing as if the sun had just warmed the earth with its golden radiance. This plump and brilliantly-plumaged wood warbler checked me over for a few seconds and then proceeded to sing and go its merry way. I went back to bed and fell asleep, knowing I had completed another puzzle in the mystery of birds. A naturalist's job is never done, day or night, neither is the wonder of nature in the Appalachians.

Dancing waters are flowing in Big Run, a mountain tributary on Spruce Knob, the highest point in West Virginia. This June afternoon is unseasonably warm, but a bank of clouds above me offers some relief.

With the clouds building up and some thunderstorm looming on the horizon, I decide to rethink my strategy to go to the summit. I turn my attention instead to the cascading waters of Big Run. My dear friend Marcie Demmy of the Mountain Institute coined the term "dancing waters" for describing cascades of spring runoff. I love this romantic description and so dancing waters it will be.

I park my truck, grab my camera gear, and start exploring the rushing stream. Heavy rains have drenched the Spruce Knob region for the past several days, so the streams and rivers are running at capacity. Big Run is bursting with dancing waters this afternoon, so I'll have little difficulty finding a great composition to photograph. The challenge will be deciding which one to tackle first.

The last time I was here, Big Run wasn't very big and it didn't run very much, a trickle here, a trickle there. For most of the season, Big Run has been a small stream whispering down the ravine. But today, the soothing rhythm of tumbling water fills the air. With the exception of one determined indigo bunting, the cascades drown out all other sounds.

I soon discover a cascade that offers up several different compositions; nice dancing waters to get immersed in, photographically speaking. Slipping on my hip waders, I cautiously enter the stream and position my tripod. It is spring in the Appalachians

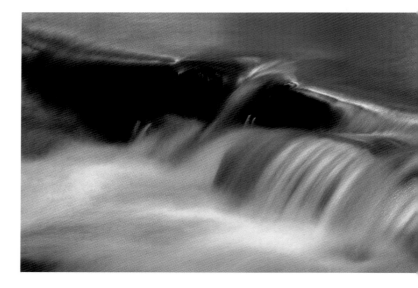

Cascade (Dancing Waters) – Summer along Big Run on the road to Spruce Knob

and I'm standing in the middle of a mountain stream photographing the essence of this wonderful landscape. Life doesn't get much grander than this.

I need a more even light on the landscape and the clouds help when they pass by the sun. But they are not cooperating too much today. It seems to be a conspiracy between them and the wind. The clouds turn ever so slightly, bypassing the solar sphere. I try not to take it personally. As a seasoned and patient photographer, I wait. Eventually, a cloud or two blocks the sun and I go to work photographing the scene.

I only have a minute at most to photograph before the clouds pass on and the sun comes out. I wait and wait and wait some more before another group of clouds move into position. Despite playing this cat and mouse game with the sun, I don't mind waiting. Photography, especially nature photography, requires patience. It also requires the right type and amount of light, and I'm willing to spend most of this afternoon waiting for those right conditions. Besides, as a naturalist, the waiting offers me a chance to watch and hear the spring season on Spruce Knob. To love nature photography, an individual must first love nature.

There's too much going on and too much to see. To hear anything will be difficult with the rushing water dominating the airwaves. But the indigo bunting perched along the stream is singing loud enough for everything to hear it. He has one strong set of vocal chords.

Tiger swallowtails fly back and forth over the stream. At first, I'm not sure why there are so many here, but upon closer inspection, I see they are congregating on a lone hawthorn tree along the bank. The tree's fragrant, white blooms are at their peak and the butterflies keep busy sipping nectar.

Water striders rest along quiet eddies of the stream, away from the rushing water. I'm sure they are not resting as much as they are waiting for something edible to float by. When the sun peeks around the clouds, the surface of the water glitters where the striders' legs touch the water. The striders appear to be wearing shoes of diamonds.

A golden yellow composite flourishes along the stream bank. I am not sure what species of flower it is, but that doesn't stop me from admiring it. Tufts of willow seeds break from the branches and float gently across the stream. A bold red squirrel negotiates a wobbly red pine branch over the stream. The squirrel successfully reaches the other side. Here's to boldness and risk-taking. And here's to patience and cooperative clouds.

A few hours have passed and the fluffy summer clouds continue marching across the sky. I conclude I have enough images of the dancing waters. I return to my truck and decide

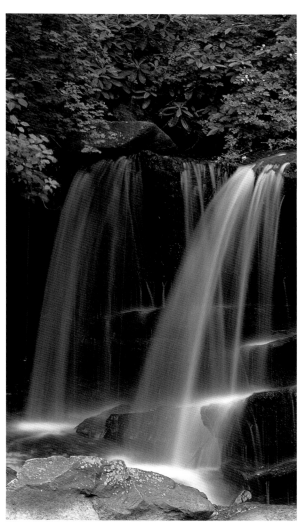

Cascade on Glade Creek – Babcock State Park

a fitting end to this wonderful afternoon would be a short nap in the sun. The sun's warmth will feel nice on my face as I slowly coast into a light slumber. The steady rhythm of the dancing waters will lull me into dreamland. I lie down along the stream bank and ready myself for the sun to warm my face with its energy. Just as I close my eyes, I feel the sun's radiance subside. My face cools. I open my eyes and look up. A large collection of clouds completely covers the sky. I close my eyes and drift off to sleep with a smile. Patience is a virtue.

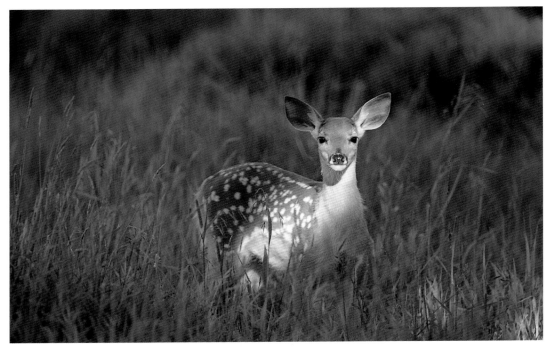

White-tailed Deer Fawn – Tucker County

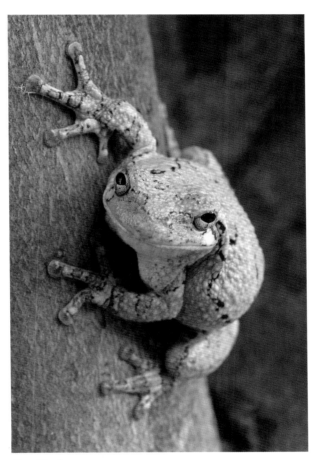

Gray Treefrog

74

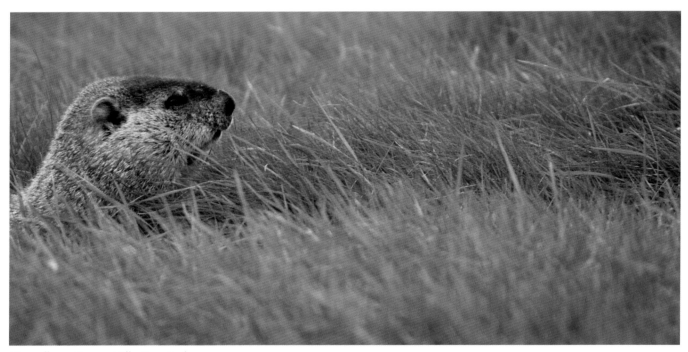

Groundhog – Canaan Valley State Park

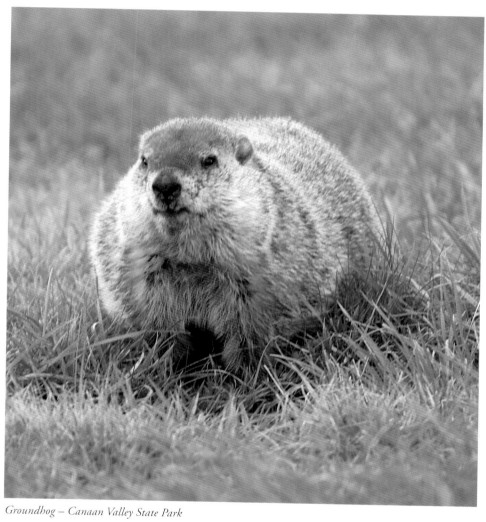

Groundhog – Canaan Valley State Park

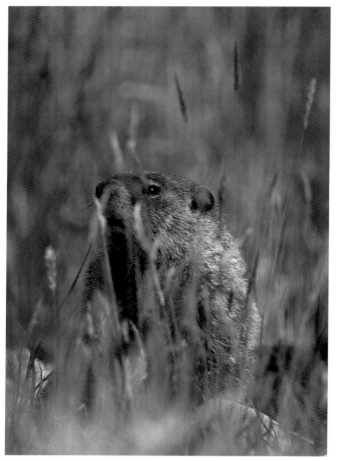

Groundhog – Canaan Valley State Park

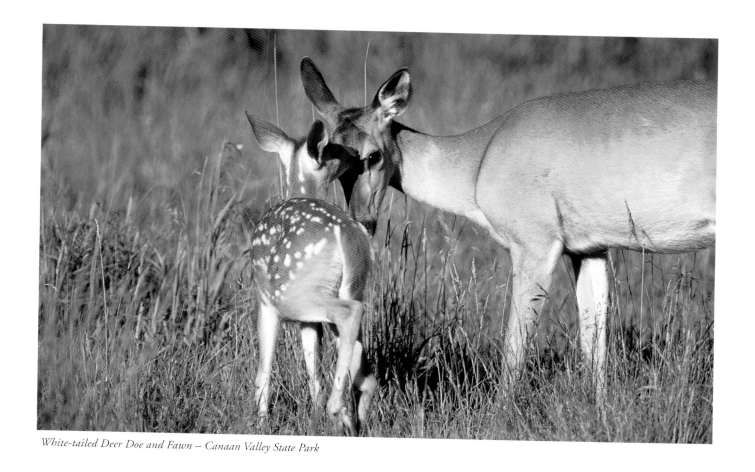

White-tailed Deer Doe and Fawn – Canaan Valley State Park

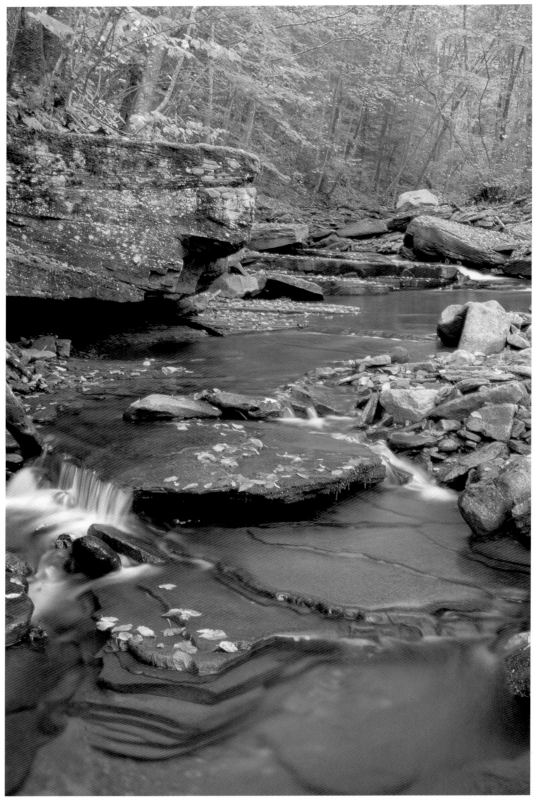

Autumn Cascade along Big Run – Monongahela National Forest

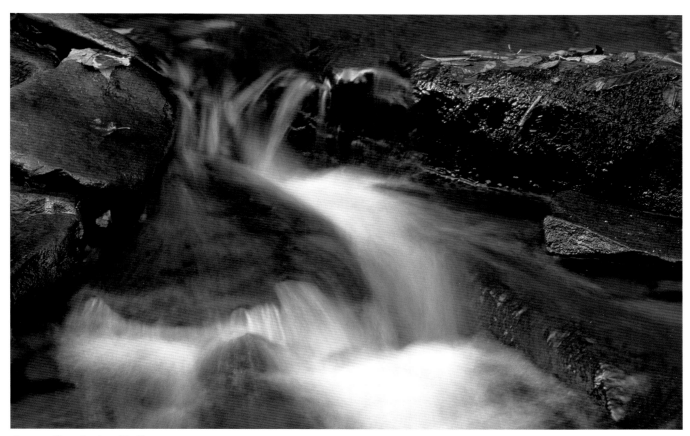

Autumn Cascade along Big Run

Following page: Spring Vista along road to Smoke Hole Canyon – Monongahela National Forest

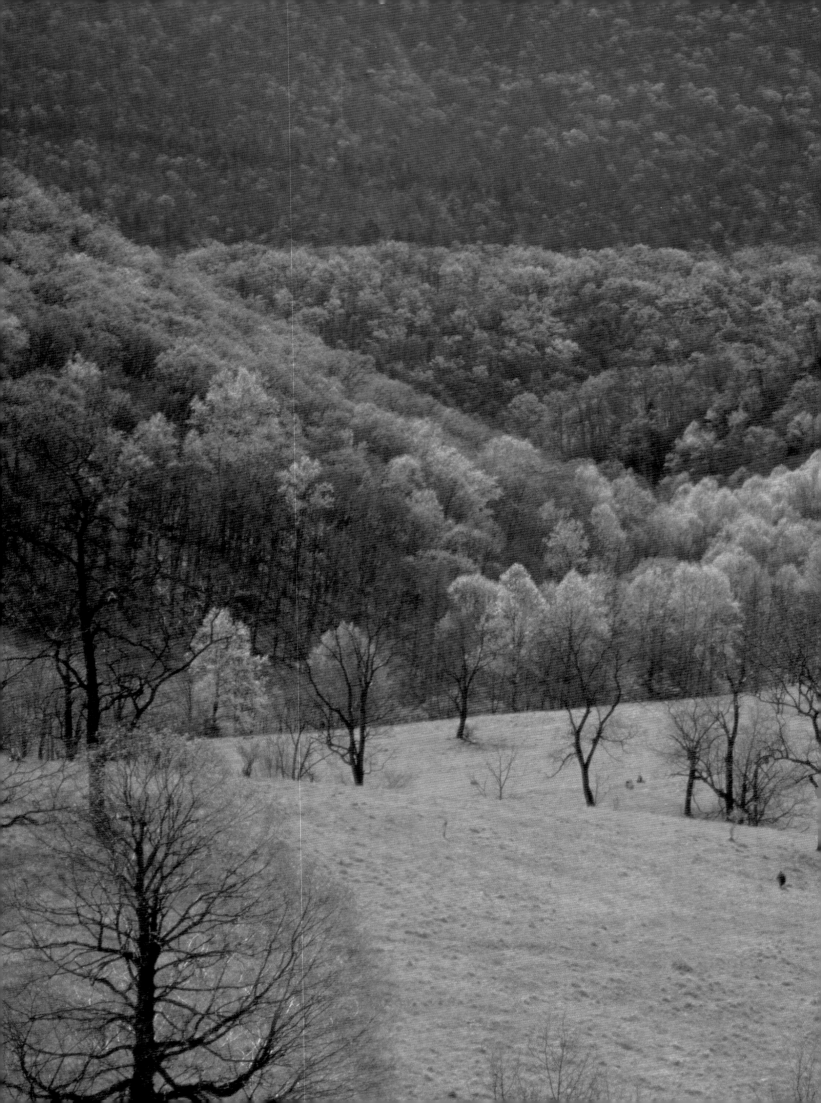

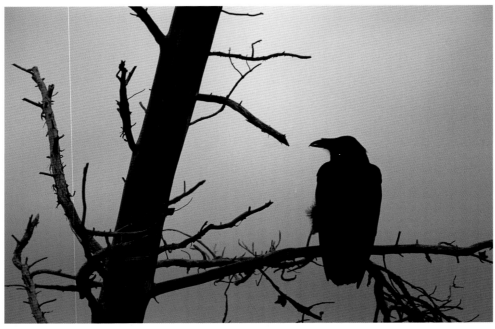

Raven

"How sweetly did they float upon the wings of silence, through the empty-vaulted
night, At every full smoothing the raven down of darkness till it smil'd!"

—John Milton

Raven Speak

Outside my office window, the symphony is warming up. With the dawning of this early June morning, birds of all shapes, sizes, and colors offer musical interpretations to the new day. Leading off the concert is the cardinal, soon followed by a couple of eastern bluebirds. Next, a robin joins in. Carolina wrens, song sparrows, and Baltimore orioles follow suit, each adding their own harmonious mix. The air becomes saturated with magical melodies. Aaron Copland would have been pleased with this Appalachian spring.

As the sun's golden rays beam between the trees' fresh green leaves, an assortment of avian delights dash back and forth from tree to tree and shrub to shrub. I catch glimpses of scarlet tanagers, great-crested flycatchers, and catbirds in the old red oak tree outside my window. Below my office, along the banks of the Potomac River, a male belted kingfisher dashes by, probably heading to a special overhanging sycamore branch that serves as its favorite hunting perch. Sushi for breakfast. Along the riverbank, a teetering spotted sandpiper scurries among a scattering of beached logs. Across the river, a flock of wild turkeys ventures from the safety of the forest to wander along the river's edge. An occasional gobble resonates down river.

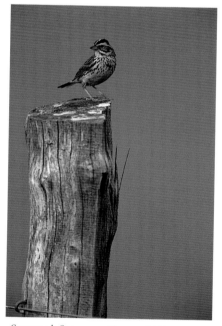

Savannah Sparrow – Canaan Valley National Wildlife Refuge

Along the river, the soft warm glow of morning fog adds a special mood to the waking day. Away from the river, patches of fog float through the upland meadows before dissipating into the spring air. Warmed by the sun, butterflies glide over the glistening fields of grass and wildflowers. Savannah sparrows perch carefully on slender stalks of bluestem, each stem decorated with strings of dewdrops. Eastern meadowlarks and indigo buntings offer their voices to the morning, while red-winged blackbirds – not content with just singing – display their bright red epaulets to any potential would-be competitor. A lone male kestrel treads the sky above, its wings beating furiously as it scans the meadow below for a vole. Suddenly, the kestrel takes flight and dive-bombs an unsuspecting meadowlark. Using its innate knowledge of angles and geometry, the kestrel swoops and swerves around its frantic flying prey. In the end the meadowlark avoids becoming a meal. The kestrel remains hungry.

As the temperature warms, turkeys and black vultures take flight, soaring in the cerulean sky. They occasionally pump their large black wings to stay aloft. A murder of fish crows joins them. Tree and barn swallows attack insects flying just above a pond's surface. In these most ancient of mountains, stories are written on the wings of the raven and in the melodies of the wood thrush.

❖❖❖

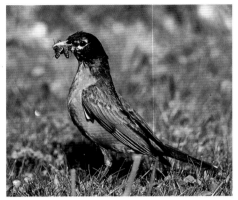
Robin – Canaan Valley State Park

Birds have always been a source of fascination for me, and as for memories, every species I have seen takes me to an earlier time, to a special memory. Birds were the catalyst that started my passion for nature. And the Appalachians became a challenging location to learn the craft of bird-watching.

Most hard-core birders flock to the coastal regions of the United States to watch the dizzying mix of shorebirds, waterfowl, and other wading birds. And rightly so. These larger, more obvious birds are a bit easier to see than the warblers, cuckoos, and tanagers of the Appalachians. But for me, that's the challenge I enjoy in my birding. Nothing comes easy in the Appalachians, not even birding. It takes more straining of the neck muscles to capture the bird in your binoculars. A good dose of physical dexterity for walking up mountains is needed as well.

As for songbirds such as warblers, a birder can't find a better place than the Appalachians. In West Virginia alone more than twenty-four species of wood warblers are found, either as migrants or breeders. Add in the hundreds of other bird species, and these mountains offer a very respectable menu of life-listers for the passionate birder. For at least one young mountain-loving birder, it was enough to keep him occupied for years. And it was enough to keep him out of trouble, too.

During my hard-core birding days, I combed the mountains around home for every bird lurking amongst the fields and forests. Whether common or newly discovered, colorful or drab, it didn't matter; I just wanted to watch birds. I became intent on learning the ways of the turkey vultures silently soaring high over our house on warm summer afternoons. The mysterious and solitary great blue heron skulking in the far reaches of Berwind Lake piqued my passion for waterbirds, and the beautiful fluted notes of the wood thrush helped fine-tune my ability to identify birds by their song. Birding became my opening into the world of nature and ecology.

Birds also helped me develop the skills needed to become a naturalist and photographer. Birding showed me how to be patient, but at the same time, it taught me when I needed to move quickly. By watching birds, I developed my dexterity in stalking to uncover those "little brown jobbers" hiding in the thickets. Birding helped develop my sense of hearing. Birding helped develop my strong sense of sight, to see colors, shapes, and forms hidden in the deep recesses of the landscape. But the raven, that mysterious bird of legend and lore, would be the one fine-feathered friend to help me rediscover my love for these ancient mountains.

Feared. Loathed. Respected. Hunted. Vilified. Coveted. The raven has transcended the spectrum of good and evil, of reality and myth. Steeped in folklore, the raven is characterized around the world as a prophet of death and evil, and for some, a messenger of goodwill. Every culture has a fable about this independent and mysterious creature.

In Greek mythology, the raven's plumage was once pure white. As Apollo's courier, the raven returned one day with news about a nymph's infidelity, which so infuriated the Gods that the raven's plumage was turned to jet-black. This was probably the first recorded case of someone shooting the messenger.

Even Noah had his problems with the raven. During the major flood, Noah sent both the raven and dove out to discover if the flood had receded. The dove returned with the olive branch, but the independent minded raven relished his freedom too much to cooperate. According to one non-Biblical legend, angry Noah turned the raven's feathers black. According to Greenland lore, the snowy owl changed the raven's feathers from white to black because of a disagreement between the two. What the disagreement was about remains a mystery, but the owl wasn't too gracious about it, pouring sooty lamp oil over the raven. Now, I'm not sure who to thank here, Apollo, Noah, or the snowy owl, but I am happy the raven is black. Regardless of how its plumage was switched, the raven is a most regal creature with its rich ebony attire.

In other cultures, the raven has been revered. Native American folklore has the raven as a generous creature, sharing its food with people stranded by floodwaters. Both Hindu and Norse sailors used ravens to help guide their armies across the land. Some arctic cultures consider the raven as the creator of the earth. I'm also one to consider the raven a sign of good luck. Just a fleeting glimpse of a raven is enough to stir my imagination. When I see a raven in the Appalachians, I know I'm in a special place.

My interest in ravens started with my rediscovery of West Virginia. After a nearly fifteen year absence, I returned to the state and started photographing the highlands. The more I explored, the more I learned. And what I learned about the raven is that, this bird calls the mountain state home – not only in the higher elevations, but also along the rolling hills of eastern West Virginia.

Ravens do not occur in the southern coalfields where I grew up. Instead, the raven's relatives – crows and blue jays – dominate the Corvid pecking order. Both were considered scourges of the earth. I never quite figured why, since the mining community where I was from never had any major agriculture for the crows to attack – the hills were too steep and the soil too poor to sustain such a livelihood. But as Henry Ward Beecher wrote, "If men had wings and bore black feathers, few of them would be clever enough to be crows." And if crows are clever, ravens are brilliant.

Weighing in at four pounds and with a wingspread of nearly four feet, it is hard to imagine the raven as a songbird. But as a member of the family Corvidae and cousin to the crow, blue jay, and magpie, a songbird it is; just a big one. Often confused with the common crow, the raven is much larger with a thicker bill and wedge-shaped tail. Its call is quite unmistakable: a low, drawn-out "croak". When I hear the raven's call, I know I'm in the highlands.

Although the raven occurs in the eastern panhandle of West Virginia, its primary domain lies in the highland region of 4,000-plus-foot elevations, a landscape of red spruce lined summits, deep valleys, and nervous red squirrels. This is also the home of other special mountain birds—the melodic hermit thrush, the nomadic cedar waxwing, and the most diminutive member of the forest avian clan, the golden-crowned kinglet. The kinglet might be tiny, but its song belies its minute stature. Among this wonderful array of bird life, the raven reigns.

In exploring the Highlands, imagine my excitement at discovering these skilled aerialists flying along the conifer-covered ridge tops. Even today, I enjoy watching these birds soar over me, drifting from one valley to another, maybe just flying for the pleasure of it. Often times, while I am admiring a sweeping vista along the Highland Scenic Highway in Pocahontas County, a raven or two will suddenly appear from nowhere. Cavorting in the late afternoon sky, the ravens suddenly plunge into the valley, leaving one earth-bound human wishing he could do the same.

What is it about this bird that has captured my imagination? Maybe it is because, as I see it, the raven is the surveyor of its domain. Its apparent air of self-confidence impresses me. The raven, unlike the edgy red squirrel hiding in the boughs of a red spruce, can be inquisitive without becoming obvious and annoying about it. Unlike the chattering red squirrel, the raven doesn't make a scene if something or someone enters its territory. It investigates, of course. Maybe a croak or two. But knowing it controls the air space, the raven is content with scrutinizing the situation from above. I've even had ravens fly past me, then circle back to check me out one more time. At times during my forays into the highlands, ravens were my only company for the day. Their companionship has always been welcomed. And as companions, the ravens are a family-oriented and devoted bunch of birds.

Ravens are excellent parents. They are very affectionate to each other when they form pairs. With a life span of thirty years, ravens mate for life and work together as a team to protect their territory, which can be rather large. Ravens live in family and clan territorial groups, spending years together. Often pairs are accompanied by a third raven, which assists the pair in daily family life. This is not to say a raven's life is without challenges. Although a mated pair protects a large territory, they are no match for a "gang" attack. Juvenile gangs – the unmated ones – sometimes cause problems with the mated pairs.

Unmated ravens are wanderers, continually searching for food and working together with other unmated individuals to acquire it. If a pair takes possession of a food source, let's say a carcass, the unmated birds work as a team to snatch the food. The adult pairs may quickly become outnumbered and the delinquent mob will usually win the battle. Even within the gang, the biggest raven gets first dibs. Beyond this competition, however, ravens are a congenial bunch of birds. When mating season comes around, they can get downright giddy.

Ravens court and mate in late winter or early spring, depending upon elevation and terrain. Nests are made in cliffs and trees, and the pairs frequently return to previous years' nests, cleaning and rebuilding for another nesting attempt. Mated pairs raise their chicks, and juveniles and adolescents remain with their parents for a few years to learn social and survival skills. While mated pairs can be seen throughout the year, a change occurs in February. An assortment of metallic and melodious sounds from the raven echoes through the early spring air: it is courtship time. With the season comes the incredible aerobatics of ravens in love.

Unmated birds search high and low for mates to share in nesting responsibilities. Once a likely partner is found, the pair flies more closely together than normal. Wing to wing, they somersault and soar, eventually diving back to earth. Once paired, the ravens perch together in trees, allopreen (mutual cleaning of hard to reach spots), make sweet sounds, and rub bills in a type of "Eskimo kiss." Capricious these birds might be during the breeding season, but little doubt exists about their intelligence. Even smart birds deserve to fall in love.

Not only are they opportunistic, ravens are also very intelligent. Renowned animal behaviorist Konrad Lorenz believed ravens to have the highest mental development of all birds. As a smart critter, they are also bold and daring in their efforts to find something to eat.

Ravens exploit any situation to acquire food. They will enter buildings, cars, and even the storage compartments of motorcycles. They have been documented walking into a chicken coop to steal eggs from a laying hen. In the highlands, carrion is their preferred and sometimes only food source. Whatever a predator kills and leaves, the raven

eats. Out West, they often return the favor by alerting wolves and coyotes to potential prey such as an injured deer or elk. Ravens are also excellent sentinels for the forest denizens. When the first sign of disturbance occurs, the raven alerts others with its call.

Regardless of what you may think of ravens, I hope you'll see that at least in the Appalachians, they are not only overseers of their domain, but they serve a role in keeping order among their community. Beautiful, intelligent, and altruistic, the raven rules in these mountains.

I would be remiss if I did not state right now that I love all birds, not just ravens. Yes, ravens are special. But not a flash of vibrant flying feathers goes unnoticed by me. From the admonishing mockingbird in the rose thicket, to the quiet brown creeper sneaking up the oak tree, to the wood duck winging down the river—they all fascinate me. So, let me pay homage to one more highland bird that enriches my Appalachian sense of place: the perfectly sculpted cedar waxwing.

Nomadic, gregarious, and daring. These are all attributes of the cedar waxwing. Although not confined to the higher elevations of the Appalachians, the waxwing nonetheless frequents the ridgelines and summits of the highlands. Itinerant in its search for food, the cedar waxwing is an intriguing species: lovely in appearance, but ungainly in its feeding habits.

The waxwing, fashioned with a fine coat of feathers colored a fawn hue, is one of the stateliest looking birds to grace the Appalachian landscape. A crest further enhances its sleek appearance. Its tail feathers are tinged at the tip with yellow that appears as freshly dripped wax; hence the name, waxwing. Add a black mask across its face, and you have not only a beautiful bird, but a mysterious looking one as well. With such a sleek appearance, one would assume its song to be just as glamorous. But it isn't.

The waxwing's song is practically nonexistent – a high-pitched "sree" is about all it has to offer. If your ears are attuned at picking up high pitched-sounds, then you'll have no trouble locating a flock of waxwings perched high in a sycamore or red spruce. Otherwise, you are more likely to just enjoy watching them. And they are fun to watch.

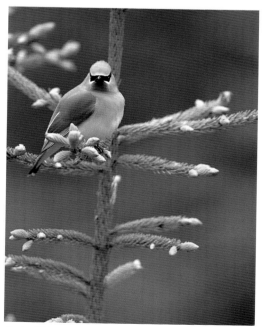

Waxwings are a tolerant lot as well, accepting close proximity by humans who take their time approaching them. I have photographed a flock of waxwings perched on the branches of a red spruce sapling along a pull-off on the Highland Scenic Highway. The birds were so patient that they stayed put until I went back to my truck (about 50 yards away), retrieved a longer telephoto lens, walked back to the tree, and commenced photographing them again. It might have been my imagination, but I think they were actually posing for me.

Cedar Waxwing – Highland Scenic Highway

As a collective force, waxwings scour the woodlands, looking for a tree loaded with seeds or berries. They are deliberate in their search, but relaxed in their attitude. Waxwings are also adept at catching flying insects. Like a flycatcher, a waxwing will swiftly dart into the air, grab the unsuspecting bug, and return to the same branch where it took off. But for pure culinary enjoyment, waxwings love to eat fruit and seeds, and they love to be communal about it. But as beautiful and well-groomed as these birds appear, their table manners, at least in the bird world, are a bit unnerving. Miss Manners would not be happy.

Waxwings are downright gluttons. Not only do they gorge themselves until they literally can't move, they sometimes become a bit intoxicated by consuming fermented berries. Waxwings also have the reputation for consuming so much at one sitting that the berries will literally fall out of their mouths. No seconds or thirds for them – just grab everything at once.

Eating habits aside, the cedar waxwing along with all the other birds of the Appalachians provide this landscape with grace, beauty, and life. To all feathered creatures of the forest: forever may you add your songs to the morning and your vibrant colors to the world.

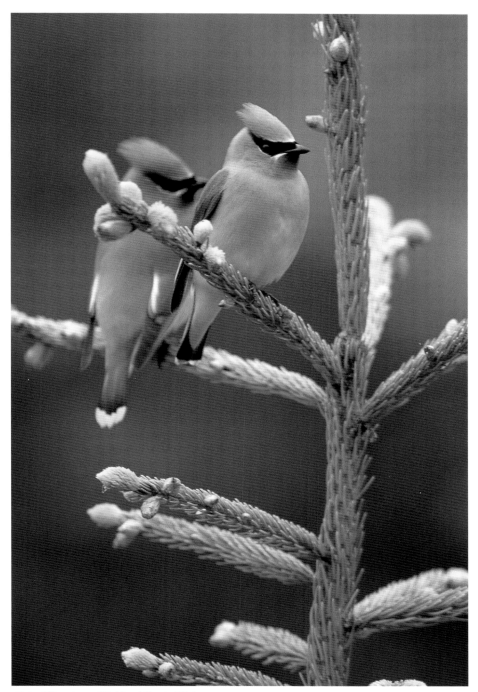

Cedar Waxwing – Highland Scenic Highway

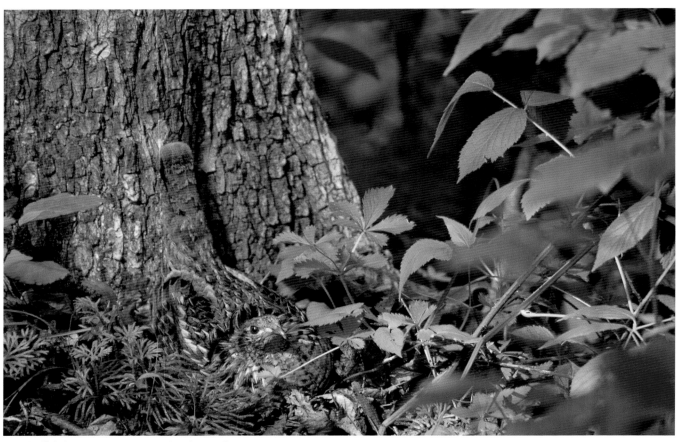

Hen Ruffed Grouse sitting on nest – Pocahontas County

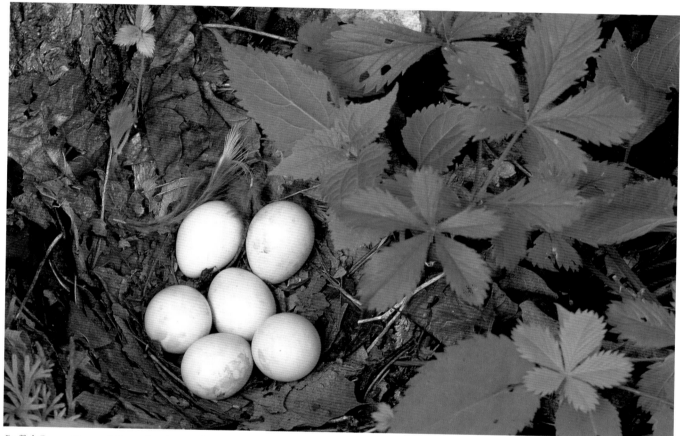

Ruffed Grouse Nest and Eggs – Pocahontas County

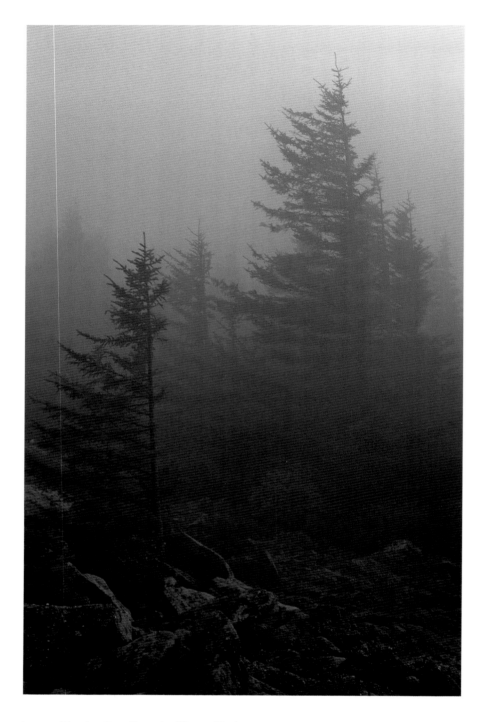

Autumn Morning Fog – Summit of Spruce Knob

"You will find something more in woods than in books. Trees and stones
will teach you that which you can never learn from masters."

—The Epistle 106 - Saint Bernard

River Tree

L ate March has arrived and a sense of anticipation surges through the landscape. Emerging from winter's grip is a fervent sense of rebirth and renewal. We welcome it without hesitation. Warm the earth, warm our hearts, and bring on the flowers!

In the sun-dappled woodlands, the impatience of new life escapes as wildflowers burst forth. The forest floor remains matted with a carpet of last year's leaves. The leaves have served their purpose insulating the seeds and providing nutrients. Now it is time for the flowers to boast. Bloodroot, hepatica, and spring beauty start the show. Spring is their season in the sun. The leaves will have their day again when autumn arrives.

From all angles and depths, spring's resurrection becomes evident. Ephemeral wildflowers – those completing their growth and reproductive cycle before the leaves are fully-grown – find the Appalachians much to their liking. When conditions become favorable in terms of temperature, moisture, and canopy opening, the forest floor becomes covered with an array of colorful wildflowers. The meadows are embellished with a variety of seasonal color. Along the riverbanks with their rich alluvial soils and nutrients, the land abounds with flowers. Bluebell, trillium, trout lily, and harbinger of spring decorate the woodlands and wet seeps. Along the cut banks and riverbeds, Dutchman's breeches, Jack-in-the-pulpit, May apple, and blue phlox flourish. From valley to summit, the spectrum of the rainbow is well represented.

A mountain spring is more than flowers. An Appalachian spring is the time to savor the freshness of an April rain. Who can resist sitting on a rocking chair or front porch swing and being gently put to sleep by the gentle tempo of raindrops dancing on the surface of a pond or on a tin roof. Spring is the season to listen to the cascading rhythms of a rushing stream and to enjoy the symphony of songbirds as they return from their winter homes. And have you heard the spring peepers during a spring night? Spring music.

Even the trees with their colorful buds and blooms add special tones to the landscape. We become so intent looking down at the wildflowers, we forget that the trees offer their own unique colorful attire to the spring as well. One only has to think of two trees that serve as icons of an Appalachian spring: the red bud with its burgundy color and the flowering dogwood with its creamy white petals. For most trees, however, the colors are bit more discreet and subtle. Think Monet. Imagine pastels of pink, white, and claret. Look up and you'll be surprised at what you see. And of course, without the trees, there is no forest, and without the forest, Appalachia would be without its heart.

Redbud in Spring – Jefferson County

Trees embrace all that matters in these mountains. We love them. We cut them. We admire them. We use them. We abhor them. We nurture them. We manage them. We decide which ones are good for us and which ones are bad. We respect and worship them. Some of us love them vertical; others prefer them horizontal. Trees provide something for every stage in our lives. From cradle to grave, trees play a role. Whether as a seedling or a decaying nursery log, trees contribute something to life's processes.

West Virginia's mountains and valleys are home to some of the finest hardwood forests in the nation. The state's 15.4 million acres remain 78 percent forested, placing West Virginia as the third most forested state, behind only Maine and New Hampshire. If you love tree covered mountains, you'll adore West Virginia.

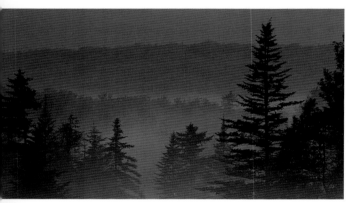

Summer Sunset and Fog – Canaan Valley State Park

Growing up in southern West Virginia, I was surrounded by trees. I could never imagine living in a landscape that did not have them. I felt sad for folks in the desert and the prairies. How depressing it must be to not have trees to climb or to sit beneath. Of course, as I became more knowledgeable about ecology and ecosystems, I understood why trees weren't found everywhere, at least not in the abundance to which I was accustomed. I even learned that some folks from the West could become claustrophobic simply walking through forests.

The forests covering the mountains around my home were primarily of the oak-hickory-poplar variety. For me, just a step outside the kitchen door and a few hundred feet up the road, and I was in the forest. No matter the direction I headed, I would be among the oaks and hickories. This forest association would serve as my living laboratory during years of fine-tuning my skills as a wildlife biologist.

If you like oak trees – black, red, white, scarlet, chestnut – then southern West Virginia is the place to be. There are also tulip poplar, various hickory species, and other non-oaks, but oak dominates the canopy. In the cooler recesses of the forest – in the coves and north-facing slopes – red and sugar maple, basswood, yellow birch, hemlock, and beech are found. I quickly discovered this was the part of the forest to frequent during those hot and humid days of summer. To this day, I have a special fondness for exploring these coves of maple and beech. It also provides a great place for a tired photographer to experience an afternoon nap.

Two of my favorite "non-oak" species, which are common in the mountains around my home, are American beech and tulip poplar. The thin, smooth, steel-gray bark of the beech and the furrowed bark of the tulip poplar distinguish them from the oaks and hickories. Both add additional color to autumn in the southern Appalachians, which is void of the deep, rich colors of the beech-cherry-maple forests found further north. An extra bonus for the beech is the placement of its branches, just the right arrangement for easy climbing.

On warm autumn afternoons, with a cerulean sky and light breeze, the tulip popular and beech tree also added a sweet fragrance to the fall. With the sun backlighting the scene, their gold leaves glimmered. Lying on the forest floor and gazing toward the heavens, I would soak in the view of the amber leaves of tulip poplar softly parachuting to the earth. If I was lucky and quick enough, some of the leaves would drift my way and I would grab them.

To the north and beyond the oak-hickory forests of home, other forests in West Virginia harbored tree species I knew very little about. Once I returned home, I quickly discovered these fascinating plant communities. The summits of the state's Allegheny Highlands are covered with red spruce forests. On the wind-swept slopes of the state's highest point, Spruce Knob, grows mountain ash, a sure sign that you are at least 4,000 feet above sea level. Just west of and along the Allegheny Front, forests of maple, beech, and cherry thrive. Bordering the high elevation bogs and glades grows balsam fir, and in one swamp in northern West Virginia larch can be found. On the drier slopes of North Fork Mountain, in the ecological province known as the Ridge and Valley, groves of red pine grow, a tree more common in the northern reaches of the Appalachians. In the Canaan Valley, the meadows are thick with prickly hawthorn. All total, more than 130 species of trees can be found in West Virginia.

Anyone who has a strong attraction to trees has at least one or two favorite species. I'm no exception. I have several "favorite" trees, but one in particular is a special one for me, taking me back to my days growing up in these mountains: *Platanus occidentalis* – the Eastern Sycamore, or as I like to call it, the river tree.

Behind my Mom's house, which faces west, grows a large, grand sycamore. Precariously surviving on a steep slope, this sycamore greeted me every morning when I looked out the kitchen window. I was always amazed at how such a large tree could grow on such a steep incline. I'm sure Norfolk and Western Railroad was amazed as well, since this massive tree wasn't that far from the tracks below our home. One strong windstorm could have easily caused the tree to crash toward the tracks, but fortunately for everyone, it hasn't yet.

As grand as it is, the sycamore is not a tree of the forest, but rather, a tree of the forest border. You will not see it on the tops of the highest summits, nor will you see it very often growing on the slopes. If you do, it's a solitary tree that has become established due in part to some disturbance. Above 2,500 feet, don't expect to see a sycamore at all.

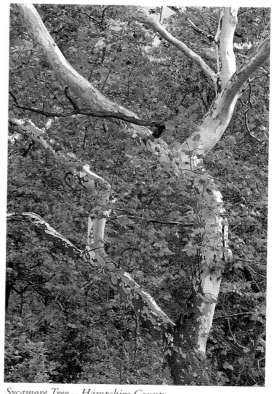

Sycamores flourish along the banks of the major waterways in the Appalachian Ridge and Valley Province. In the Shenandoah Valley, the sycamore remains a common sight along the meandering streams and meadows gracing the landscape. Along the floodplains, the sycamore prospers. While western river systems have cottonwood galleries, back home along the broader and more nutrient rich bottomlands are sycamore groves. Sycamores are also a pioneer species, becoming one of the first trees to grow on disturbed sites, even strip mines.

Sycamores are very distinctive in appearance. They cannot be confused with an oak, a beech, or a hickory. Their massive girth, light-colored and flaky bark, and sprawling branches give them away. Even at a long distances, its shape and color helps to distinguish the sycamore from any other tree. Regardless of the season, sycamores remain conspicuous.

Sycamore Tree – Hampshire County

One of my favorite times to see this tree is in early spring, just before the leaves have emerged. With dark storm clouds looming in the background, the tree appears majestic, the mottled color of its trunk and sprawling branches making a perfect complement to darkening gray skies. With frosty mornings and fog draping the rural landscape, large stately sycamores are a sight to behold as well. On early winter mornings or just after sunset, with the sky a deep scarlet or purple, the dark silhouettes of solitary sycamores stand sentinel to the landscape.

The sycamore is among the largest of all the eastern deciduous trees. Fast growing, it can reach heights of seventy feet within 15 years or so, and some of the grander, mature trees may be as old as six hundred years.

When considering the splendor of this tree, one has to see the tree in its entirety. The beauty of a sycamore lies not within its leaves, which are broad and green in the summer and very dull brown in the fall. (Earthworms, however, probably think otherwise since they love to gorge on the sycamore's sugar and nitrogen-rich decaying leaves.)

The beauty of the sycamore lies not in its flowers; they are not extravagant by any measure. And sycamore's buttonball fruit – a collection of nutlets clothed in downy hairs – is rather unique, but hardly showy.

The beauty of this amazing tree lies within its beautiful abstract arrangement of gray, brown, and white bark. With the bark continually sloughing off, the patterns become even more pronounced as the tree ages. Although the base of the tree has a brown, furrowed texture, the upper reaches of the sycamore shows off its unique beauty.

The sycamore forms cavities rather easily in its large trunk and branches. The tree's hollow trunks were preferred nesting and roost sites for chimney swifts. John James Audubon reports that near Louisville, Kentucky, he watched thousands of chimney swifts swooping into a sycamore cavity one July evening. Upon his return the next morning, he stayed long enough to watch the swifts depart in a steady thirty-minute stream.

Other cavity-nesting birds – the wood duck, pileated woodpecker, flicker, and great crested flycatcher – are also fond of the sycamore. One of the nation's long forgotten and extinct birds, the colorful and gregarious Carolina parakeet, favored the fruit of the sycamore. The only parakeet native to North America, the Carolina parakeet probably opted to use cavities in the sycamore as nesting sites as well. Even early explorers used the sycamore's hollow trunks as shelters, often for months at a time.

In the overall scheme of nature, the sycamore provides shelter for wildlife, and for nature enthusiasts such as myself, solace. As many times as my mom had the old sycamore behind the house trimmed and cut, it would grow back to its original size and shape in a few years. I admired its determination to survive. For me, that tree also helped ignite my love for birds and nature.

Sycamore Trees – Jefferson County

❖❖❖

While I was developing my passion for birds, I became aware of naturalist, painter, and birder extraordinaire Roger Tory Peterson. The very first nature book I ever had, at age ten, was Petersen's *Field Guide to the Birds – Eastern Edition*.

Before long I had amassed a collection of the many field guides in the Peterson series: trees, mammals, reptiles and amphibians, and wildflowers. Add in a pair of binoculars, some work boots, and a bird feeder, and I was ready to conquer the outdoor world. Of course, I would have to conquer it within the confines of my backyard in War, West Virginia. No one said it would be easy.

Spellbound by the stories Peterson wrote about his expeditions around the world, I would dream about experiencing the same journeys. Learning later in my life that Mr. Peterson's interest in birds resulted from him seeing a flicker in a sycamore tree just made that sycamore tree in Mom's yard even more special. For me as well, a flicker and a sycamore tree also played a role in my interest in birds.

A flicker pair had established residence in the sycamore tree behind our house. With the tree right outside my bedroom window, this situation provided an excellent vantage point to monitor the nesting activity. After the young had hatched, Mom and I became concerned after watching the young birds continually stick their heads in and out of the cavity. We had assumed, and wrongly so, that the young birds could not leave the cavity.

Sycamore Trees – Jefferson County

With this lack of knowledge, Mom and I decided to do something to help them escape. With axe in hand and Mom's supervisory direction, I proceeded to chop around the nest hole to make it bigger. I carefully lifted each bird out of the cavity and let it fly away. Prior to releasing them, I held their warm bodies and carefully studied their striking plumage. What magnificent creatures to behold. Thankfully, the birds were old enough that when I let them go, they immediately took flight, safely landing in some trees below the house.

When visiting Mom today, I stand at the kitchen window every morning, admiring that grand old sycamore. I hope that one day my young son will have the chance to stop and really look at this tree and maybe, just maybe, have a chance to save the world like I did so many years ago.

98

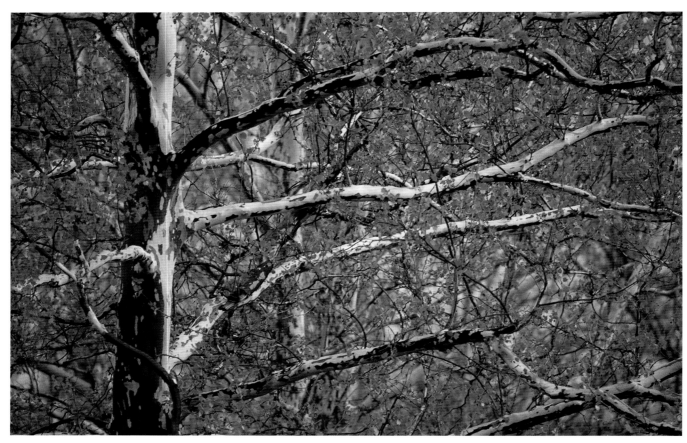

Sycamore Tree – Jefferson County

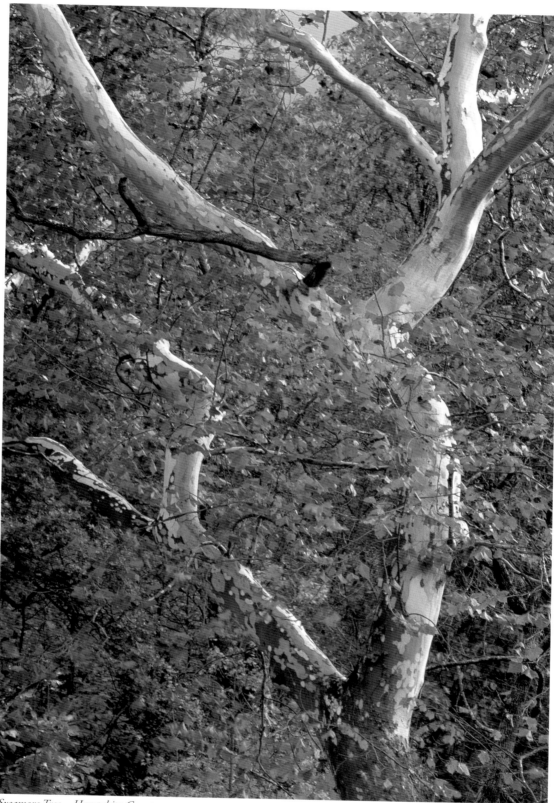

Sycamore Tree – Hampshire County

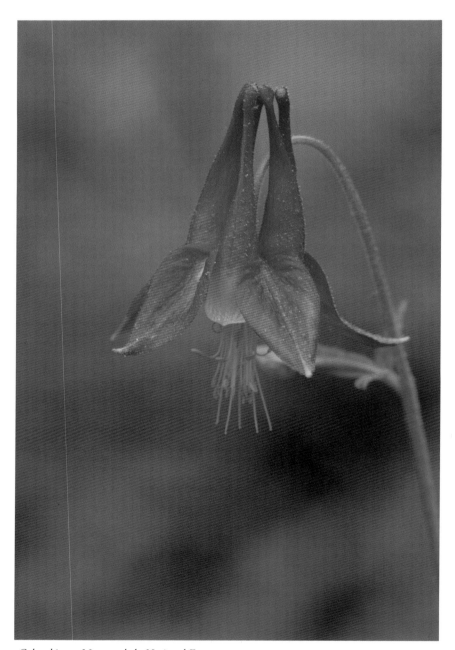

Columbine – Monongahela National Forest

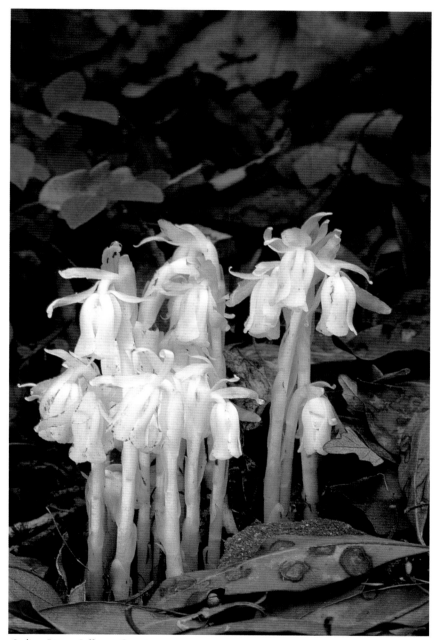

Indian Pipe – Jefferson County

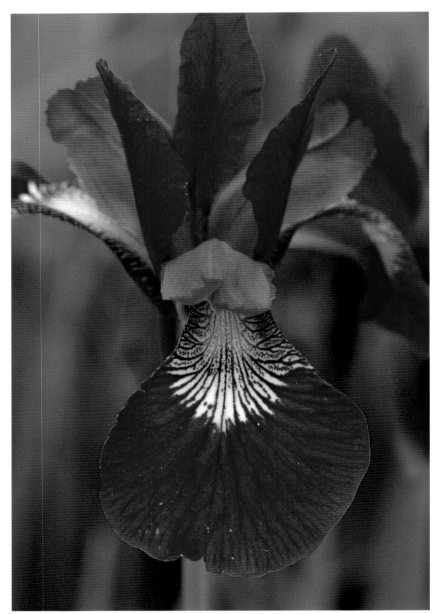

Wild Iris – Canaan Valley State Park

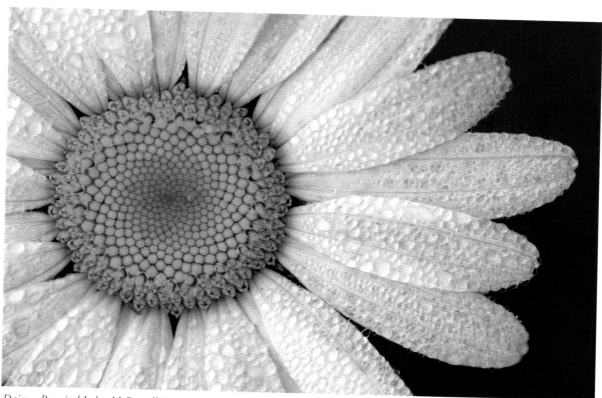

Daisy – Berwind Lake, McDowell County

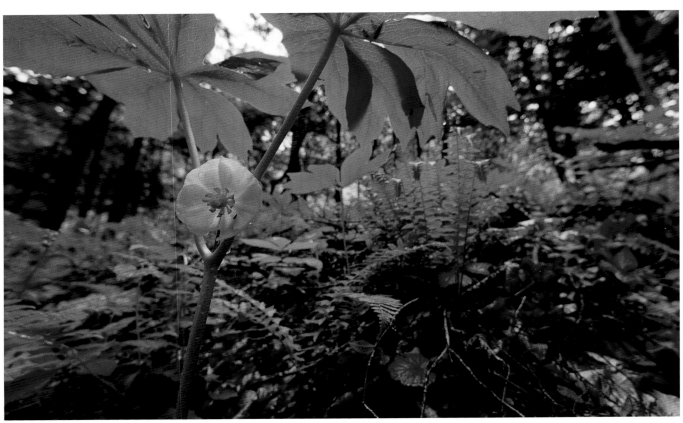

May-apple Bloom – Berwind Lake, McDowell County

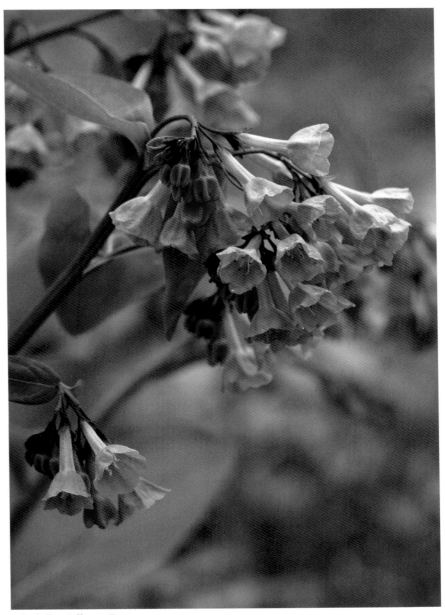

Bluebells – Jefferson County

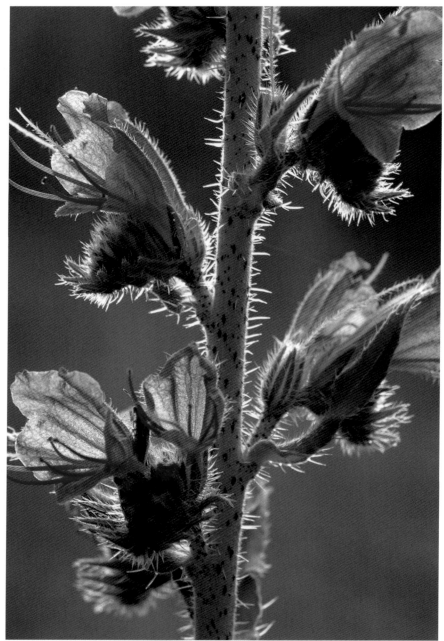

Viper's Bugloss – Highland Scenic Highway, Pocahontas County

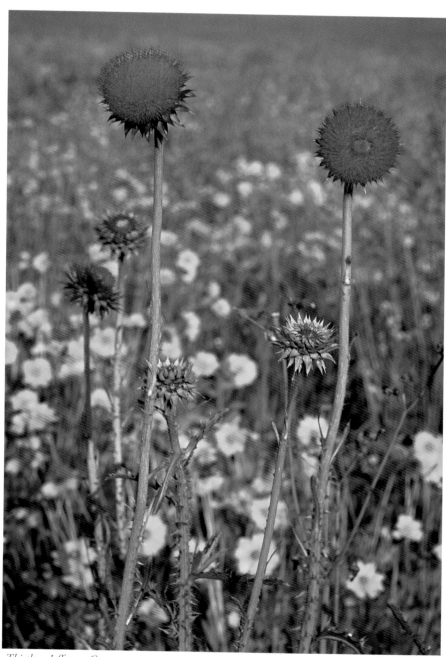

Thistle – Jefferson County

Dutchman's Breeches – Jefferson County

Squirrel Corn – Jefferson County

Bloodroot – Jefferson County

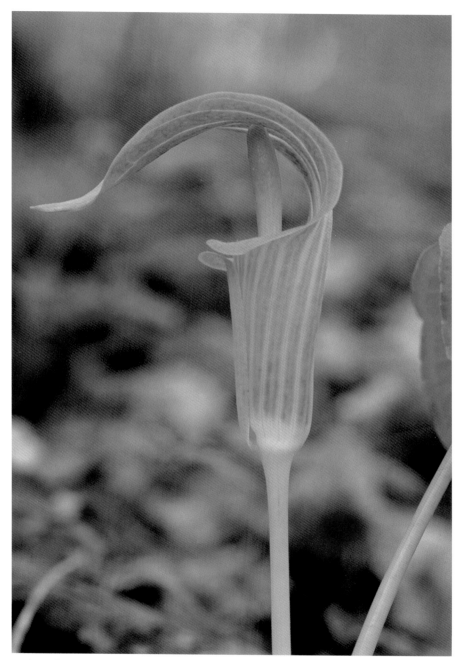

Jack-in-the-Pulpit – Jefferson County

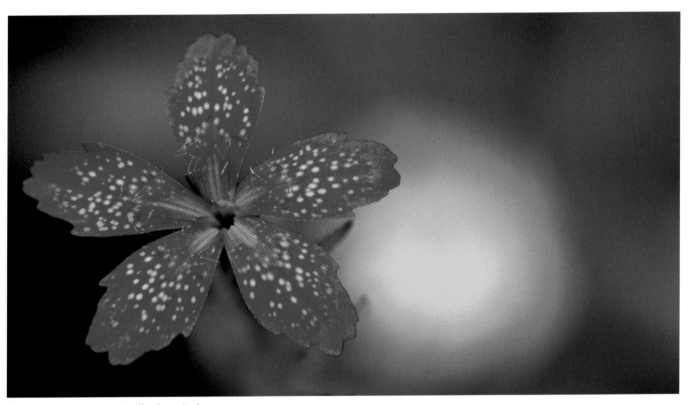

Deptford Pink – Canaan Valley State Park

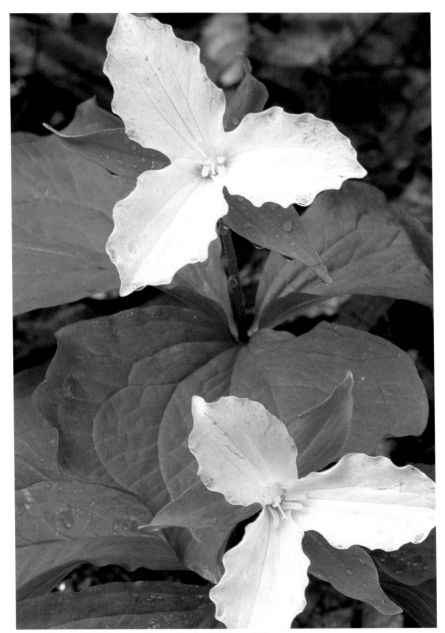

Large-flowered Trillium – Berwind Lake, McDowell County

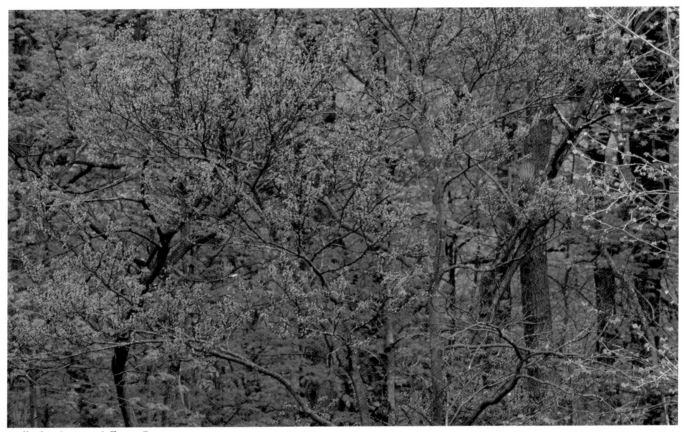

Redbud in Spring – Jefferson County

Following page: Mountain Ash in Autumn – Highland Scenic Highway, Pocahontas County

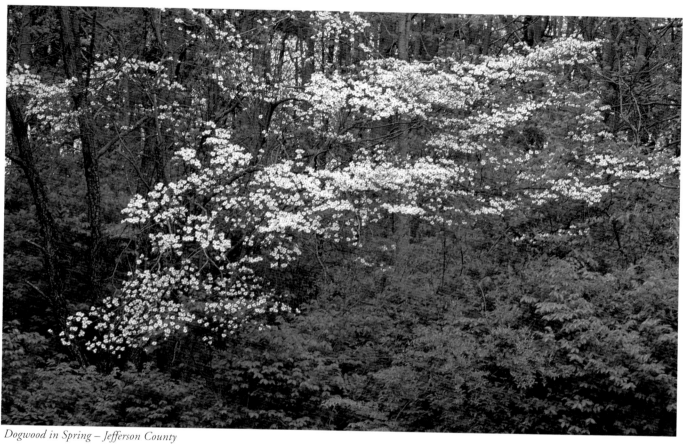

Dogwood in Spring – Jefferson County

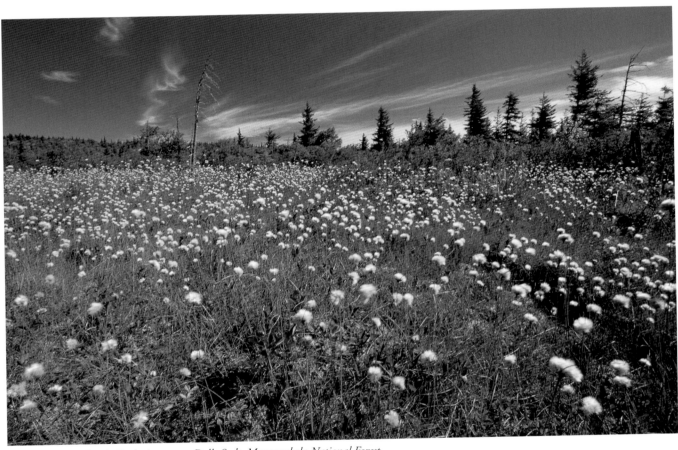

Cottongrass Meadow in Early Autumn – Dolly Sods, Monongahela National Forest

"History will remember today's generation for what we leave of the land,
rather than what we build on it."

—Jamie Rappaport Clark, Director – U.S. Fish and Wildlife Service,
1997-2001

The Glades

Thick fog and mild temperatures greet me as I arrive at the Cranberry Glades Botanical Area in Pocahontas County, West Virginia. I am preparing to spend this June morning exploring a collection of wetlands nestled in the heart of the Monongahela National Forest. My watch now reads 6:30 a.m., and not a soul, or at least a human soul, is anywhere to be seen.

Quiet prevails for the moment; even the birds have yet to start singing. Along with the fog and lack of human presence, this is what I expected and what I had hoped. With my morning free of any duties at the West Virginia Youth Conservation Camp in Cowen, I plan to take my time photographing this fascinating mountain ecosystem.

Visibility is nearly zero, but with the temperatures warming up, the fog will soon disappear. Red spruce trees and clusters of cinnamon fern scattered throughout the glades offer subtle and intriguing compositions. As a bonus, a sow black bear with two cubs and a yearling has been frequenting the half-mile long boardwalk circling the glades. Whether I photograph anything or not, it is great to be here, and to think that maybe I'll catch a glimpse of the bears makes it even better. Seeing these bruins will add to my Mason jar of memories.

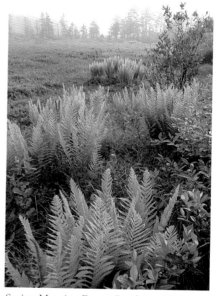

Spring Morning Fog at Cranberry Glades Botanical Area – Monongahela National Forest

On the boardwalk, the fog-drenched landscape engulfs me. For most of the morning, the fog remains thick, shaping the spruce and hemlock into ghostly silhouettes. As a photographer, I don't mind what the moisture has done to the landscape. The wet environment, however, has created some slippery conditions on the boardwalk, making each step a challenge. I manage, however, to beat the odds of slipping.

Marsh Blue Violet – Cranberry Glades Botanical Area

The first segment of the boardwalk winds through a tract of yellow birch, hemlock, and red spruce. Thickets of alder, holly, and rhododendron blanket the midstory, while skunk cabbage, violet, and marsh marigold cover the water-saturated ground. A few steps more and the landscape opens into the first glade: an expanse of sphagnum moss, lichen, and cottongrass. Various sedges, grasses, and cranberries cover the glades as well. Shrubs such as bog rosemary dot the flat terrain. The view is like another world, far from the Appalachians.

Hidden within the beds of the spongy substrate are sundews, tiny insectivorous plants — lovely in appearance, but deadly for insects. Most visitors will not see these marvelous little insect-trapping plants; some effort and stooping are required to find them among the moss. Along the boardwalk are also pitcher plants, another insectivorous plant introduced to the glades. This insect grabber is much easier to spot, with its tall burgundy stalks rising above the mossy substrate.

The most striking plants this morning are vibrant clusters of green cinnamon ferns scattered throughout the glades. The collective combination of fog and diffused morning sunlight creates a deeper, more saturated color, which, with their tan-colored stalks, makes the ferns stand out against the other vegetation. The ferns appear to glow.

The mountains ringing the glades remain concealed by the fog. Visibility extends for maybe a hundred feet or two, so my photography remains focused on close-ups and isolated scenics. But with an infinite arrangement of shape, color, and form to photograph, there is no shortage of subject matter.

Sundew – Cranberry Glades Botanical Area, Monongahela National Forest

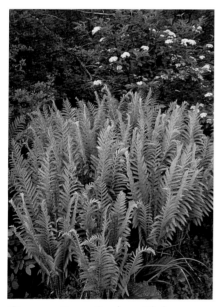

Cinnamon Fern – Cranberry Glades Botanical Area, Monongahela National Forest

Dew blankets the glades; every piece of vegetation saturated with moisture. Spider webs of all sizes and shapes are heavy with dewdrops. The bog floor has transformed into a necklace adorned with watery diamonds. The glades are gems among these mountains.

The glades take me back to my days living in Fairbanks, Alaska; the vegetation, or at least its appearance, comparable to the boreal forest of the last frontier. At any time I expect to see a grizzly or a moose, or to hear the haunting call of the varied thrush. But what I'll see instead will be white-tailed deer or maybe a black bear. What I'll hear will be the flute-like serenade of the hermit thrush. Here, within the heart of the Appalachians, are echoes of the arctic, but with a southern accent.

Adding to the cheerful mood of this spring morning are the many songbirds. The northern water thrush – a warbler – and Swainson's thrush – a true thrush – sing from the alder thickets. From its perch on the top of a hemlock, an American robin (another thrush species) sings, its "cheerily cheer-up cheerio" melody filling the morning air. Although robins are common in my suburban neighborhood near Washington, D. C., here it seems different. A robin in the glades takes on a new persona. Its song sounds richer, its red breast looks redder, and its stature, more admirable. I find myself not taking the robin for granted.

Song sparrows and juncos also offer their melodies to the glades. A bold song sparrow lands on the boardwalk in front of me, hopping around looking for something to eat. The sparrow doesn't provide a photographic opportunity – it's too close for my lens to focus – but it is entertaining. Where the boardwalk fronts a small beaver dam, I hear the

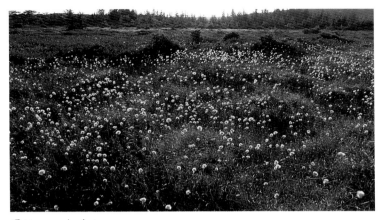

Cottongrass in Autumn

familiar "oo-eek" call of wood ducks as they dash overhead. Along the bog edges, cedar waxwings dash back and forth from one spruce tree to another, their high-pitched calls barely audible. A lone tree swallow glides by, while a convention of chimney swifts chatter above me as they head in a southerly direction. High above the glades, two red-shouldered hawks scream out. The glades are awake.

Other glade creatures add to the mood of this spring morning. Red squirrels scamper among the spruce and hemlock, eliciting their alarm calls any time I make a move. Rounding a corner of the boardwalk, I am startled by the alarm call of a white-tailed deer. Looking up, I see the south end of a north-heading doe as she leaps into the alder thickets. Leopard frogs call out from the wetter portions of the bog, and a few spring peepers peep their affections to all females still wanting a date. From their consistent calling, they are mighty determined to find someone, and I wish them luck.

I remain watchful for the bear family. The closest I get to them are the large piles of fresh droppings on the boardwalk. Bears are opportunistic when finding the most convenient paths to travel, and the boardwalk has proven to be one of their favorite routes. The aroma of wet fur permeates the glades, further convincing me they are close, probably watching from somewhere among the alder and rhododendron.

After a few hours photographing, I take a break near the end of the boardwalk. I place my camera gear to the side and find a nice spot to sit. Leaning against the trunk of an old tree, I listen to the stories the glades are telling me. They have much to say.

What I am experiencing this morning is a result of the glaciers moving southward many thousand years ago. Although glaciers never reached this far south, their influence did. The northern species of plants and animals found in the glades became established after they migrated south to escape the glaciers. Once the glaciers retreated and warmer temperatures prevailed, these displaced plants and critters remained. For this spring morning in the heart of the Appalachians, I am enjoying the results of that last Ice Age.

Cottongrass in Autumn

I have had nearly three hours to myself in this mysterious, magical place. Sounds of car doors shutting and voices of youngsters and their parents filter through the glades. The fog lifts and a light veil of clouds causes the skies to take on an airy tenor. The conditions are great for more photography, but I decide to depart and find another location to explore. The glades have made my morning memorable, but my appetite has not been sated. I will be back for more. Here's to the Ice Age.

The Appalachians hold a remarkable diversity of life. In this ancient landscape of worn-down mountains are species of plants and animals found nowhere else in the world. Even more amazing are those species of plants and animals that really shouldn't be here, more typical of what would be found in northern or southern regions. But because of glaciation and migration, these plants and animals exist among the oak, hickory, and maple forests. Slices of their habitats exist in the remote recesses of the valleys and summits, providing us a special glimpse into their world. Ecologists refer to these collections of misplaced critters and plants as disjunct populations. I refer to them as special houseguests.

In the Appalachians of West Virginia, the higher elevations and cool climates nurture forest communities that have become specialized in their family makeup of plants and animals. From first glance, it would appear improbable that this landscape of hardwood forests would include among its communities red spruce forests, plants such as aspen and fireweed, and high mountain wetlands such as the Cranberry Glades. You would assume that you were in southern Canada, not the heart of Appalachia.

Unique ecosystems usually feature specialized adaptations among their plants and animals, and this specialization leads to special fragility. Far too many of these mountain communities have already felt the effects of the axe and plough. What remains are just postage-stamp slices of their past glory days.

*Wood Fern in Spring – Cranberry Glades
Botanical Area, Monongahela National Forest*

The Cranberry Glades remains one fragile ecosystem that has been protected. Referred to generally as mountain bogs but locally as glades, these wetland complexes form on poorly drained soils located in the higher elevations of the Appalachians. The sedimentary rock formations in the unglaciated portions of the Appalachians, especially in the Allegheny region from Pennsylvania to southwestern Virginia, provide a perfect substrate for formation of high elevation wetlands. These are the most special, most exceptional ecological communities found in the Appalachians and the Cranberry Glades are a perfect example.

With the exception of an occasional hemlock or spruce, the glades are treeless. They may be bordered by thick stands of alder, but in the heart of the wetlands, you'll find mattes of moss and cranberries. The underlying substrate, composed of layers and layers of decaying vegetation called peat, is very spongy. Walking on these mats would be like ambling on a waterbed. With their extraordinary water storage capacity and their location in the higher elevations, the bogs remain much cooler than the surrounding forest. The ability of these bogs to affect local temperatures becomes obvious once you set foot on the boardwalk at Cranberry Glades; the temperature drops several degrees from the parking lot to the first glade opening.

These remote wetland complexes play host to an assortment of plants and animals more attuned to northern latitudes. Dwarf dogwood, buckbean, and bog rosemary reach their southern limits in the Cranberry Glades. Northern bird species such as Swainson's and hermit thrushes, mourning and Nashville warblers, and purple finches nest here.

The glades are only one of the many rare plant communities protected within the Appalachians. For nature enthusiasts, these wetland communities offer innumerable surprises. Special, unique, and isolated. The Cranberry

Glades, as other mountain wetlands in these ancient mountains, provide an additional charm and magic to the Appalachians.

Just above the glades, lining the higher ridges of West Virginia's summits lies another unique mountain forest community: red spruce.

Early June has arrived on the Highland Scenic Highway, a nationally recognized scenic thoroughfare winding along the national forestlands of Pocahontas County, West Virginia. Bordering the Cranberry Wilderness and Cranberry Backcountry areas, the Highland Scenic meanders through one of the state's most remote regions. Since no commercial vehicles are allowed on the highway, traffic is light. With plenty of turnouts and extra-wide shoulders, the highway offers an invitation to pull off the road and explore the trails and vistas.

On this sunny Monday morning, the air is exceptionally warm at 4,000 feet. The valley below is cool and covered with a thick mantle of fog. North of Big Spruce Overlook – 1.3 miles to be exact – lies a tract of red spruce. My objective for this morning is to explore its inner sanctum. I pass a sign informing me the spruce forest sits at an elevation of 4,454 feet.

I've always been fascinated with red spruce, which has seen better days in the Appalachians. The tale of red spruce and its demise in West Virginia is a story of manifest destiny. It is a story of how timber barons never saw a tree they wouldn't cut. It is a story of how early in our country's history, no such thing as a future vision or a sense of protecting natural resources existed. It is a sad story in our nation's annals.

Before 1880, nearly a half million acres of red spruce forests covered West Virginia's 3,500-plus-foot summits. From a distance, the summits appeared to be coated in black. These mountaintop forests came complete with their own special assortment of critters, such as snowshoe hare, red squirrel, and northern flying squirrel. For the flying squirrel, these red spruce forests in West Virginia mark the southern breeding limit.

Red spruce forms thick canopies, making the understory sparse in species composition. Because of cooler temperatures and the lack of sunlight penetrating through the trees, the forest floor is covered with ground pine, crow's feet, moss, and mushrooms. To the undiscerning eye, this community might be viewed as unproductive, but for those species dependent upon this plant community, it is otherwise.

Many of the state's neotropical migrants, including several wood warbler species, nest in these forests. Warblers such as black-throated blue, blackburnian, and chestnut-sided nest here. Since spring arrives late to these high-elevation forests, so too do the warblers. With the lack of warming temperatures to stir up the insects, these migrants are in no hurry to get here.

Historic photographs of these sub-alpine forests before they were logged show immense red spruce trees, many towering more than 90 feet. Some of these majestic trees were estimated to be more than 350 years old. At first glance, it would be easy to assume the photograph shows a towering sequoia or redwood from California. But they were in the Appalachians, and their impressive size led to their demise. Today, they are only celluloid memories.

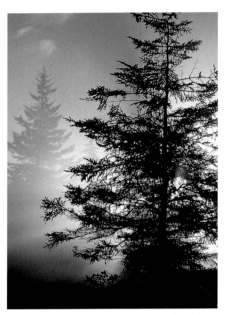

Sunrise through the red spruce – Dolly Sods, Monongahela National Forest

What old-growth red spruce remains in the state is now restricted to about 300 acres, including 130 acres protected in a grove near Gaudineer Knob in Pocahontas County.

Within a forty-year span, from 1880 to 1920, nearly every acre of old-growth red spruce in West Virginia was logged, cleared, and burned. We can thank the Shay steam engine and society's thirst for more pianos for this relentless onslaught. Most of the red spruce remaining today is second and third growth, and nowhere near the glory of their ancestors.

Where red spruce has been logged, the second growth is much more hardwood in composition. A mixture of spruce, red maple, and black cherry are more likely to occur than pure stands of red spruce, hemlock, and yellow birch. The conversion of these transitional communities into a pure red spruce forest will not happen anytime soon – forest ecologists estimate a timetable from hundreds to thousands of years. Lack of an adequate humus layer prevents the spruce seedlings from getting a much-needed head start over their competition. Because of the elevation, the seedlings are also subject to severe climatic conditions, especially during the harsh winter. The American beech and red maple are also likely culprits preventing red spruce from having a fighting chance as well. These hardwood species are much more aggressive in their initial stages of growth. With these odds stacked against it, the red spruce ends up second best in the survival game.

So here I am at this second-growth red spruce forest on a Monday morning in June along the Highland Scenic Highway. I want to experience a few hours listening to the red spruce. I want to savor the sweet aroma of spruce needles. I want to see what the forest will offer me this morning. I want to imagine what this forest looked liked before 1880.

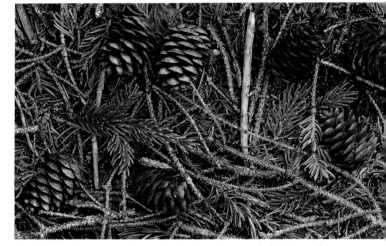

Red Spruce Cones – Gaudineer Scenic Area, Monongahela National Forest

Once I safely park my truck, I hike into the forest. Clumps of cinnamon fern – a common high-altitude species – decorate the forest edge. Another fern, the hayscented fern, which in autumn turns a rich golden color and saturates the air around it with the aroma of fresh cut hay, grows in profusion under the forest canopy along the highway. Once inside the tract, I find a comfortable spot to sit and lean against a large red spruce.

Just outside the tract, chipping sparrows, juncos, and robins sing, while inside the forest, I hear chestnut-sided warblers and kinglets. I lie on the soft, moss-covered ground, which is cluttered with red spruce cones, twigs, and branches. The forest floor is not very thick with vegetation; the moss covering and the high acidic content of the soil limits what grows here. Nevertheless, the floor is decorated with an assortment of smaller shrubs. The flies and mosquitoes are practically nonexistent in the forest, so napping should be a pleasurable and relaxing experience. I discover that it is.

After a restful and reflective hour in the forest, I leave to find lunch in the valley. During the afternoon, I return to the same spot. The temperatures have warmed up even more and a strong breeze whips through the forest, rustling the branches of the red spruce and hardwoods. Dark, scattered clouds cover the sun frequently, providing a welcome relief from the midday heat.

I go to the same tree, sit down and listen, watch, and wait. The same birds are calling from along the edge and within the forest. However, this time, in the recesses of the tract, just south of where I am sitting, a call similar to a young black bear cub pierces the forest. It is a bawling type call, a sound I had become all too familiar with during my career as a wildlife biologist. For nearly six years I lived in Alaska and studied grizzly bears. Whether grizzly, polar, or black, a bear cub whine is unmistakable.

Against better judgment, I decide to explore the southern reaches of the forest – where I think the cub is located. Hiking over, around, and under the downed timber isn't an easy endeavor. I never find the youngster or its mother. I decide to retrace my route to the best of my ability and leave whatever bruins are in this forest alone. I hope the bears, wherever they are, will extend the same courtesy to me.

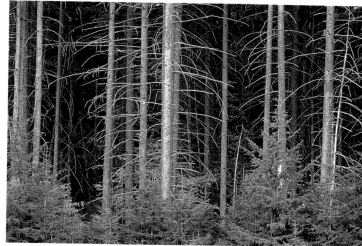

Red Spruce Forest – Highland Scenic Highway, Pocahontas County

I return to my favorite red spruce tree and lie down once again. Looking up, I watch the slender trunks of the spruce swaying in the wind. Only the upper portions of the trunk have branches covered with needles. The lower extremities are just skeleton branches, completely bare. A few of the older and taller trees creak when the breeze nudges them. I also hear the noisy chatter of red squirrels – fairy diddles as they are called here – as they anxiously scamper from tree to tree and log to log. With these creaks, groans, and screams I can sense the forest would be a scary place to be if I were younger. For more than an hour, I hear no vehicles on the highway, only sounds of the forest. While I welcome the warm weather, I can only surmise how magical this forest would look during and after a steady rainfall. With shrouds of fog drifting in and out among the spruce, the forest would remind me of a scene from the tales of King Arthur. For me, regardless of the weather or the season, these forests will always be magical. It is nice to know that once in West Virginia, we indeed had a Camelot.

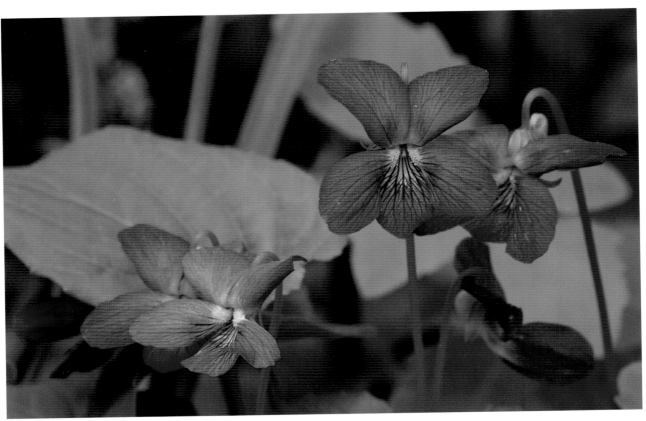

Marsh Blue Violet – Cranberry Glades Botanical Area

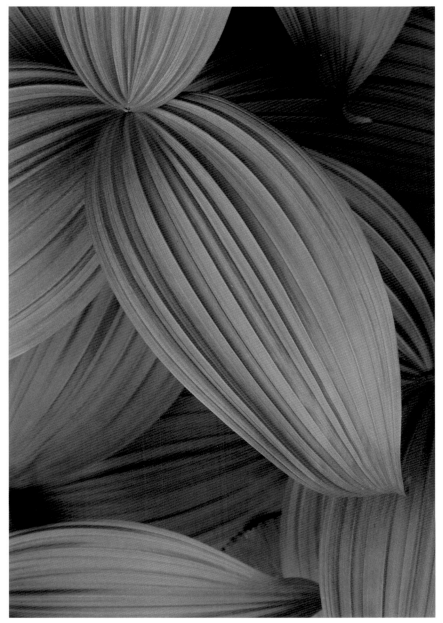

False Hellebore – Dolly Sods, Monongahela National Forest

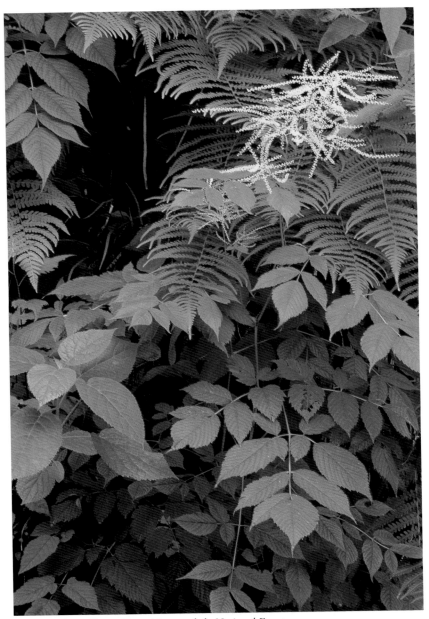

Goatsbeard – Williams River, Monongahela National Forest

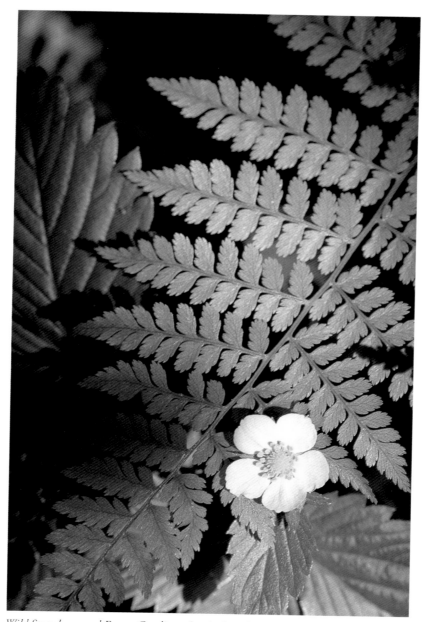

Wild Strawberry and Fern – Gaudineer Scenic Area, Monongahela National Forest

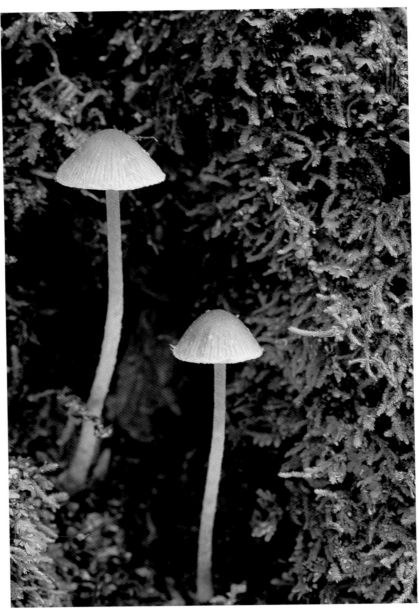

Mushrooms – Cathedral State Park

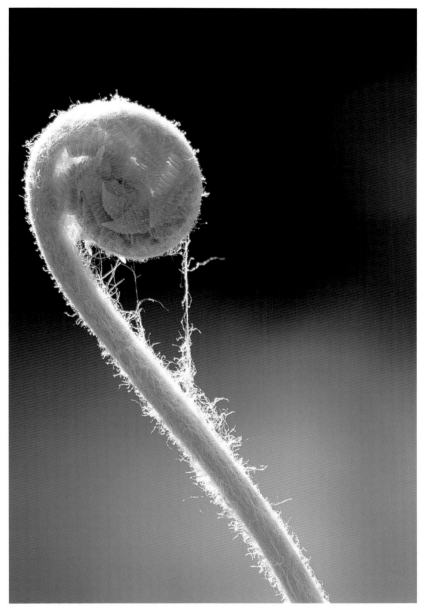

Fiddlehead – Dolly Sods Wilderness Area, Monongahela National Forest

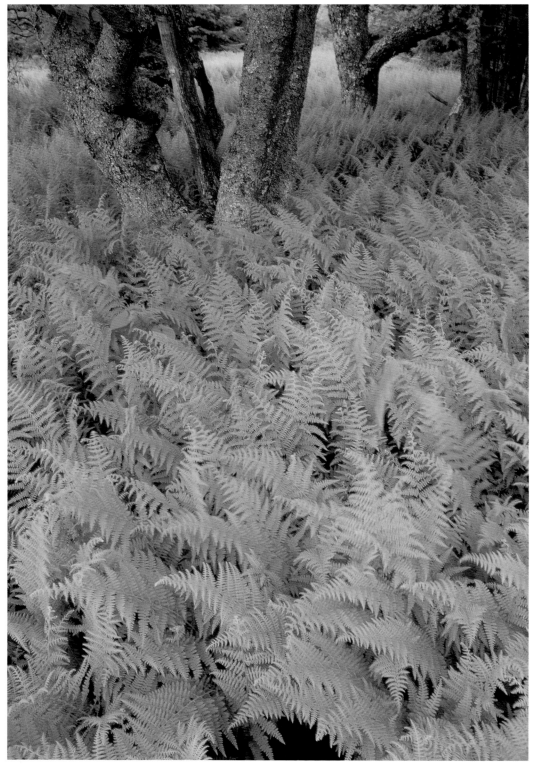

Hay-scented Fern in Summer – Dolly Sods, Monongahela National Forest

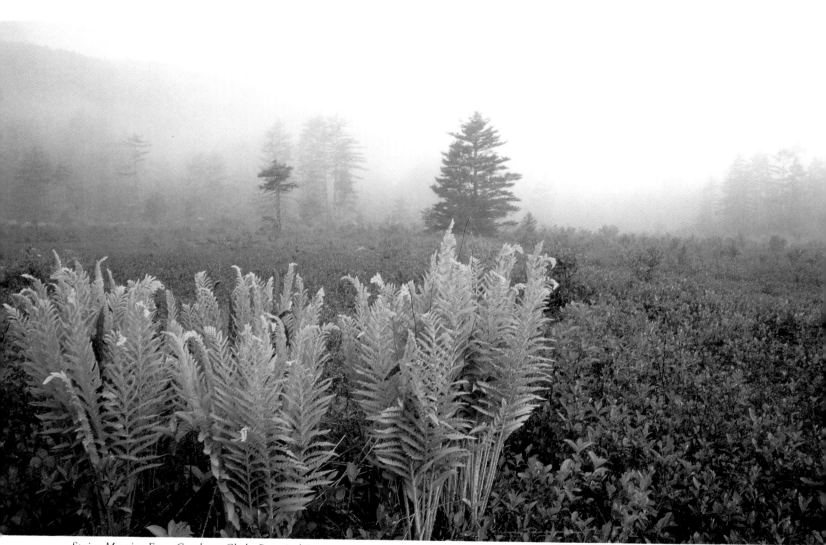

Spring Morning Fog – Cranberry Glades Botanical Area

134

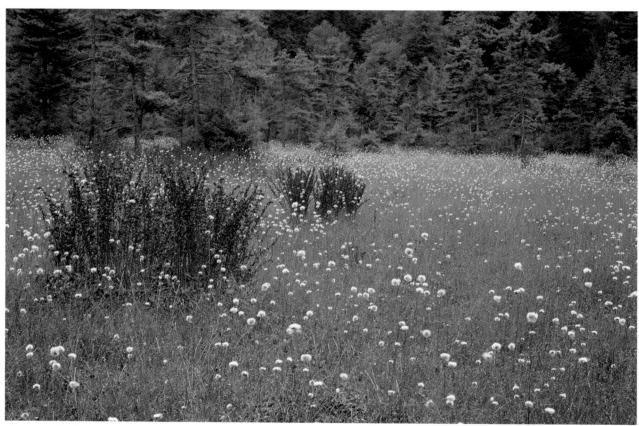

Cranberry Glades in Autumn – Monongahela National Forest

Cranberry Glades in Autumn – Monongahela National Forest

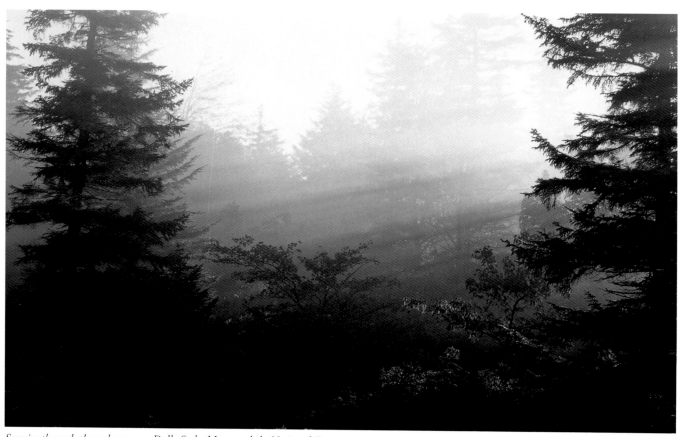

Sunrise through the red spruce – Dolly Sods, Monongahela National Forest

Thunderstorm looming over Dolly Sods – Monongahela National Forest

Following page: Boulder field – Dolly Sods, Monongahela National Forest

Barn in Early Autumn Morning Fog – Tucker County

"To the attentive eye, each moment of the year has its own beauty, and in the same field,
it beholds, every hour, a picture which was never seen before,
and which shall never be seen again."

—Ralph Waldo Emerson

Dawg Days

For late July, the weather has been phenomenal. Either global warming has slowed down or the Creator has given us a reprieve from the late summer doldrums. Instead of hot temperatures, high humidity, and intense discomfort, we are blessed with mild temperatures, cool breezes, and lovely blue-sky days. During rainy days, temperatures dip into the 60's. We revel in a weeklong celebration of mildness. It's autumn in July.

Even the songbirds – goldfinches, wood thrushes, and field sparrows — continue to fill field and forest with song. And while I am not a superstitious person, every day the clouds have obscured the sun, it seems the soft "coo-coo-coo" call of the yellow-billed cuckoo becomes more noticeable. Legend suggests the cuckoo's call portends the advent of rain, and by golly, it has been doing quite a bit of that this week. The rain crow lives.

During my first jog of the week, a daring fox squirrel stands in a meadow, either cheering me to victory or wondering why such a pathetic looking creature is allowed outside. The squirrel stands on its hind feet, stretching as high as it can to get a better glimpse. As I get nearer, the squirrel scampers to the nearest clump of trees. I'm not a threat – I'm just not entertaining enough.

On the second day, along a more wooded stretch of my jogging route, a doe browses near the roadside, unaware of my impending arrival. I first notice her about one hundred yards away. My tired old legs work overtime to help me inch closer. I try not to exhale too hard and I succeed at getting even closer. She remains oblivious. As soon as I get to within 20 feet, she leaps up the hill, stops, and peers at me from behind a cluster of paw paws.

Paw Paw Fruit in Early Autumn – Jefferson County

On the third day, a thick-furred red fox strolls just ahead of me, reminding me of who the real winner would be in a race between a fox and a middle-aged jogger. The fox disappears into the cool recesses of the forest shadows. On the fourth day, a red-tailed hawk flushes from its perch in a tulip poplar. To see this bird is a most magnificent sight any day of the year. Finally, on the fifth day, a lone pileated woodpecker bravely scours a tree along the road while I pass by. A most regal creature if ever there was one, and a fitting end to the week — a week's worth of distractions, a week's worth of memories.

The seasons of the Appalachians are filled with surprises, from the explosive profusion of colorful wildflowers in the spring, to the extraordinary feat of bird migration in the spring and fall, to the quiet solitude of winter. During my years exploring the Appalachians, I discovered three more seasons – the "seasons of in-between," which are the

transitions between summer and fall (August and September), fall and winter (November and December), winter and spring (February and March). Where one season's influence subsides, the other season takes over. Let's take a stroll through these seasons. (The transition between spring and summer is rather subtle, so I'll forgo a description of that one.)

August-September:

Late August in the eastern panhandle of West Virginia. On this summer morning, the full moon is setting in the west. In low-lying areas, sheets of fog pass over the landscape. As the morning warms and the fog lifts, a blue sky is revealed.

Once the temperatures rise, cicadas fill the woods with their pulsating, raspy buzz. Crickets are finally getting some airplay as well. With the avian chorus diminishing this time of the year, the insects' trills, buzzes, and chirps are more noticeable. Still, an occasional melodious chant from an indigo bunting, or the monotonous drone of a red-eyed vireo, or the sudden "KRREEP" of the great-crested flycatcher can be heard. Most birds, however, make plans for their trips south, fueling up and adding to their fat reserves to sustain them during their journey, which they will make within a few weeks. For once, amore is not on the minds of our fine-feathered friends.

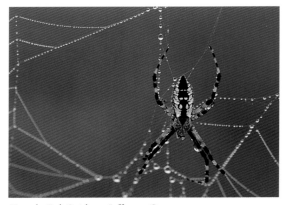

Female Orb Spider – Jefferson County

Throughout the countryside, dew-laden spider webs glisten in the meadows. Gossamers float effortlessly in the light morning breeze. Every stalk of grass has been used for anchoring thousands of the spiders' intricate handiwork. The webs are not as noticeable when the sun is behind me. But viewed with the sun in front of me, it appears the meadow is completely covered with them, an insurmountable gauntlet for the unsuspecting flying insect.

As the day warms, tiger and zebra swallowtails, meadow fritillaries, and monarch butterflies flutter around the road edges and meadows. Where a puddle of water collects on an old dirt road, a convention of clouded sulfurs and cabbage whites gather to soak in the precious fluid. At a small pond, a few croaks and plunks from leopard and green frogs can be heard. Water striders dart across the pond's surface, while dragonflies such as the eastern blue darner and the common skimmer zip back and forth above the pond. Flocks of swallows – barn and tree – swoop and dive over pond and field in search of insects. When not performing aerial assaults, they congregate in mass on the telephone lines along the highway, a sure sign their migratory urges are heating up. There's activity aplenty this late August day.

The forests take on a new appearance. The rich luster of the leaves on every tree has faded into a more weathered look. Sycamores along the Potomac River look ragged and worn. Their once verdant green leaves appear to have been sandblasted. Oaks, hackberries, and box elders show signs of wear and tear, as well; galls and egg cases of various insects coat the undersides of their leaves. For trees not forlorn in appearance, the dramatic transformation from summer's green to autumn's color has begun.

Leaves of walnut and spicebush have turned yellow – an early tease of the wonderful extravaganza that is autumn in the Appalachians. With their leaves a blush red, staghorn and winged sumac have initiated their costume change, too. The ripened fruit of paw paw hangs heavy from the branches. Soon, the fruit's sweet fragrance will disperse through the autumn forest. Redbuds are also overburdened with their fruiting masses, and a few tulip poplar leaves, already light yellow in color, drift down from their high perches in the canopy. At this time of the year, everything is a little worn, a little sluggish — and in the meadows and riverbanks, a little tall.

In the abandoned fields and along roadsides, blankets of goldenrod dominate. Unkempt clusters of yellow wingstem grow in profusion in scattered openings along the trails. In one field, the yellow-flowered wingstem reaches heights of more than nine feet, serving as cover for four white-tailed deer whose presence is revealed when the lanky stems sway back and forth. Joe Pye weed towers over all the other late summer flowers along the stream banks. Queen Anne's lace and pokeberry are no match. The other gangly latecomer, ironweed, colors the abandoned fields with its purple majesty.

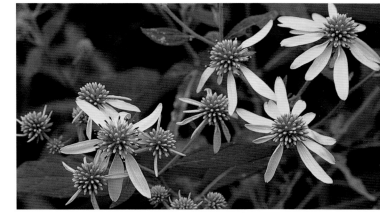

Wingstem – Seneca Rocks, Monongahela National Forest

With abundant late-summer rainfall, jewelweed covers the shaded portions of the roads and riverbanks. Yellow-drenched pale jewelweed envelops selected portions of the shaded cut banks along a country road, while thickets of orange-dipped spotted jewelweed flourish along the shorelines. Bees and ruby-throated hummingbirds explore every flower. The aerial scuffles between the hummers keep me entertained while I wait for just the right moment to snap the shutter on a composition of jewelweed. With dewdrops lingering on the lower petals, every flower becomes a great subject to capture on film.

For the animals, this is the time to relax, gorge, and for the youngsters, to celebrate their independence. A groundhog, fat and sassy from a summer of feeding, stands sentinel in a field. Eastern cottontails, especially the youngsters, have become more daring, venturing forth along the woodland edges to feed. Fawns kick, jump, and dash. As a father of an energetic four-year old boy, I understand why these young whitetails like to expend so much energy. For both youngsters, deer and child, it's a great feeling being fleet of foot. Squirrels, both gray and fox, busy themselves with gathering hickory nuts for the upcoming winter season. Perched on

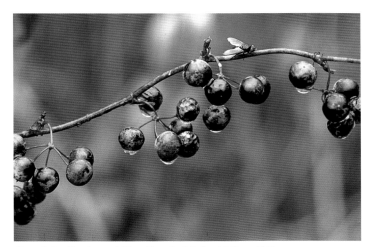

Greenbrier Berries and Fly – Berwind Lake, McDowell County

a snag in the field, a pair of kestrels, absent during the peak of summer, survey their hunting grounds.

The mornings have a tinge of cool air, but enough humidity collects by midday to remind us summer is still here. In the afternoon, rain clouds hover overhead. The sky becomes darker and the temperatures cooler. A light breeze rustles the leaves on the grand red oak outside my office window. Within minutes, a little drizzle starts,

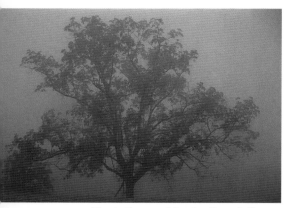

Tree in Summer Morning Fog – Jefferson County

creating a tapping rhythm as each raindrop strikes the oak leaves. The dull sheen of each leaf transforms into a shiny, reflective pool of water. The drizzle becomes a bit steadier, and before long the storm arrives, gently but firmly soaking the ground with much needed moisture.

In spite of the rain, crickets continue chirping and a single male eastern bluebird rides out the storm perched on a dead branch of the sycamore tree. In the distance, the "tick-bird, tick-bird" call of the male scarlet tanager can be heard. I don't see him, but from past observations I can imagine his dazzling deep red plumage and jet black wings, a combination of color expected from birds in the tropics, not in the temperate hardwood forest of West Virginia.

Within an hour, the storm passes. The soothing patter of raindrops ceases, and for now the moment is calm, with only the incessant call of crickets breaking the silence. After the rain subsides, I stroll along the paths and trails outside my office. It's late afternoon and I'm itching to hear what nature has to say about this wet relief. Nature doesn't take long to inform me.

Blue jays in the distance converse with each other. In the shrubbery next to the trail, the hunger calls of a young chipping sparrow beckon the parents to attend to its immediate needs. The sharp "chip" of a female cardinal adds to the natural conversation. Above, a fish crow soars by and a flock of sunshine-yellow American goldfinches undulates at tree level. In the middle of a sycamore gallery, a lone yellow-billed cuckoo clucks. Although the peak season for breeding has past, the storm has tempted a few spring peepers to call out. Wishful thinking on their part, I think.

Joe Pye Weed – Berwind Lake, McDowell County

Once the sun disappears below the horizon, cool temperatures return. Katydids find the climatic conditions much to their liking, and their raspy cadence adds to the special character of these "dawg day" nights. At dusk, little brown bats explore the air space above the ponds. Along the river, a lone wood duck passes by, probably going to its favorite roosting site. Life proceeds even in the doldrums of summer.

November – December

November in the Highlands signals the passing of autumn; winter just moments away. On this November morning quiet prevails. No birds. No crickets. No sound. The landscape silently waits for change.

As the day matures, a gentle breeze nudges ground fog into the sycamore gallery along the river. The wind picks up, and within a few hours displays its persuasive mood with gusts that propel autumn leaves to the ground. Maple leaves drift softly to the earth, while the larger sycamore leaves tumble down with abandon. More leaves cover the ground than are left on the trees. Autumn's glory has now become history.

Banks of dark clouds loom over the horizon, hinting of rain. Although a few color drenched leaves still linger on lower branches, autumn's rainbow is fading fast. A more pastel and bare look takes hold. Within weeks, winter's palette of white, gray, and black will color the land. However, for now, autumn remains for one more day or two.

While winter's touch softly embraces the landscape, signs of autumn continue to hang on. Outside my office window, the few remaining leaves on the old red oak tree rustle in the breeze, their scarlet color still glorious when backlit by the morning sun. But the oak is now just a skeleton of its glorious summer physique. It still offers up a bounty of plump acorns, and a flock of blue jays are happy to gorge on them. With the oak nearly bare, I can now see the Potomac River.

On this balmy day, a flock of Canada geese wing overhead, heralding a change across the November sky. In the thick undergrowth, white-throated sparrows and juncos gather. Despite their restless activity, a lone male kestrel

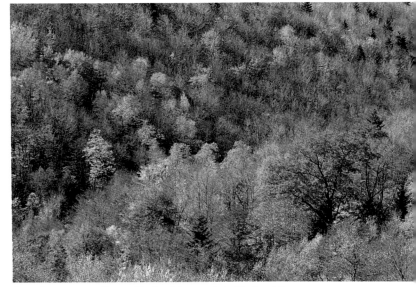

Late Autumn near Spruce Knob – Monongahela National Forest

perched on a snag tree above the thicket pays no mind to this potential prey source. A diminutive ruby-crowned kinglet searches for insects in the higher reaches of the trees, its location revealed only by its high-pitched call. A pileated woodpecker's sharp call betrays its presence in the forest. Along the forest edge, two white-tailed deer munch on honeysuckle. Milkweeds in the fields hang onto their silky-white seedpods. The next strong wind gust will disperse the seeds, leaving the pods empty of their precious cargo.

With less humidity in the air, the skies are a beautiful deep blue. Stunning cloud formations waltz across the autumn sky. Sunsets and sunrises become more dramatic. The mornings are colder and frost blankets the ground. At sunrise, the colors of dawn play on the ice rimming the pond, creating wonderful reflective abstract patterns. By late morning, winter clouds loom on the horizon. Eventually thin, gray-layered clouds cover the sky. The air smells of snow. The temperature drops. A flake here, a flake there. The biting chill of winter nips at us just enough that we keep our jackets and hats nearby.

With warm gloves, hat, fleece jacket, and a warm heart, I take a stroll into the woods. Finding a large log to lean against, I wait for the chickadees, titmice, and nuthatches to find me. It doesn't take long. I know these woodland clowns are busy finding something to eat, but the way they do it is entertaining nonetheless. Once the gang has moved on, I continue my hike.

The sweet aroma of a passing autumn permeates the air. With the exception of the chickadees, titmice, and nuthatches, the early winter woods are quiet today. There are subtle breaks in the silence – seasonal music – that speak of this time of year. A single leaf scrapes against a branch as a light breeze picks up speed. The leaf's "rat-tat, rat-tat" sound repeats over a course of minutes. Along the woodland edges, I hear the sound of rustling in the leaves. Is it a song sparrow or junco scraping the leaves for something to eat? Or is it just a single brittle stalk of goldenrod grating against a patch of snow? Whatever it is, it's music to my ears – music of the season.

My hike leads me out of the woods and onto a country road, where I watch an army of Isabella tiger moth caterpillars troop across the highway. My Mother calls these critters woolly worms, and mountain legend suggests the thickness of their "fur" forecasts the severity of the oncoming winter. From the look of these woolly worms, winter is going to be a cold one.

Every few feet, one, two, or three of these orange and black-banded trekkers are making time, determined to reach their destination, whatever that may be. Within a few days, when even colder temperatures prevail, only a handful of them will be brave enough to journey forth. With the onset of the first hard freeze, very few caterpillars will be seen. Even for the woolly worms, nature has hinted: winter is here.

In the higher elevations of the Highlands, persistent gray skies frame the horizon above and beyond. A cooling wind whispers the onset of winter. A light dusting of snow covers the ridges. In the forests, only the tan leaves of the oak and beech trees are left rustling in the breeze. The beech will win over the oaks in the battle of lingering leaf endurance. One can now actually see the forest for the trees.

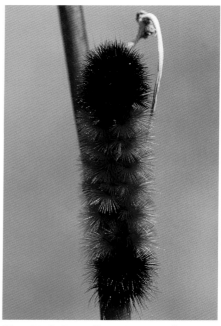

Further south in the mountains of my childhood home in southwestern West Virginia, tulip poplars stay clothed with leaves up to November. Most of the oaks and hickories retain their leaves as well. On a rich blue-sky day, the leaves glimmer. Looking up, I see the amber and rust-colored leaves shimmer with the slightest breeze. As the breeze turns into gusts, the sound of wind rushing through the trees makes one think a cascading waterfall is nearby. As the wind becomes constant, the leaves detach from the branches and gently float to the ground, leaving the trees bare.

Tiger Moth Caterpillar – Canaan Valley State Park

At night, stars sparkle against the clear dark November sky, echoing colder temperatures as autumn nears its end. Nighttime clouds with their silver edges glisten in the glow of the full moon. The glories of an autumn season are passing. Nature signals a change for the land, a good change. Stepping outside into the late autumn night, I hear flocks of songbirds pass overhead. I have no idea what species they are, but it's music of the season. A year has passed, and in a few months spring's rebirth will touch the land once again. But for now, the land rests and the birds fly.

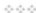

February – March

This is the season when the landscape sleeps, but the slumber is not deep. As the days lengthen and the temperatures rise, the land begins waking up, while its creatures become more active. Life is starting to stir just a little.

With a hard freeze the night before and a bright but chilly morning, the meadows and fields are decked with pendants of sparkling ice crystals. The sun's rays rake across the land, but winter is still here and the cold soaks into our bones. Strong gusts of frigid air move through the trees, and while the sun does warm our faces, we know spring is not here yet. Winter remains sovereign for a bit longer.

Little by little, the rhythm of life pulses into every mountain, every river, every valley within this primeval landscape. The search for activity is a bit challenging, but doesn't take very long. A quick trip to Berwind Lake in southern West Virginia and I'm off hiking along the trails and dirt roads discovering all sorts of icons of this in-between season.

First stop: a large American beech with faded tan leaves hanging on its lower branches. Although the colors are faded, they contrast nicely with the background of dark brown and gray. The leaves must be making a statement to the harshness of the winter season — they persist in spite of it.

Continuing on my hike, I discover a bed of Christmas ferns, which are the only rich green colors seen on the forest floor. Soon they will be overshadowed by a multitude of greenery from the foliage of other ferns, shrubs, and flowers.

Near the lake shoreline, I photograph intricate bite mark patterns on a maple tree gnawed by the local beaver family. On the lake's northern section, at its widest point, a pair of hooded mergansers rests in the center of the water. Crows continually patrol the lake for something to eat and along the southern end, where the beavers have impounded the stream flowing into the lake, two does dash into the forest. In the distance, a pileated woodpecker lands on a large snag tree on the eastern slope. With the trees bare, this is the season for catching glimpses of this forest emperor.

Beaver Cuttings – Berwind Lake, McDowell County

With winter's demise and spring's emergence, the blue skies appear bluer and the white clouds whiter. From a continual somber palette of white and gray, the rising spring season is slowly bringing freshness to the world. Winter still holds a grip on each day, but slowly it releases its firm hand, allowing spring to seep back into the mountains.

At day's end, the night arrives a little later. Sunset clouds glow and then fade with the darkness. With the night air still crisp, clear, and cold, the clouds again glimmer in the presence of the full moon. Hang on. Spring is just around the corner.

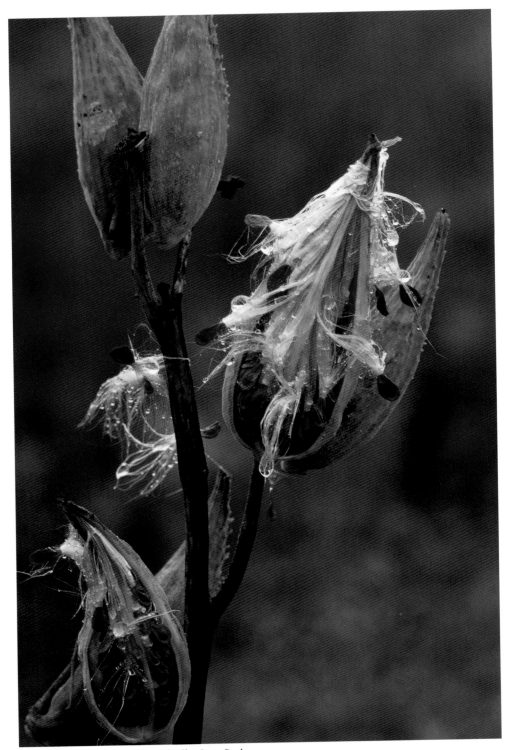

Milkweed in Autumn – Canaan Valley State Park

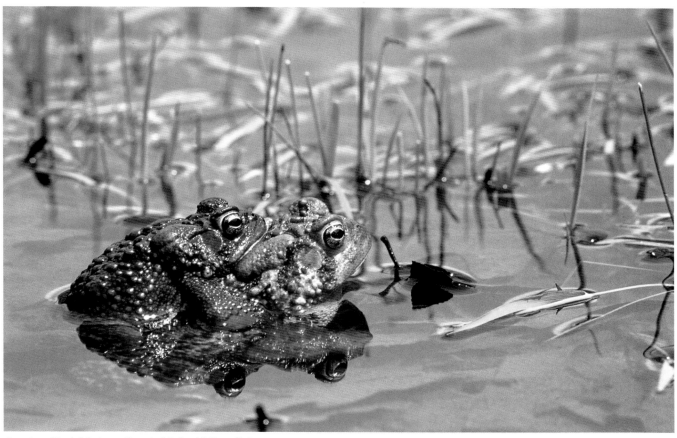

American Toads Mating – Berwind Lake, McDowell County

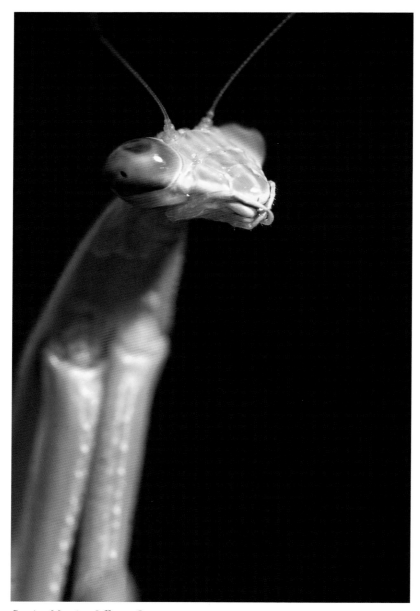

Praying Mantis – Jefferson County

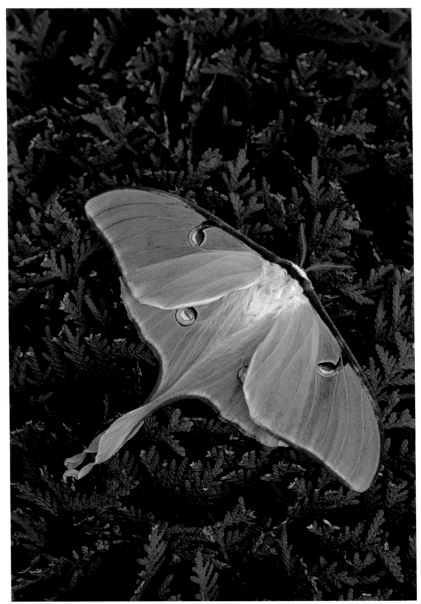

Luna Moth – Jefferson County

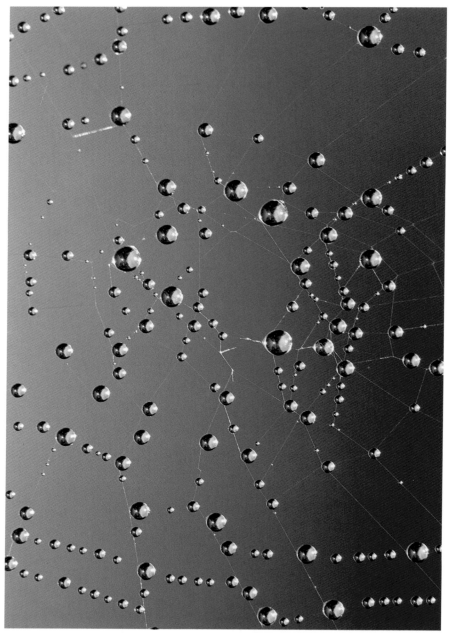

Morning dew on spiderweb – Berwind Lake, McDowell County

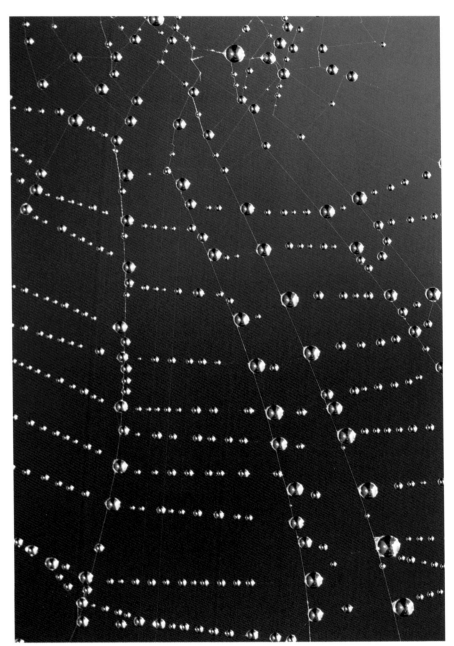

Morning dew on spiderweb – Berwind Lake, McDowell County

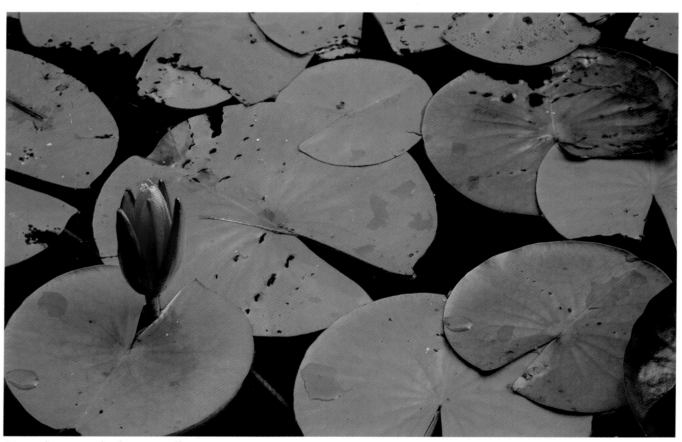

Water Lily – Berwind Lake, McDowell County

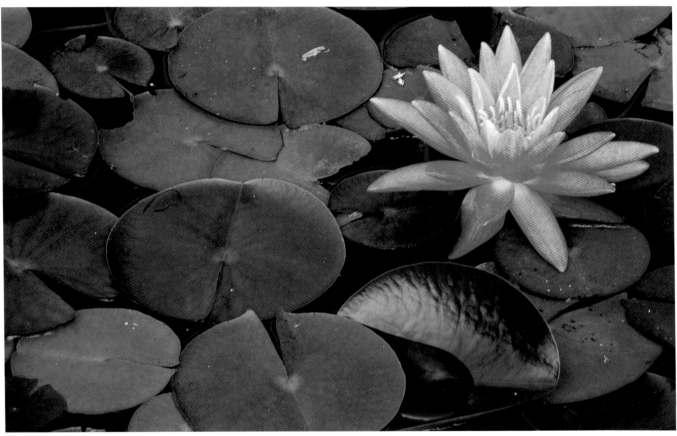

Water Lily – Berwind Lake, McDowell County

Spotted Jewelweed – Berwind Lake, McDowell County

Dogwood Fruit in Autumn – Seneca Rocks, Monongahela National Forest

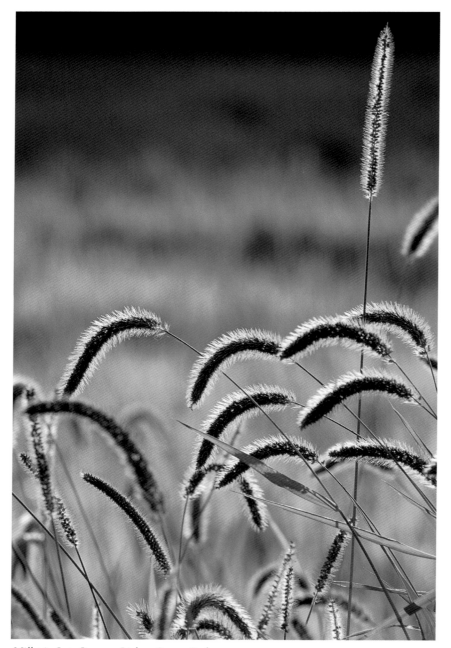

Millet in Late Summer Light – Seneca Rocks

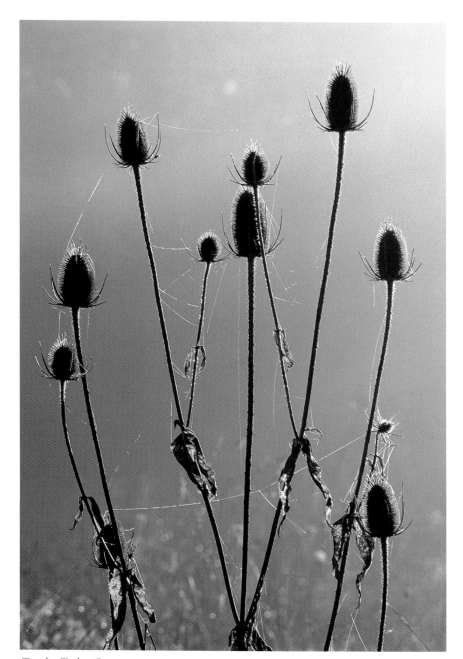

Teasel – Tucker County

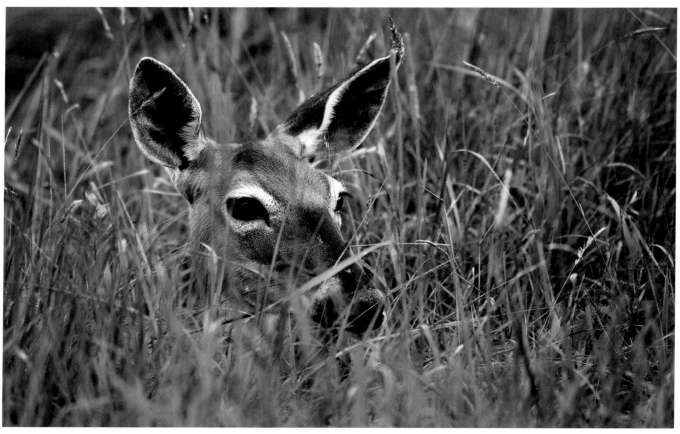

White-tailed Deer – Canaan Valley State Park

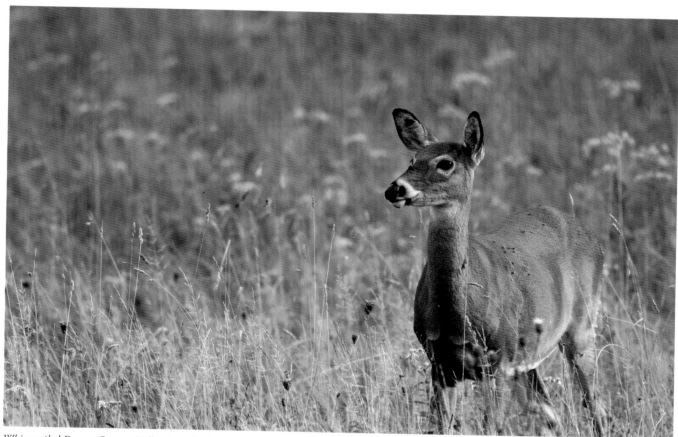

White-tailed Deer – Canaan Valley State Park

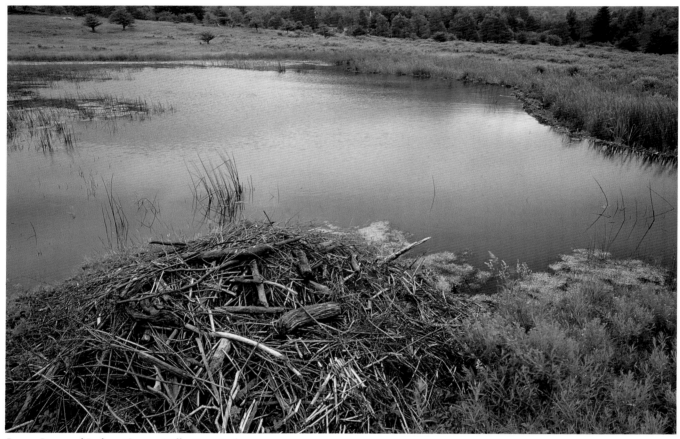

Beaver Dam and Lodge – Canaan Valley State Park

Beaver Cuttings – Cranberry Glades

Following page: Vista from the Mountain Institute along road to Spruce Knob

163

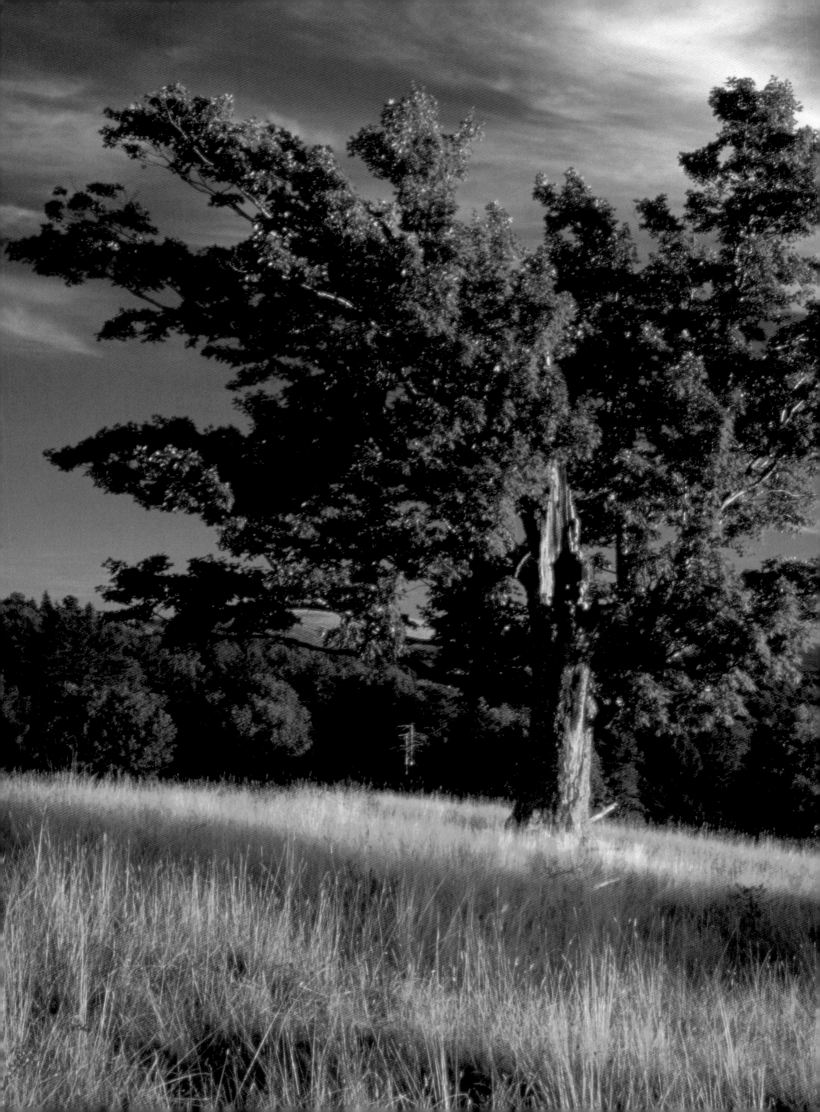

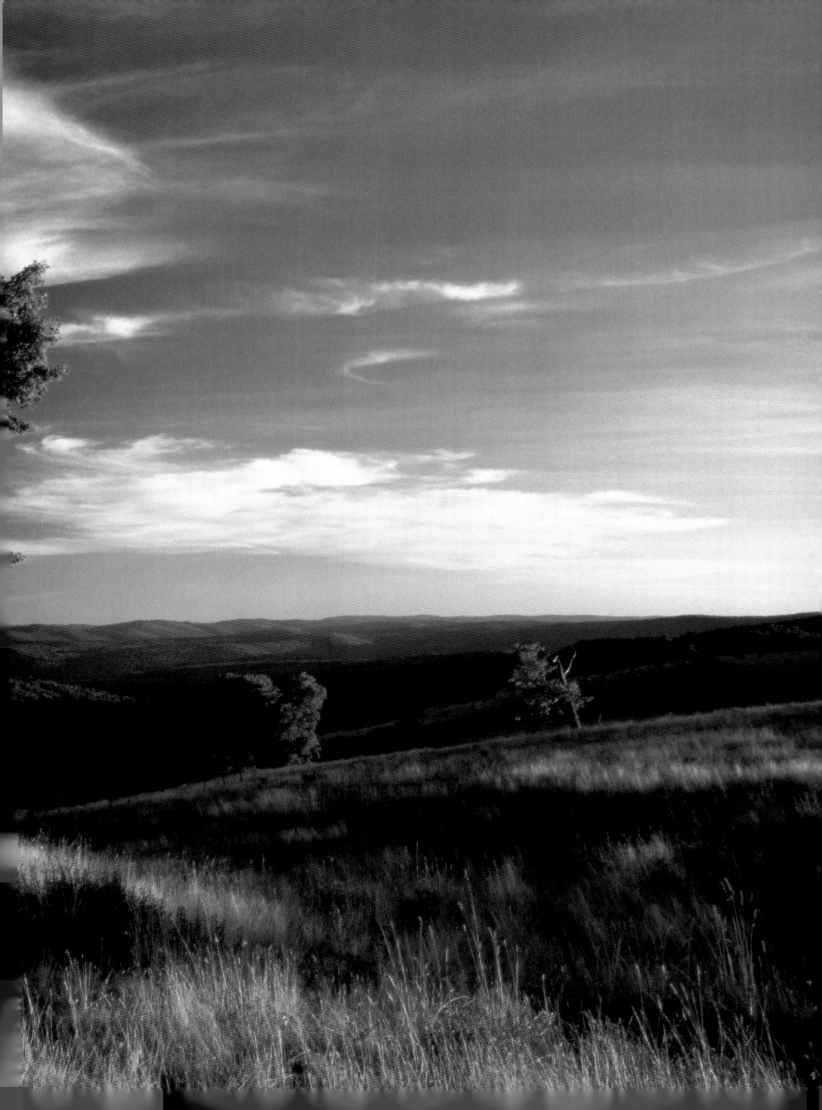

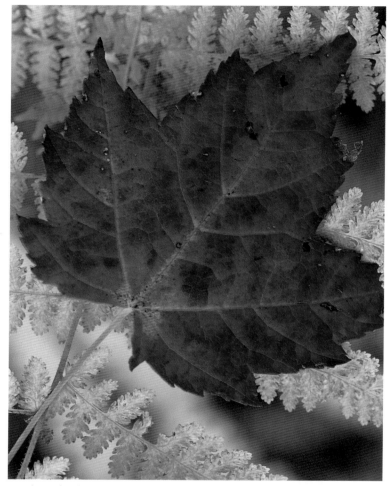

Maple Leaf on hay-scented fern – Cranberry Glades, Monongahela National Forest

"Autumn is a second spring when every leaf is a flower."

—Albert Camus

Kaleidoscope

October has arrived in the highlands of West Virginia and it's a kind of autumn morning that makes you think nothing can get any better. Soft, gray clouds float along the high ridge tops. Trees bordering the highway are edged with color. Within days, the mountains will transform into a rich tapestry of red, orange, and gold.

Light mist softens the sun's rays and raindrops hang like sparkling trinkets on the goldenrod along the roadside. The sun plays hide and seek with the clouds as it peeks above the horizon. The clouds win.

Along the Highland Scenic Highway above Marlinton, West Virginia, the sun completely disappears and a heavy fog swiftly drapes the landscape. A delicate but persistent drizzle softens the scene into a pastel watercolor. Monet in the Appalachians.

Although the fog limits my visibility, there is no mistaking what's ahead. Just a mile from the Cranberry Mountain Visitor Center, I watch an oversized black bear lumber along the road. Sheets of moisture-drenched fog drift in and out of the landscape as the bear fades like a spirit into the forest, only to re-emerge a few seconds later. I watch for several minutes as this majestic bruin disappears and reappears from the forest. Ghost bear.

Autumn in the Blackwater Canyon – Tucker County

Driving closer to where it has entered the forest, I pull over hoping to get one more glance of the phantom. But no such luck this morning. It has entered the forest for good and that's okay with me. Just by chance, the wind tears a hole in the clouds and a single shaft of light breaks through where I last saw the bear. I just count this as another magical moment during a most magical season of a most magical place. Another Mason jar memory.

❖❖❖

Poet William Brown wrote, *"There's no delight such a season can bring, as summer, fall, winter, and the spring."* In West Virginia, as in all of the Appalachians, this especially rings true. Winter is cloaked in a subtle decorum of snow and ice, while spring replenishes the earth with colorful displays of woodland flowers. Summer's natural mysteries are framed by sunny, warm days and cool, breezy nights. And autumn, well, let's just say for most of us mountain folks, this is the season when the rugged and beautiful Appalachian landscapes make the human spirit soar.

Whispers of an autumn breeze always ignite my yearning to go outside. Soaking in the season's sweet aromas makes me reluctant to go back inside, while the autumn colors extending to the horizon create a welcomed visionary overload. Autumn intoxication is a nice — and healthful — addiction.

Autumn casts a magical spell over the Appalachians, covering the mountains and valleys with a parade of colors. Native American legends say the constellation Little Dipper is upside down in autumn to allow the season's motif to pour down from the sky, decorating the trees with blazing reds, sparkling yellows, brilliant golds, and flaming oranges. Not only magic, but pure mountain magic.

Maple Leaves in Autumn – Monongahela National Forest

Surrounded by an extraordinary kaleidoscope of colors, my eyes experience a sensory celebration. From the gold luminance of sugar maples to the scarlet glow of sumac, the cavalcade of colors autumn paints on these mountains rivals the fall displays found elsewhere in North America. But an Appalachian autumn is more than colors.

Autumn offers so many Mason jar memories you may need more than one jar to capture them. A few of mine:

Invigorated by the fragrance of autumn leaves, I engage my child-like curiosity while hiking a trail at Watoga State Park. Exploring the hardwood forests of the Potomac River shoreline in early September in the eastern panhandle of West Virginia, I savor the sweet aroma of paw-paw, its golden yellow leaves a stark contrast to the fading green of the surrounding trees.

Photographing at Dolly Sods, I watch clouds of monarch butterflies – splashes of sunlight floating above me – gather on milkweeds. Along the narrow, dirt road that rides the ridge, my friend Bill Campbell and I enjoy watching a male ruffed grouse ruffling his "ruffs" and fanning his tail feathers to impress two reluctant, but intrigued hens. From the hens' initial reaction, he has a bit more convincing to do.

I photograph abstract color patterns mirrored on the surface of the Williams River bordering the Cranberry Glades backcountry in Pocahontas County.

Near the summit of Spruce Knob – the highest point in West Virginia – on an overcast autumn day, a persistent mist kisses my face as I watch a nomadic flock of cedar waxwings wander the edges of a red spruce forest. The stillness of the morning is broken only by an occasional croak of a lone raven. The moment is serene on the top of the world. Soon, the skies darken as swirls of turbulent clouds drift in. The heavens open up and the light mist becomes a steady downpour sweeping across the landscape. Once the clouds are drained, the rain subsides, transforming the downpour back into a light mist. The fog starts lifting, slowly drifting in and out of every nook and cranny of the rocky terrain. The sweet fragrance of maple, beech, and birch saturates the moist air. A light breeze stirs the leaves. The waxwings resume their roaming and the raven returns to keep me company.

Autumn has barely started in other parts of the state, but the fall colors have peaked in Canaan Valley. Bill Campbell and I sit on a knoll overlooking an active beaver dam. The sun slowly dips toward the horizon. With our cameras off and tripods folded, we sit, watch, and listen, soaking in what we've been capturing on film for nearly a week. As the sun sinks into darkness, the water's surface turns red. Two beavers silently appear, swimming back and forth to investigate us. Their silhouetted movements create soft ripples that slowly lap upon the shoreline. From the north, a lone wood duck glides to a landing on the eastern edge of the dam, near a stand of bulrush. Beyond the wetland, a song sparrow and northern yellowthroat break the silence with their song, their melodies most likely a tune-up for next spring's breeding season. A flock of Canada geese — we count twenty — flies overhead, making a circle around the pond before landing on the western edge. They seem convinced, as the other critters are, that Bill and I pose no threat. We both are thankful for that. Two more woodies soar over from the north and land, followed within minutes by a few more. All total, more than thirty wood ducks take refuge in the beaver dam. Without a single image taken, we capture more memories for our Mason jars.

While exploring a red spruce forest along the Highland Scenic Highway, I hear what sounds like someone tossing rocks from the reaches of the highest spruce. Upon further investigation, I discover a very determined red squirrel busy gnawing red spruce cones from the branches and letting them plunge to the forest floor. The cones smack against the autumn leaves covering the ground. It's early autumn, and this squirrel is preparing its cache for the winter months ahead.

Autumn Leaves (Maple) — Coopers Rock State Forest

If you have never experienced an Appalachian autumn, I invite you to take time to explore this most glorious season, in West Virginia or any other region of the Appalachians. Each region is special, with its own palette of colors, aromas, and sights. And remember, there is more to autumn than colorful leaves. For me, autumn in West Virginia also heralds the season of woodland elves, winged sunshine, and blue boldness, known by others as chipmunks, monarch butterflies, and blue jays.

❖❖❖

Autumn marks the collecting season of the eastern chipmunk, that nervous, inquisitive, and fast-paced little critter of the hardwood forests. From their constant clucking call to their never-ending scurrying across the forest floor, these diminutive denizens of the eastern forests are hard to ignore. And who would want to ignore them?

From late August through October, chipmunks keep busy making final preparations for winter. They are most active at this time of the year and they don't mind offering a comment or two to any human intruding into their territory. The chipmunk's call might not strike you at first, but after some time, its continuous, non-wavering warning grabs your attention. Their call may be mistaken for the clucking of wild turkey. Wildlife photographer Leonard Lee Rue, III describes the call as a "beating of a miniature anvil by a forest elf."

The beech-maple and oak-hickory forests of the Appalachians are favorite domains of the chipmunk. Its preferences are open deciduous woodlands with a nice understory and a mixture of stumps, logs, and rocks – the more the better in terms of security and perch sites. Edges between forest and field also offer desired places for the rodent. Unfortunately for many chipmunks, they like the edges along country and dirt roads, too. With their frenetic pace during the fall, many end up as road fatalities.

As winter approaches, the chipmunk begins gathering food to store in its elaborate burrow system. Hickory nuts, acorns, and maple seeds, along with mushrooms and insects, comprise the chipmunk's primary diet. The rodent comes equipped with expandable cheek pouches that allow it to collect a sinful amount of food to carry back to its den. One biologist discovered 32 beechnuts in one chipmunk's cheek pouches. Another biologist uncovering a chipmunk's burrow found more than 300 acorns in one storage chamber alone. A chipmunk can never have enough food for the winter.

Within their underground system of tunnels, the chipmunks carve out storage bins to cache food. The chipmunk's underground home also includes a sleeping room and toilet. These are not only tiny rodents, but tidy ones, too. With such an elaborate, custom-built underground home, you would think the chipper would be content hibernating throughout winter. But such is not the case.

Although they stay underground during the cold winter months, chipmunks are not true hibernators like groundhogs. Chipmunks do not accumulate as much fat as their larger cousins, so they subsist on the stored food. Instead of hibernation, they go into a deep sleep, what biologist call torpor. If the outside temperature warms up a bit, the chipmunk rouses from its sleep to munch from its cache or to take a peek outside. Even if the days remain cold, the chipmunk will wake every eight to ten days to feed.

Chipmunks also undergo a period of relative inactivity during mid-to-late summer. During these hot periods, they opt to estivate, the summer counterpart of hibernation. They go into a deep sleep, and once the temperatures cool, they wake and become active once again. But lucky for us, during the most colorful of all seasons, the chipmunk adds another entertaining dimension with its exploratory behavior. In me, they have a captive audience.

Wispy clouds race in the brisk autumn wind. The clouds move swiftly over the 4,000-foot plus ridgeline of Dolly Sods on this late September day. Looking up, I see scattered slices of orange and black confetti grace the brisk, blue sky. Monarch butterflies are winging south.

The orientation of the mountains in the Ridge and Valley Province of the Appalachians provides excellent navigational assistance for millions of migrating songbirds and raptors. But they also serve as a pathway for the monarch. As fragile as these alluring creatures are, the tribulations associated with this migratory gauntlet fail to deter them from reaching their wintering haunts in the high forests of central Mexico. For a creature weighing less than half a gram, completing a 2,500 mile trek is just part of the deal.

Butterfly experts are not sure whether monarchs migrate at night or only during the day. Temperatures are, however, a factor; anything less than 55 degrees Fahrenheit is probably too cold to get them going. Considering the distance they can travel, however, leads one to assume they travel both day and night. Monarchs normally travel between fifty and ninety miles in a day, and on a good day they have reportedly covered as much as two hundred miles. More amazing, no monarch ever completes the round trip from their northern homes to their southern hangouts and back. A full life for a monarch is measured in months, not years.

An average of four generations separate monarchs spending one winter in Mexico from those migrating there the next winter. A female hatching in the northern Appalachians begins migrating in August, arriving in Mexico a few months later. There, along with millions of other monarchs, she seeks refuge in the mountain forests of oyamel fir and pine.

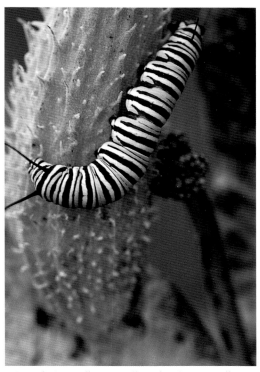

The monarch become restless by February, and beginning in March the journey north commences with the female laying eggs on milkweeds along the Gulf Coast before finally dying. She will never see her northern home again. Once hatched, her offspring will continue the migration north, laying more eggs along the route. The cycle is then repeated.

The eggs hatch in four days, and after ten to fifteen days of feeding on milkweed, the caterpillars form their chrysalis. Within this beautiful soft green and gold-flecked environment, the monarch resides for another ten to fifteen days until it emerges into a full-fledged butterfly.

Having not made this journey before and with no elders or older siblings to show them the way, how do they do it? Is it through their sense of smell? Are they guided by magnetic fields? Or could it simply be magic?

Monarch Caterpillar on Milkweed – Canaan Valley State Park

Most butterfly experts believe monarchs navigate this remarkable journey by magnetic fields. The connection comes through biosynthesis, when, as larvae, the monarch acquires magnetite they get from the milkweed they consume. Of more than one hundred milkweed species, the monarch prefers only a dozen or so.

The monarch is not exempt from a clear and present danger to its existence. Scientists estimate between 100 and 500 million monarchs start the autumn migration each year, but only 60 to 300 million reach Mexico. Starvation, weather, and predation take their toll. Once at their wintering haunts, monarchs are further subjected to loss of habitat. The trees they prefer for roosting are disappearing due to logging and firewood gathering. Pesticides constantly threaten the monarch's survival. Genetically engineered grain may be producing toxic pollen lethal to the butterfly. Even the capture of monarchs by collectors and for weddings and other special events can add to the problem. Life is not easy for the monarch.

For most, no finer butterfly exists. In summer's warmth, watching these insects softly glide across a sun-drenched meadow and gently alight on a flower is a never-ending delight. Like autumn colors, a fall day in the Appalachians would not be complete without monarchs gracing the autumn sky. Every autumn, I'll continue anticipating watching these flying jewels flutter in the skies above Dolly Sods.

When thinking of the colors defining an Appalachian autumn, red, orange, and gold come to mind. With the exception of a clear autumn day, blue doesn't seem to be a color symbolic of fall. Or is it?

For me, blue is indeed a primary autumn color, and it isn't the deep rich sky. The blue comes from that captivating azure-colored critter of the oak-hickory forest: the blue jay. Blue boldness. And in my book, one cool bird.

After living a solitary existence most of the year, by September blue jays become gregarious, wandering the forests and mountains as a collective force. Whether searching for food or just harassing hawks and owls they encounter along the way, these flocks remain content in fall to explore the forests together.

Every autumn in my hometown, I could count on the increased activity and raucous calling of blue jays. I remember watching a flock of jays fly over my home, their calls resonating across the narrow mountain valley. Beginning on the valley's east side, the flock aimed for a gallery of sycamore trees on the riverbank located on the west side. After exploring the gallery, the jays would again take flight and continue roaming up the mountainside. Although they vanished from sight after entering the forest, their constant calling would reveal their presence.

Most townsfolk considered the blue jay a criminal of the bird world – a robber of eggs. In reality, this outrageous activity accounts for a small percentage of their diet. The jay's preferred food consists primarily of acorns, beechnuts, and seeds, with insects such as grasshoppers and beetles thrown in. The jay may be of mischievous intent, but in sustaining itself, it is simply an opportunist. Aren't we all? No matter how we opine on the negatives of this creature, the blue jay remains one lovely sight. And it is a master of its own destiny.

The blue jay plays a role in maintaining the oak-hickory forest ecosystem. During autumn, the jay deposits so many acorns in the ground, there is no way it can find every one. Through their absent-mindedness they create and perpetuate their favored habitats for future generations of jaybirds. They are truly Johnny Appleseeds, only with wings.

As noisy and irreverent as resident blue jays can be, migratory flocks of jays remain eerily quiet. During the early days of autumn, I have witnessed hundreds of jays winging silently over the heath bogs of Dolly Sods. They have a job to do, and I suppose talking among themselves is not going to help. But like the woodland elf and winged sunshine, the blue jay adds another dimension to the wonders of an Appalachian autumn.

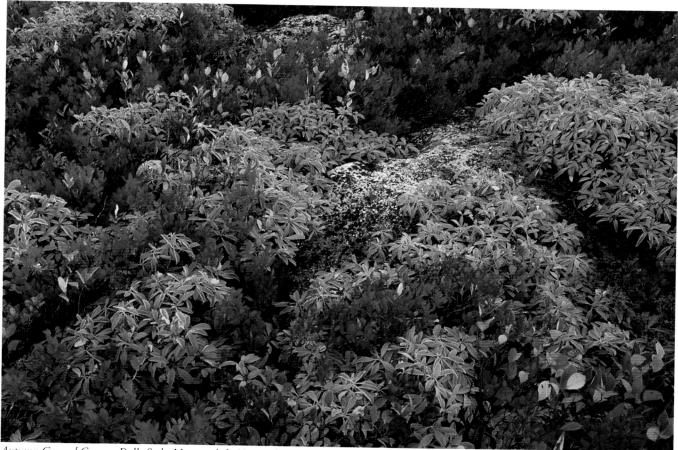

Autumn Ground Cover – Dolly Sods, Monongahela National Forest

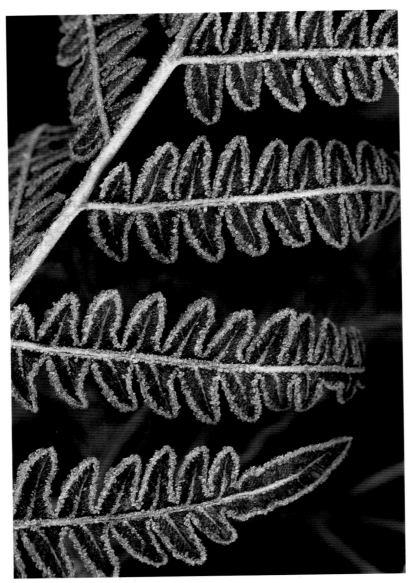

Autumn Morning Frost on Fern – Blackwater Falls State Park

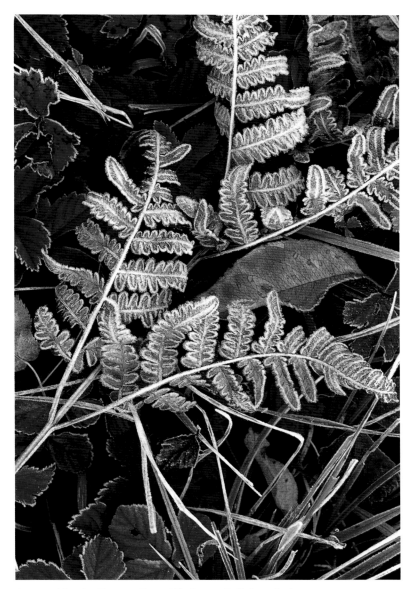

Autumn Morning Frost on Fern – Blackwater Falls State Park

Dew Drops on Red Maple Leaf – Monongahela National Forest

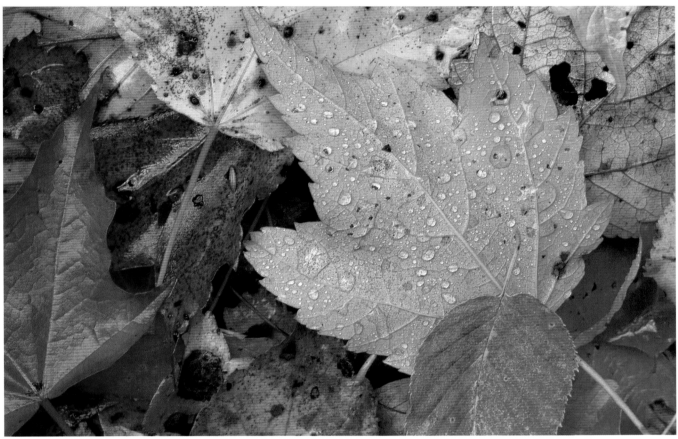

Autumn Leaves – Blackwater Falls State Park

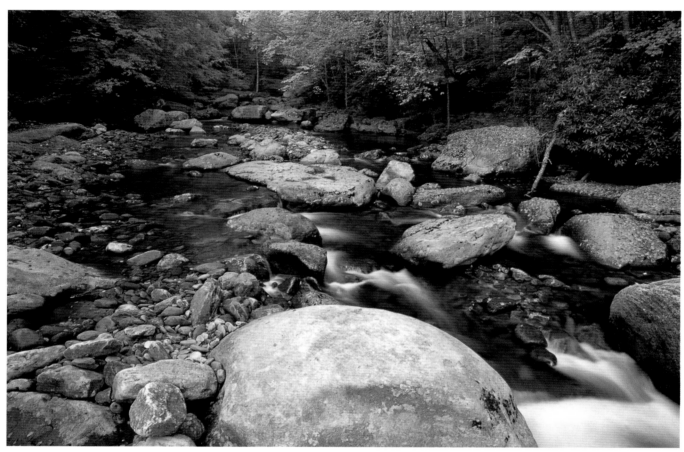

Otter Creek in Autumn – Otter Creek Wilderness Area, Monongahela National Forest

Otter Creek in Autumn – Otter Creek Wilderness Area, Monongahela National Forest

Following page: Sugar Maple Leaf and Mushrooms – Cranberry Glades, Monongahela National Forest

Autumn Morning – Dolly Sods, Monongahela National Forest

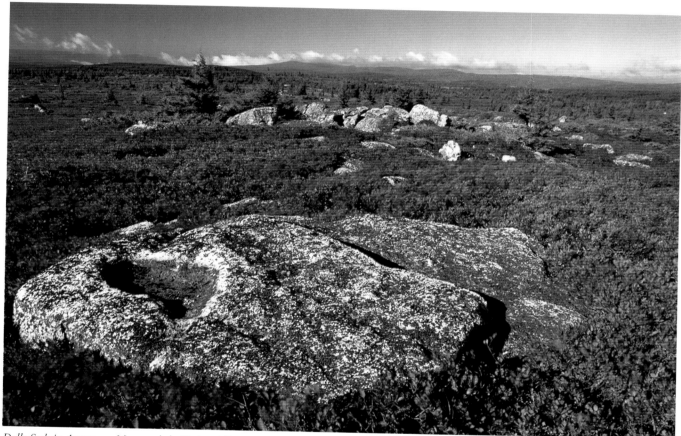

Dolly Sods in Autumn – Monongahela National Forest

184

Autumn Colors – Spruce Knob, Monongahela National Forest

Autumn Colors – Spruce Knob Lake, Monongahela National Forest

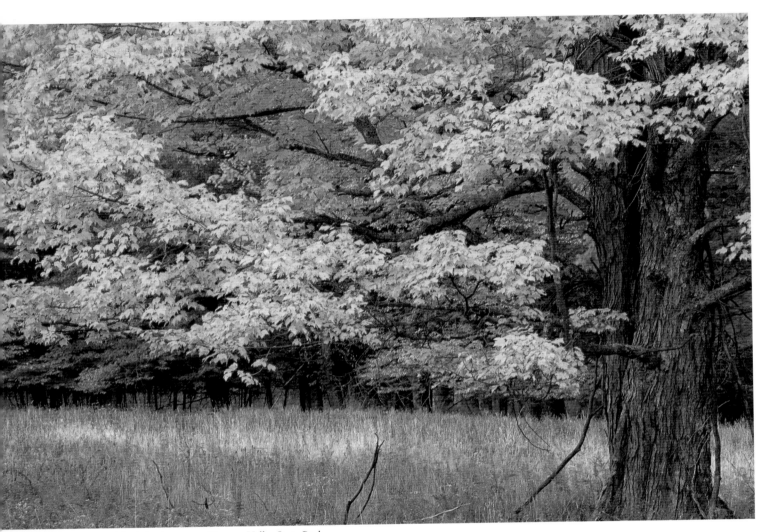

Sugar Maple in Autumn – Canaan Valley State Park

187

Maple in Autumn – Canaan Valley State Park

Autumn Scene at the Mountain Institute near Spruce Knob

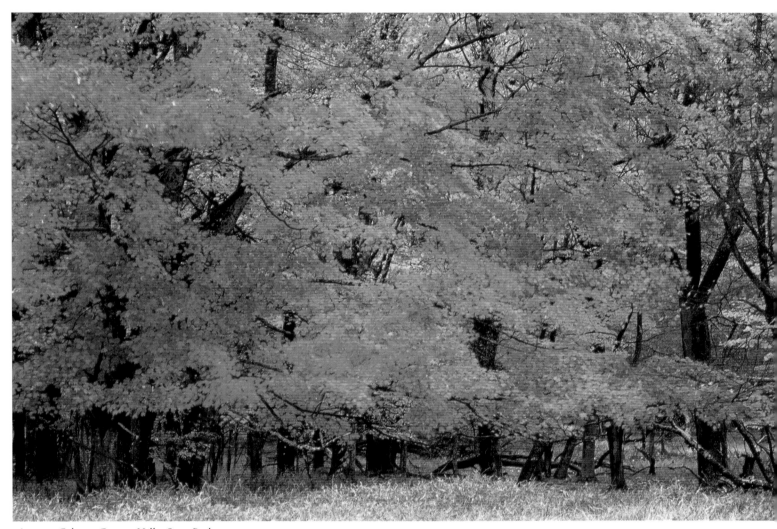

Autumn Colors – Canaan Valley State Park

Following page: Beaver Dam – Canaan Valley State Park

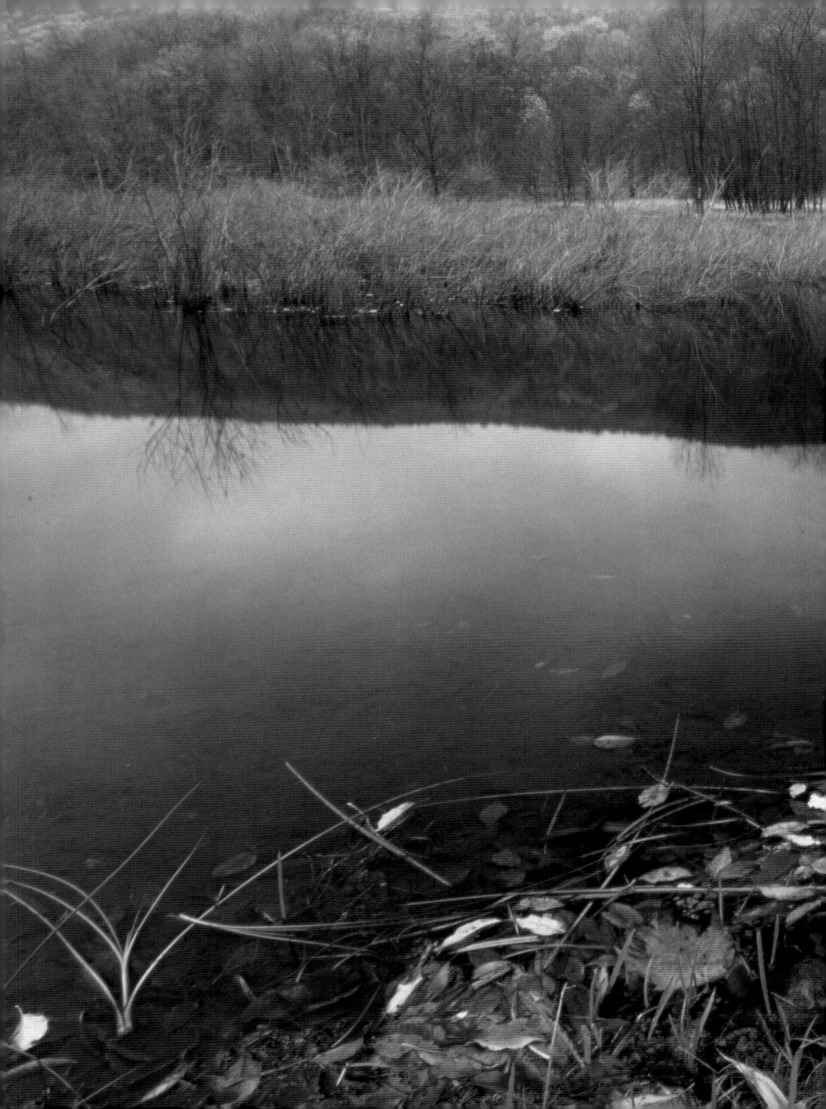

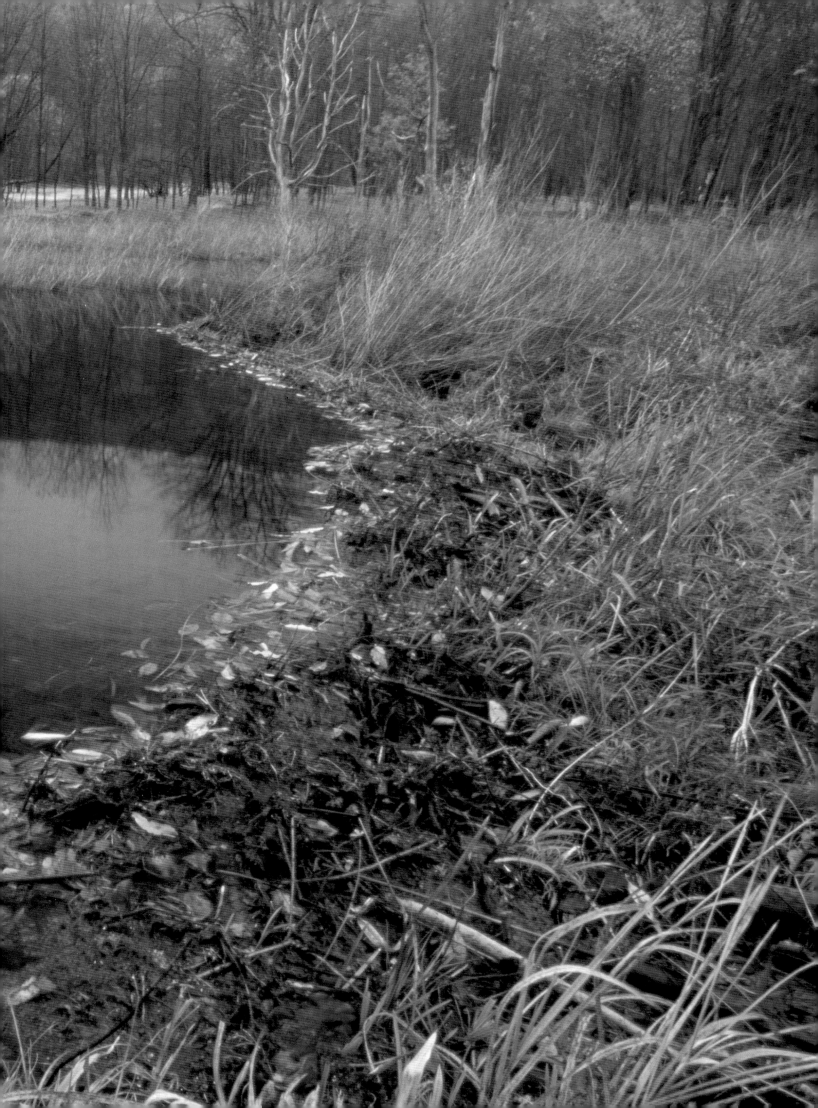

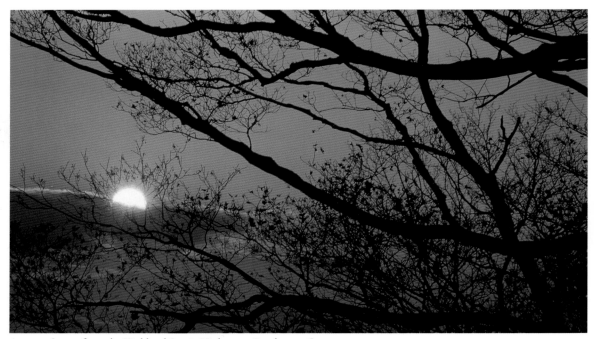

Autumn Sunset from the Highland Scenic Highway – Pocahontas County

"The oldest task in human history: to live on a piece of land
without spoiling it."

—Aldo Leopold

Ridgelines & Mountaintops

For my friends and myself growing up in southern West Virginia, the mountains continually beckoned us to scale their steep, rocky slopes. They challenged us to expend every ounce of energy and strain every muscle in our bodies in hopes of discovering some hidden treasure just on the other side.

Of course, finding the treasure would be only one of the challenges. Reaching the top remained the most formidable test. Mustering the motivation to even start the journey was a close second. But once we agreed to tackle the mountain, then only the degree of slope kept us from reaching the top. And degree of slope never deterred a group of determined young boys.

This particular stretch of the Appalachians is especially ancient – thin soils, steep slopes, and exposed rocky cliffs attest to their age. All of these characteristics became impediments in our efforts to reach the top. The thin soils ensured unsteady footing, causing us to take two steps backwards for each step forward. The steep slopes tested not only our physique, but our fortitude and perseverance as well. And once the summit was within reach, more than likely a steep-walled cliff face presented one final hurdle. When confronted with this challenge, we depended upon each other to find the quickest, but not necessarily the safest, route up or around the cliffs. We never thought before-hand whether or not the route chosen would be the best route to take when leaving. That would be something to worry about later. We were too focused on reaching the top.

Not to our surprise, instead of hidden treasures, what lay before us once we reached the summit was another ridgeline or summit, or a deep valley covered with oak and hickory. No diamonds or rubies, no treasure chest. But it really didn't matter to us. We had found our own treasure.

Satisfied about what lay on the other side, we would find a comfortable spot on a rock outcropping or cliff and soak in the vistas beyond and below. We watched turkey vultures soar, occasionally swooping below the cliff's edge. We were in no hurry to head back down, so those times on the cliffs became the place for us to solve the world's problems. Often the sun dipped below the horizon before we even entertained the notion of leaving.

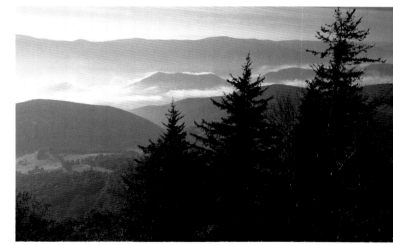

Autumn Morning from Spruce Knob – Monongahela National Forest

Regardless of how often we climbed those mountains, we always thirsted for more summits to scale. The reward, we soon discovered, was in the journey, not the destination. The true treasures – learning how to overcome the

challenges and to work together to reach a goal – would become helpful in our adult lives. Our growing wisdom was fueled by our insatiable wonder for life.

Ridgelines and mountaintops gave us treasures not of gold and silver, but of spirit, inspiration, and confidence. We always figured mountaintops and ridgelines were created for climbing, that they would be here for a lifetime. We never imagined mountains could be removed. But they are disappearing from this landscape at an alarming rate. Mountains are vanishing from the Appalachians of the mid-Atlantic region. What happens when there are no mountaintops to climb? What keeps our children's imaginations alive?

"Mountains are earth's undecaying monuments." Nathaniel Hawthorne

Thomas Wolfe wrote, "Nature is the one place where miracles not only happen, but happen all the time." Sadly, the miracle of one of God's creations – the mountains of the heart, the Appalachians – has been needlessly assaulted. Ridgelines and mountaintops are disappearing from southwestern West Virginia. We are losing our mountains, our spirit.

In West Virginia, Pennsylvania, and Kentucky, mountains have become fodder for others' insatiable hunger for coal. I have often seen bumper stickers that read, "Almost level, West Virginia." Who would have ever thought that completely removing the tops of mountains would be tolerated or recognized as an acceptable practice? As a native son, I'm very saddened by this.

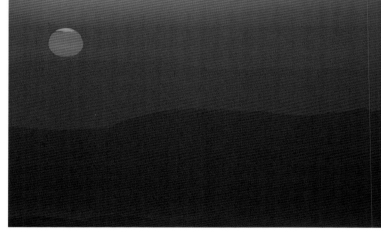

I am disheartened to see that my home state, the "Mountain" state, is having its very soul leveled. The spirit and heart of these ancient hills is quickly disappearing with nary an afterthought from those doing it. Rip it up, take it out, and move on. The tops of the mountains are viewed as expendable, and have now become waste spoil for the valleys below, choking and killing streams and rivers, and creating health and safety hazards for the residents.

Sunrise from Dolly Sods – Monongahela National Forest

Mountain communities are now threatened with their very survival by this attack on the landscape. The creatures of the forest, from salamanders to bears to songbirds, are losing their homes as well. Mountaintop removal has become the latest form of the resource exploitation that has been happening to West Virginia since it entered statehood 140 years ago. The state has become a sad commentary on the reckless mistreatment of our nation's natural heritage. I am thankful there are portions of the state protected from such destruction, but there are areas of West Virginia I would not want others to see. I would be too embarrassed.

Exploitation. For West Virginia, exploitation is viewed as progress, at least until the industry decides it has had enough. After extracting what it can from the land, it leaves everything behind, including enduring poverty for those who labored to extract the resources. Exploitation has become part of West Virginia's legacy.

From 1880 to 1920, nearly every mountain slope in the state was stripped of its forests. Then mining moved in and took control. After the strip-mining craze of the sixties and seventies, mountaintop removal became the preferred and cheaper method for extracting coal. This destructive process makes strip mining look tame, and the name describes exactly what is done. With a few massive pieces of dirt removing equipment, the mountaintop is completely removed, with the residue dumped in the valley below. Not only mountains and forests are destroyed but also the rivers and valleys.

Mountaintop removal is taking away the very reason folks come to West Virginia. Politics, money, and lack of vision seem to be the primary culprits, and these culprits have been here for a very long time. Decisions to explore diversifying industry or creating better business opportunities seldom surface. Where I grew up, mining was the one and only game in town. No one dared challenge King Coal. This attitude still prevails, despite the downturn in mining jobs in southern West Virginia.

After the mines closed and the companies left, the communities were left to fend for themselves. We were on our own. The younger generations, including myself, left to find better opportunities elsewhere. With outside interests controlling our fate, the state's motto, "Mountaineers are always free," held false promises.

Although West Virginia is the nation's second-highest coal-producing state, the coal industry accounts for only three percent of jobs in the state – from 140,000 in the 1940s to fewer than 15,000 today, with further decline inevitable.

More than 300,000 acres of West Virginia's mountains have been leveled and more than 1,000 miles of streams covered or destroyed. Massive coal-slurry impoundments threaten communities downstream. Waterways are polluted, destroying the once-abundant aquatic communities. Heavy metals leach into the soil, contaminating groundwater. Noise pollution, dust, and vibrations from explosions break windows and shake the foundations of homes.

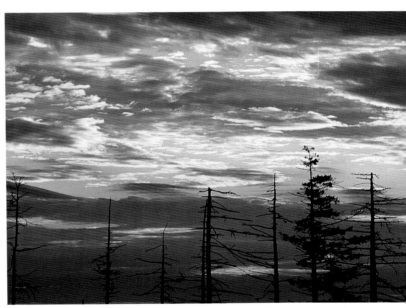

Autumn Morning on Snowshoe Mountain – Pocahontas County

A mountaintop removal site appears as desolate as a moonscape. But on the moon, you expect no life to exist; here, where the mountains once flourished with neotropical migratory birds, salamanders, wildflowers, and lush hardwood forests, there is nothing. Below the mountains, where once thriving communities of fish and other aquatic life existed, there is nothing. Majestic mountain summits no longer grace the horizon. Is this any way to treat our elders?

I have yet to see a postcard, poster, or greeting card extolling the beauty and wonder of a mountaintop removal site. If these activities are not threatening to our livelihood, to our wild places, and to our spirit, then why are they not proudly displayed in commercial venues? Where are the fine art prints or framed photographs of the damaged valleys, debris-filled streams, and crownless mountains?

While photographing at Babcock State Park a few years ago, I met a coal-mining executive who was there to get away from the pressures of his job. What irony I thought, a man who rips mountains from the earth for a living, but needs a clean mountain stream to fish so he can get away from the pressure of his job. The man expressed his disdain with "them environmentalists." "All we are doing," he explained to me, "is taking off the top of the mountain and placing it somewhere else."

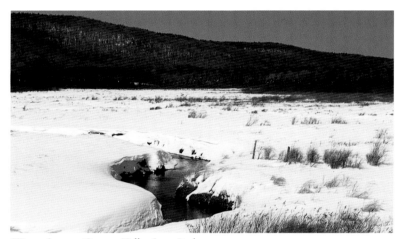

Winter Scene – Canaan Valley State Park

He continued, "The landscape we create is in fact better than what it was. We make better wildlife habitat. The grasslands we create provide excellent habitat for deer and turkey. We make these mountains better than how God made them. West Virginia doesn't have enough flat land anyway."

The coal companies make the land better than what God made. Was this arrogance to proclaim that coal companies are more knowing and powerful than the almighty Creator? In my mind, if the mighty Creator – and I mean God, not the coal companies – wanted to have mountains with flat summits and grasslands on them and polluted streams and rivers, the Creator would have done so a long time ago, not wait for a coal company to do it.

The only wildlife this coal official could say benefited from mountaintop removal was deer and turkey. No mention was made of the many species of songbirds, of the warblers, thrushes, tanagers, and orioles. No mention of the woodland salamanders dependent upon the eastern deciduous forest for their survival. No mention of the many species of native fish that are being choked out by the valley fills. Deer and turkey are so abundant that creating more habitats for them is not a benefit any more. What about the chipmunks, box turtles, insects, and hundreds of other forest-dwelling species dependent on these mountains, including their tops, to survive? Studies have shown these artificial "mountain grasslands" are even devoid of deer and turkey. Soil conditions and other ecological processes are so marred that little hope exists for these sites to ever become productive again.

My heart will always stay in West Virginia. My hope is that the wisdom and common sense of the good folks of West Virginia and neighboring states will finally prevail, allowing them to take charge of their destiny. I hope we forgo dominance of the landscape, and instead forge a partnership with it, to be wedded to the future and not shackled by the past. My hope is that my son will not live without mountains.

"The mountain cannot frighten one who was born on it." J. C. Friedrich von Schiller

Wherever the place that captures your heart, from the snow-capped summits of the Rocky Mountains to the mysterious bald cypress swamps of South Carolina's lowcountry, to my beloved mountains of West Virginia, I hope it instills in you a sense of place. I hope it ignites your own sense of curiosity. For me, this is what the Appalachians mean.

The spirit of our country has been molded by its connection to the land. The sight of a wild creature, a stunning sunset, or an awe-inspiring vista fortifies the human spirit; it affirms in our heart that something is indeed right with the world.

Wildness. Beauty. Solitude. Are they worth it? For me there's no doubt they are. I'm sure the millions of others who have had nature touch their hearts would agree as well.

For those who can listen in wonder to the call of a wolf or become excited watching a red-tailed hawk soar above the trees, it is maybe second nature to understand the connection of all living things to one another. For those amused by the antics of a

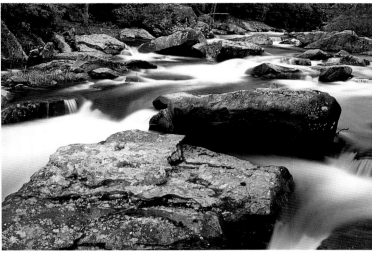
Glade Creek in Late Autumn – Babcock State Park

reddish egret chasing its dinner through a marsh or who can marvel at the fragile arrangement of dewdrops on a spider web, life remains a mystery, an infinite source of wonderment and fascination. These individuals remain inquisitive as to what lies on the other side of the lake, or over the next mountain ridge, or around the next bend of the trail.

For those experiencing a chill of anticipation while canoeing on an unknown wildland lake or for those longing for the haunting calls of a barred owl during a cool spring evening, there remains an unquenchable thirst for understanding all that surrounds them. But there is also satisfaction in knowing that this thirst will never be sated. The human spirit becomes stronger by its relationship to all wild creatures and to the land. So here's to all things natural, wild, and free. Let them forever remain a source of mystery and enchantment to us. May they always share our world.

"Bye bye geese. Night night. See you tomorrow." Carson James Leopold Clark – 2 1/2 years old

As I embark on my journey into the inner sanctum of West Virginia's highland regions, I patiently wait for nature to whisper its most intimate secrets to me. I'll be listening and ready for anything, to embrace the moment like a friend who has been gone for years. These mountains will surprise you. They will excite you. They will humble you.

For a lifetime I have been on a quest to discover a true sense of place in the Appalachians. These mountains of the heart have captured my heart, and like a seductress they ignited my love for life. I always leave a mountain with a bit of sadness – my heart longs for another hour, another day, another moment to walk its ridgelines, to sit along its river banks, and to watch the sun rise and set over layers of smoky-gray summits. The Appalachians remain a continuing source of curiosity for me, and every discovery I make enhances my sense of wonder, creating another path to discovering a sense of place. Here's hoping for more wonders to be found. And like Carson James Leopold Clark, my son, I look forward to tomorrow.

198

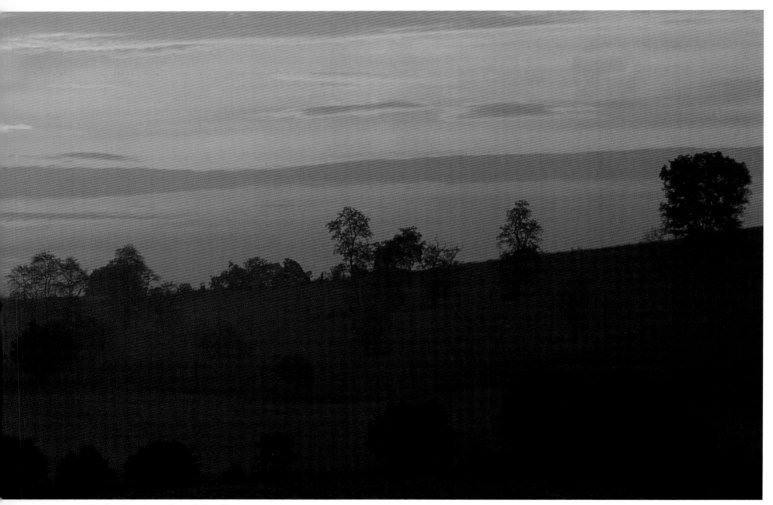

Spring Sunrise – Greenbrier County

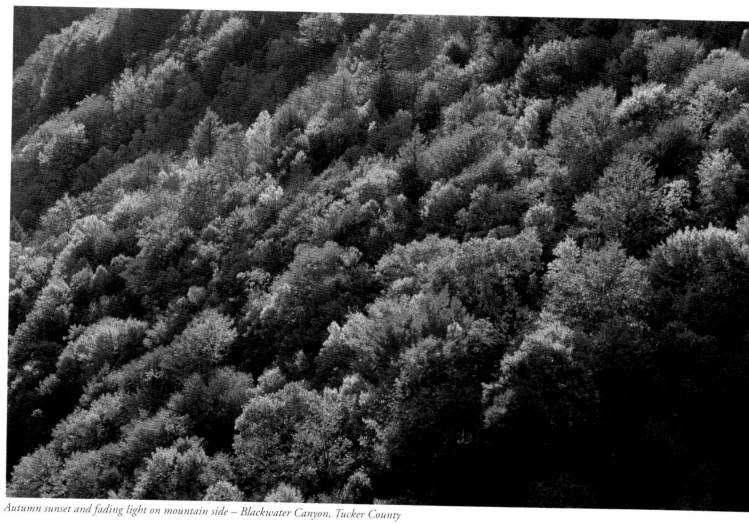

Autumn sunset and fading light on mountain side – Blackwater Canyon, Tucker County

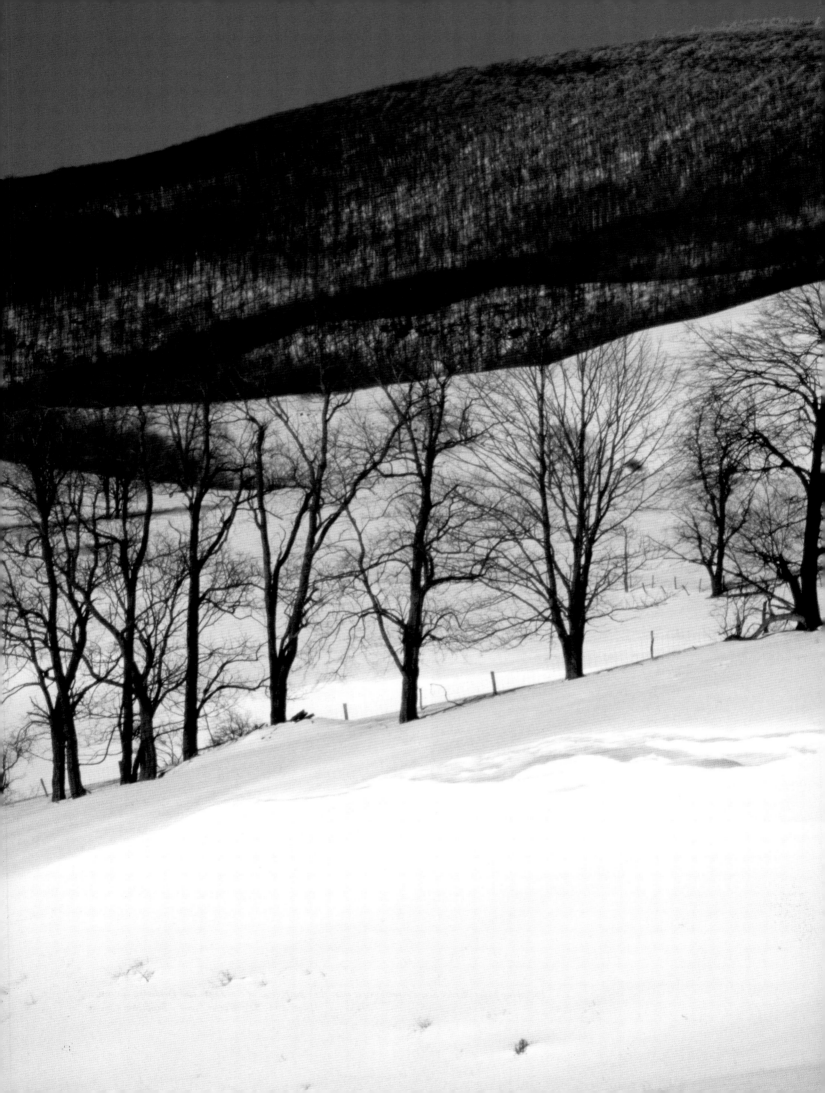

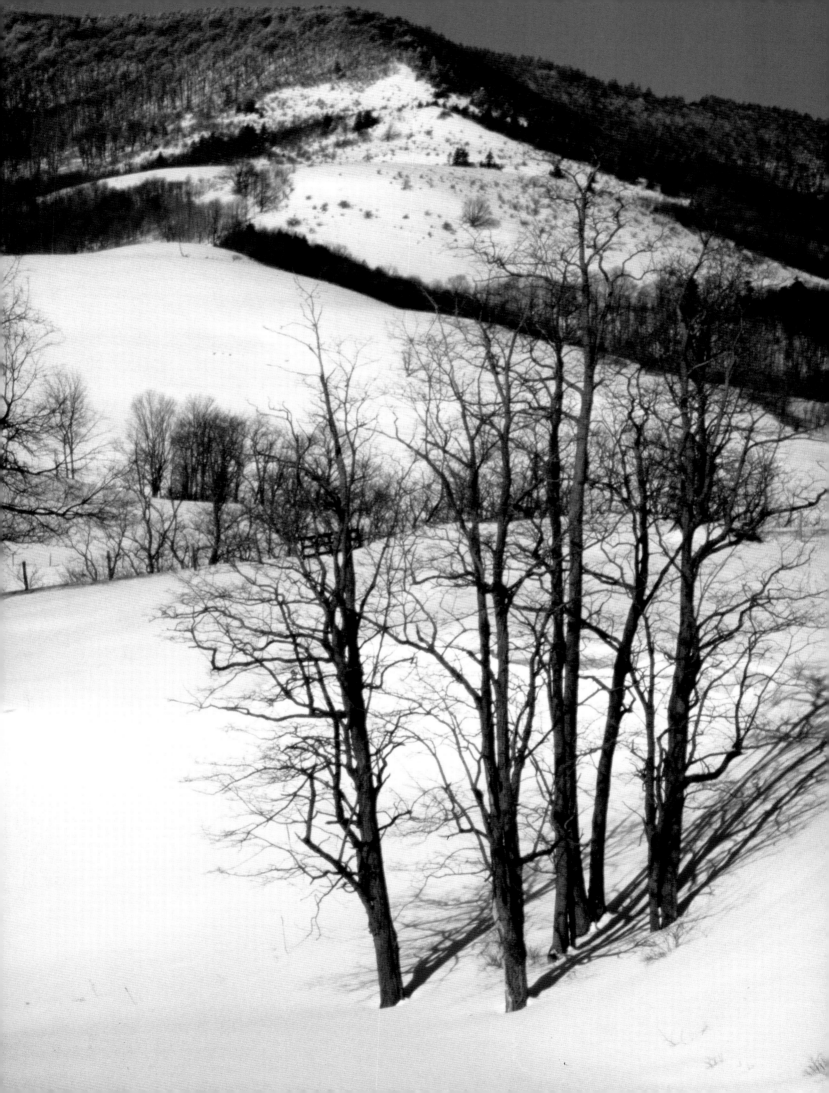

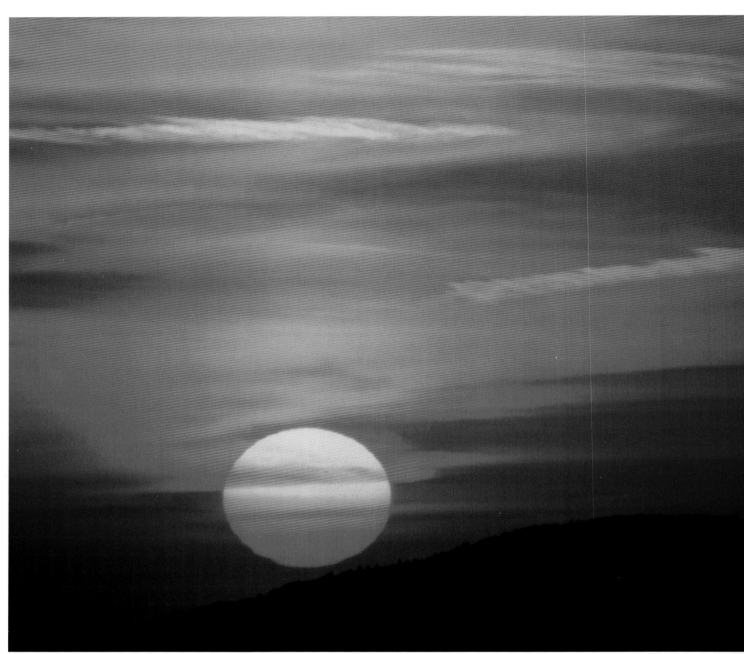

Sunset from Spruce Knob – Monongahela National Forest

Following page: Moonrise over Seneca Rocks – Monongahela National Forest;
Pages 210–211: Autumn Morning on Spruce Knob – Monongahela National Forest

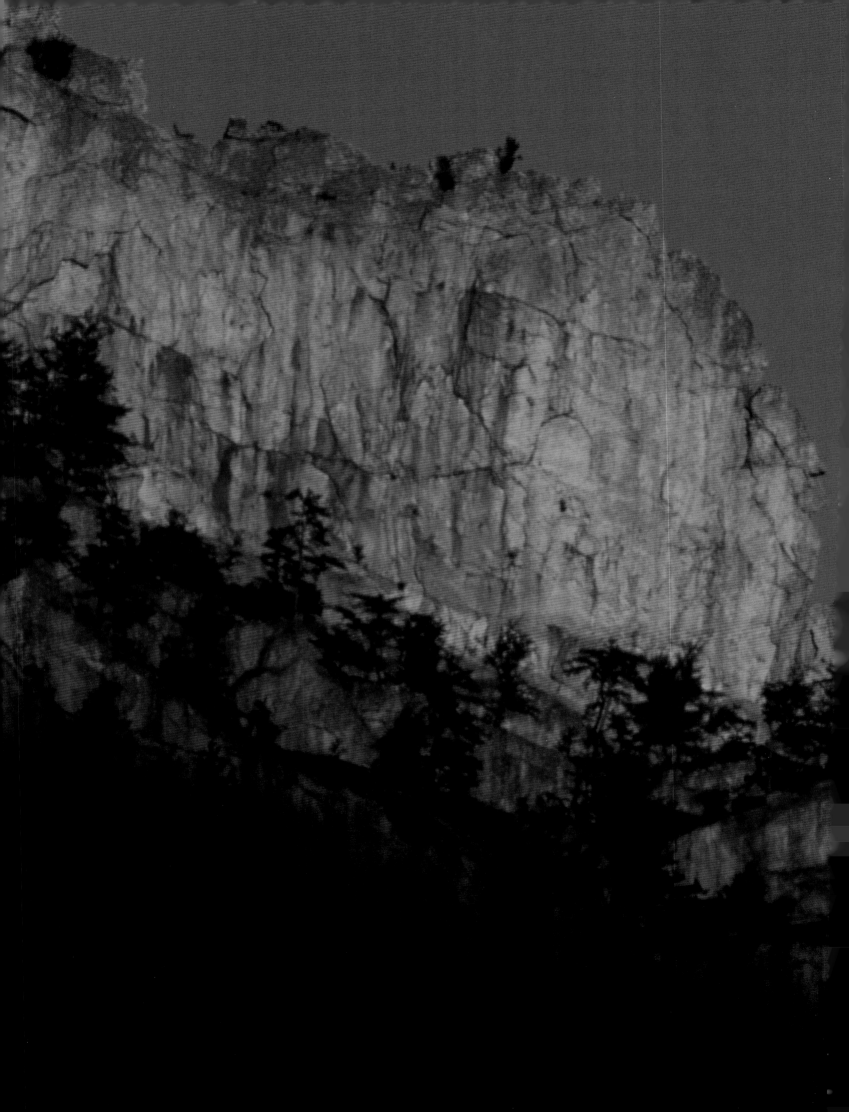

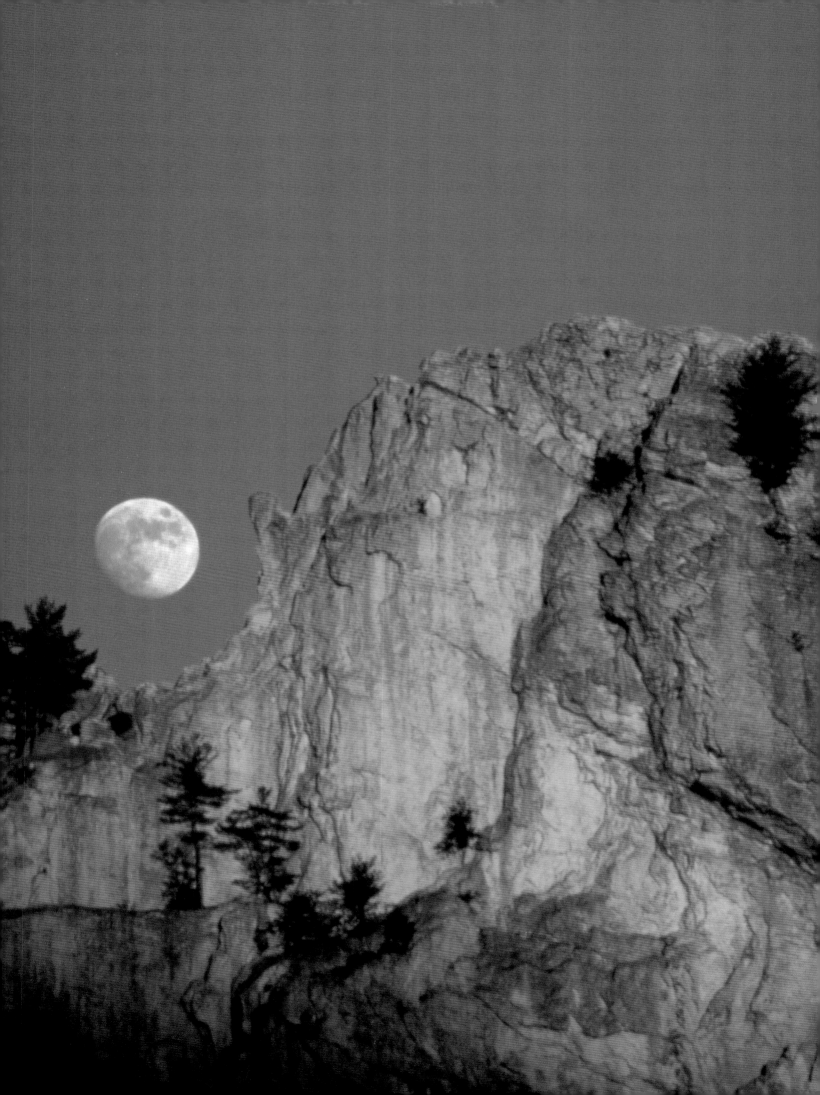

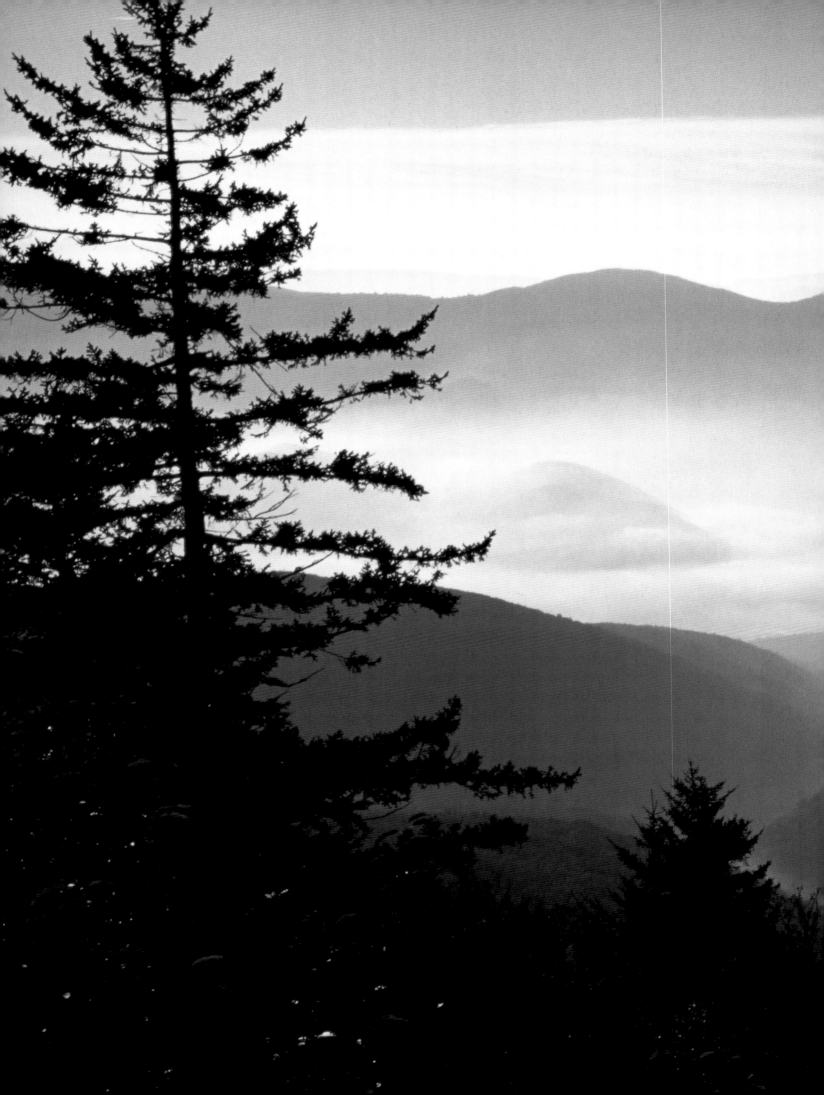

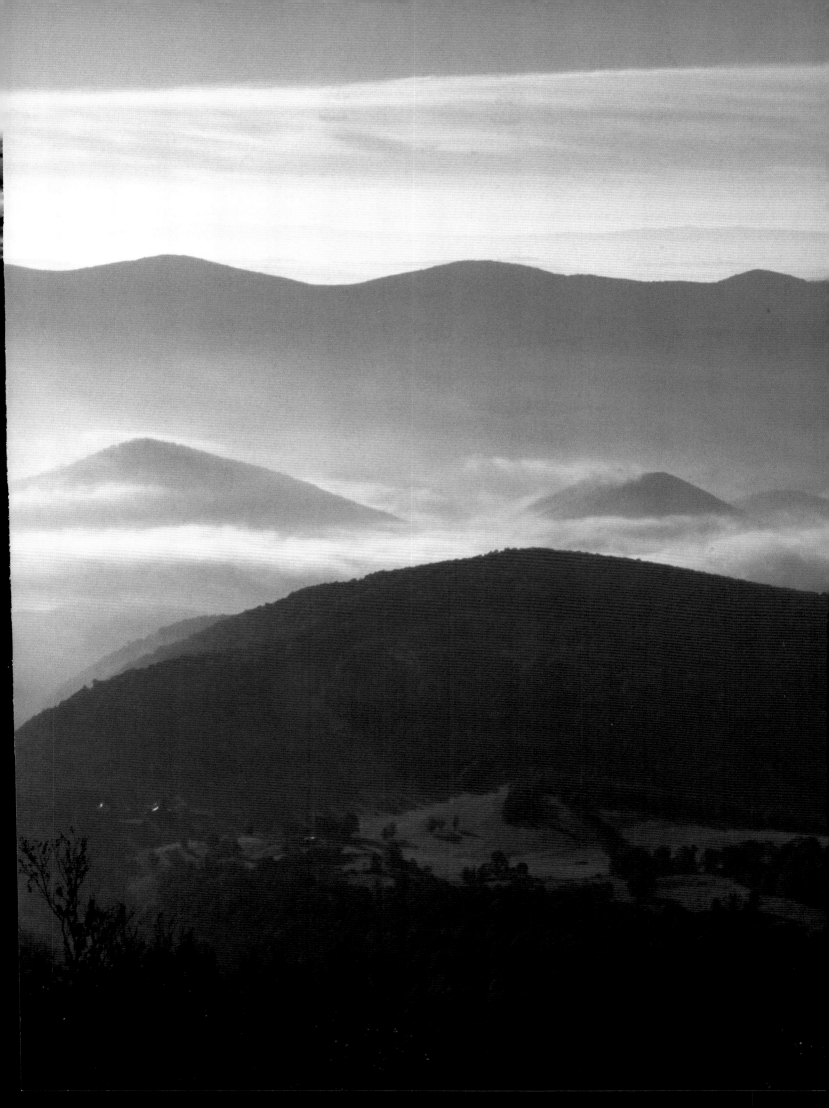

Birch Leaf — Holly Falls State Park

Whereabouts

Every year more people experience the mountains, rivers, and forests of the Appalachians. Interest in everything "Appalachian" has increased dramatically over the past decade. The region's music and crafts, history and culture, rugged landscapes, and diversity of life attract millions to the region. Where once mining and logging were the stalwart industries, today outdoor recreation has become the primary economic driver. In 1995, in the southern Appalachian region alone, more than 100 million outdoor-recreation based trips occurred on the five million plus acres of national forests found here, with eighty percent of the visitors coming from outside the region. The U.S. Forest Service estimates by 2005, visitation to national forests will increase by fifty percent.

Outdoor recreational opportunities equate to economic incentives for local communities. For example, whitewater rafting on the New River in southern West Virginia brings an estimated 45 million dollars annually to the local economy. The National Park Service estimates that over one million people a year stop at the Canyon Rim Visitor Center perched along the edge of the New River Gorge National River. The beautiful and remote Blackwater Canyon in West Virginia attracts more than one million visitors a year, with an annual economic benefit of 40 million dollars for Tucker County. The Monongahela National Forest in West Virginia estimates more than three million people visit the forest annually to participate in outdoor recreation. This is equal to the number of people visiting Yellowstone National Park.

The Appalachian forests are becoming less an extractable commodity and more an economic resource worth protecting for future generations. Instead of strip, remove, and cut, the trend is toward protect, promote, and experience. Within the region of West Virginia, Virginia, North Carolina, Tennessee, and Kentucky are more than five million acres of national forest land. If you like to hunt, fish, photograph, hike, nap, bird watch, float, rock climb, relax, or whatever, you'll find one of these national forests offering something for you:

West Virginia
Monongahela National Forest: With more than 900,000 acres, this national forest lies entirely within the state. The "Mon" includes four wilderness areas and unique forest ecosystems such as high mountain bogs. More than 200 species of birds occur here. The many logging roads and mountain trails rank the Monongahela as the East's best mountain biking location.

West Virginia/Virginia
George Washington National Forest: Encompassing more than 1.1 million acres, nearly 100,000 acres which spill into West Virginia, sharing a border with the Monongahela.

Jefferson National Forest: Covering more than 715,000 acres, the Jefferson protects the highest concentration of wood salamanders in the world; more than twenty-two species of salamanders are found in the Mount Rogers Recreation Area alone.

North Carolina

Pisgah National Forest: This national forest's 504,000 acres include deep gorges and thundering waterfalls and Mount Mitchell, the highest point east of the Mississippi. Whitewater rafting and canoeing are big business here. The Pisgah protects one of the largest remaining tracts of old growth in the Appalachians.

Nantahala National Forest: Twenty-two species of threatened and endangered plants and animals are found in this 528,000-acre national forest. The highest waterfall east of the Mississippi, Whitewater Falls at 411 feet, is a highlight.

Tennessee

Cherokee National Forest: More than 158 species of native fish occur in the steams and rivers of this 633,000-acre national forest. More than 300 species of birds and 70 mammal species occur here as well. Many mountain summits exceed 5,000 feet.

Kentucky

Daniel Boone National Forest: With more than 680,000 acres, this national forest includes unique sandstone escarpments and formations. The 13,000-acre Clifty Wilderness Area protects more than 750 species of flowers and 170 species of moss.

Photography Details

All images for this book were captured with Nikon equipment, primarily the Nikon F5 and recently, the Nikon D1X digital camera. An assortment of Nikkor lenses were used, from 17mm to 600mm. Film used was Fuji Velvia and Provia 100F. All images were captured with the camera firmly attached to a Gitzo 320, 410, or 1348 tripod. The only filters used were polarizer, warming (81A and 81B) and split-neutral density (.3 and .6). A Mason jar was always nearby to capture memories.

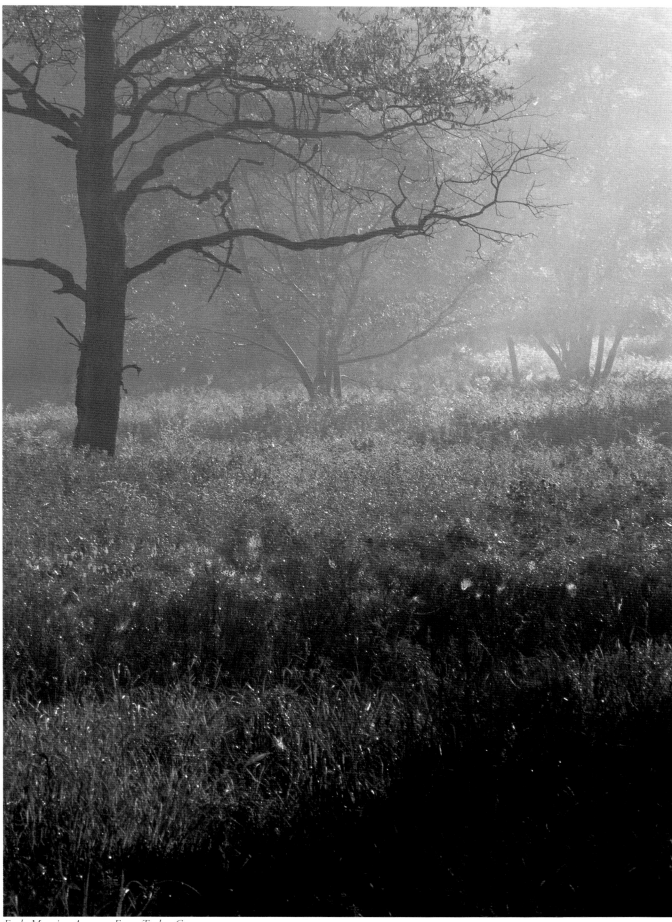

Early Morning Autumn Fog – Tucker County

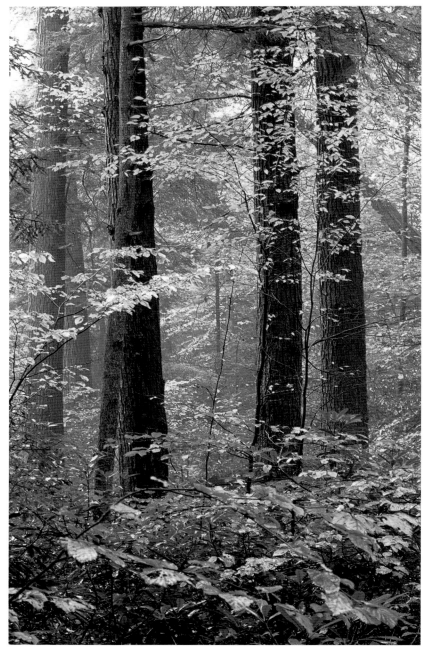

Early Autumn – Cathedral State Park

Following page: Sunrise through autumn fog – Tucker County;
Pages 220–221: Early Autumn Colors – Highland Scenic Highway;
Pages 222–223: Sassafras in Autumn – Monongahela National Forest

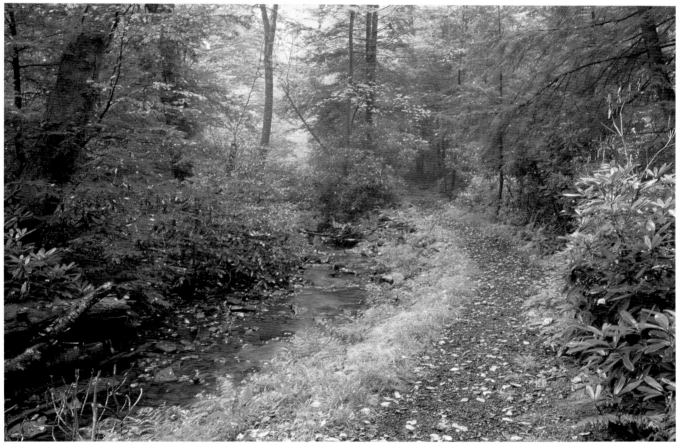

Early Autumn – Cathedral State Park

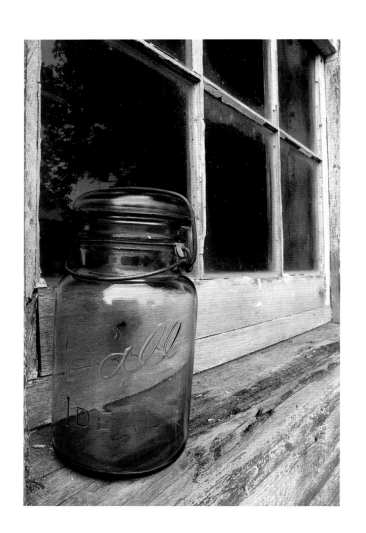